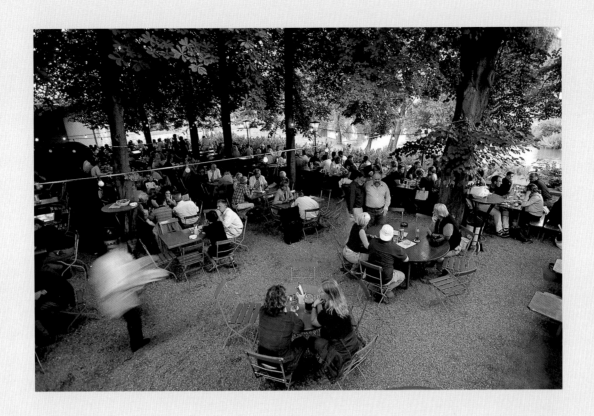

Journey through

UPPER
PALATINATE

Photos by
Martin Siepmann

Text by
Georg Schwikart

Stürtz

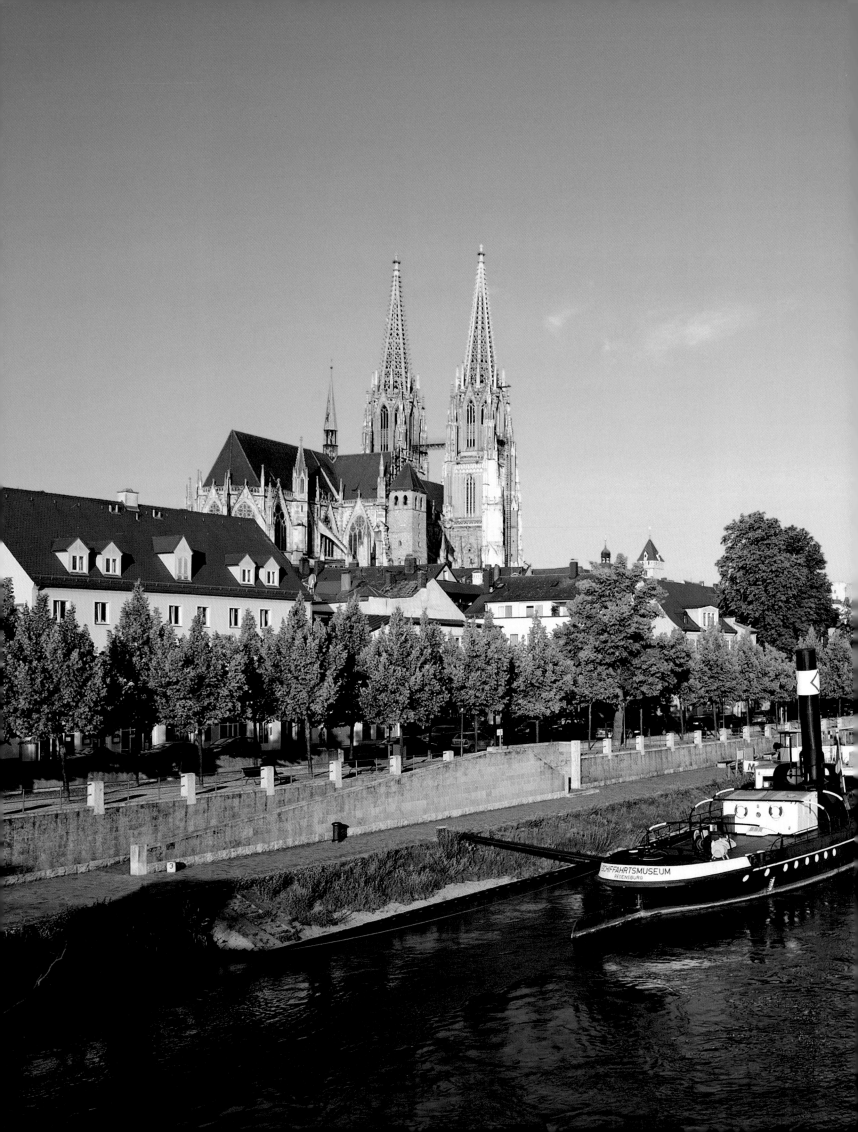

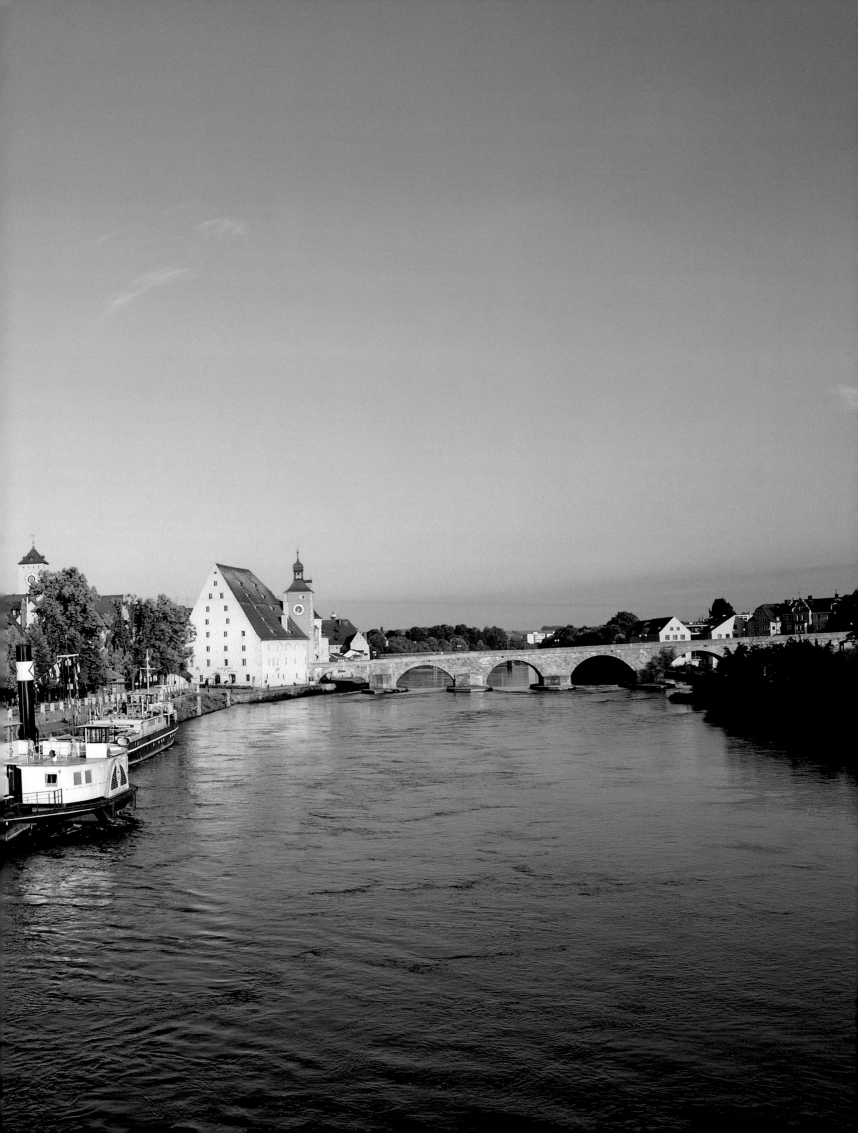

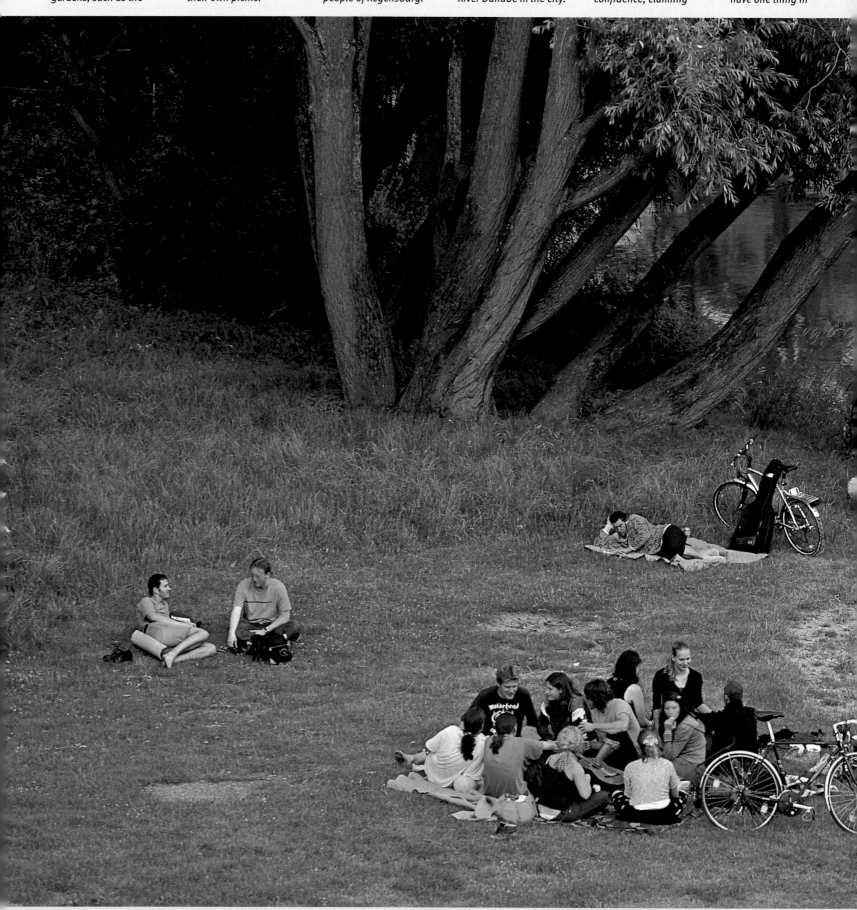

First page:
In summer you can soak up the atmosphere of Upper Palatinate in the region's many beer gardens, such as the Alte Linde here in Regensburg. At some of the more traditional establishments guests are even allowed to bring their own picnic.

Previous page:
A masterpiece of medieval architecture, the Steinerne Brücke is a major landmark for the people of Regensburg. It was built in just 11 years, between c. 1135 and 1146, and for over eight centuries was the only bridge over the River Danube in the city.

Below:
On the banks of the Danube in Regensburg. The city advertises itself with confidence, claiming it's just the ticket "for inquisitive pleasure-seekers, for lovers of art and dreamers. They all have one thing in

common; they are in love with the special sense of charm which probably only exists in Regensburg."

Page 10/11:
With its 7,720 pipes the organ in the basilica of Waldsassen is one of the largest in Germany – and is understandably regu-

larly used for concerts. Famous names, such as Leonard Bernstein, Sir Colin Davis, Lorin Maazel and Yehudi Menuhin, plus the Symphonieorchester

des Bayerischen Rundfunks and the Bamberger Symphoniker, have helped make the church a hot favourite among fans of classical music.

Contents

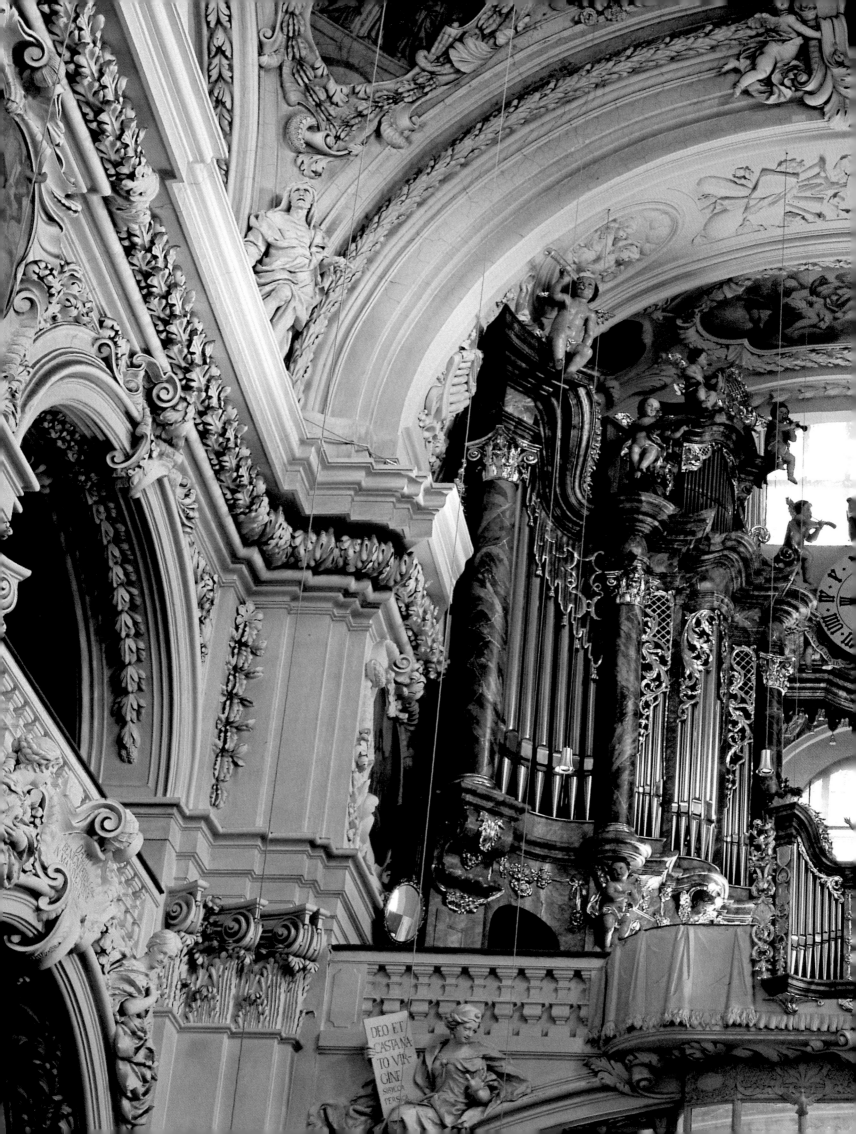

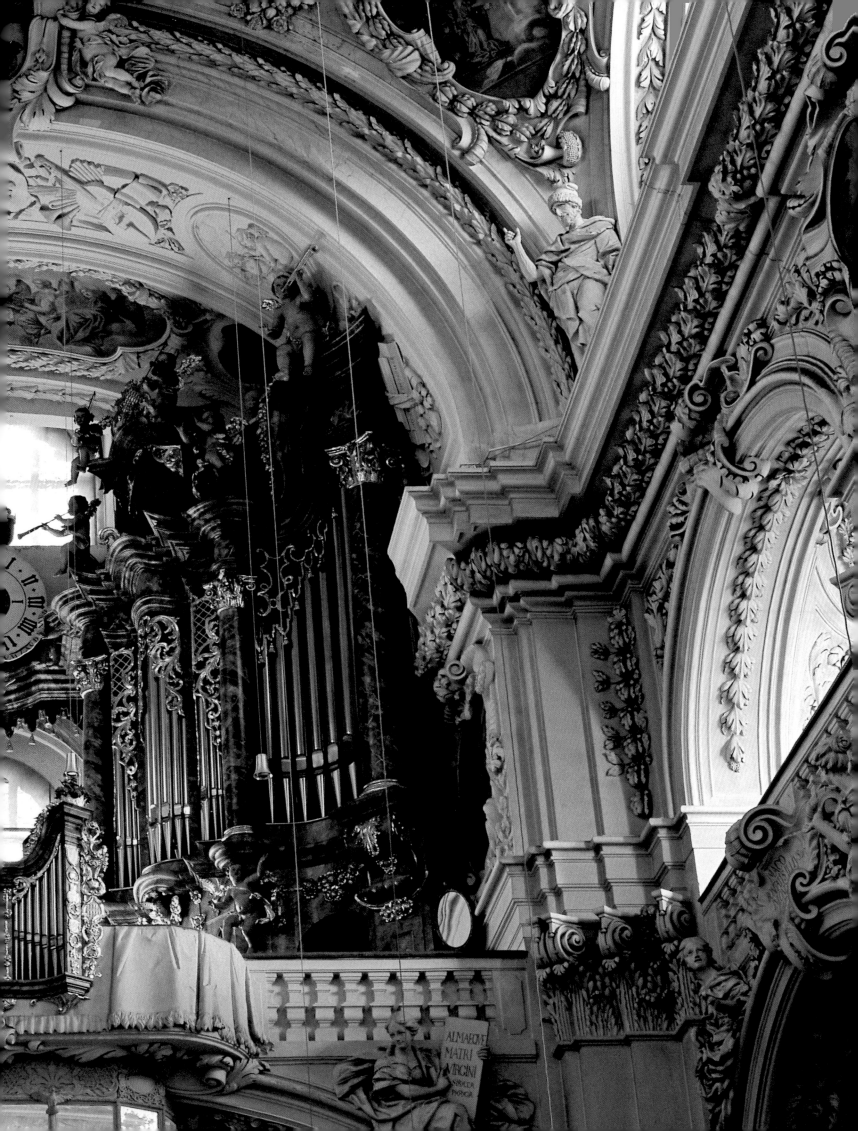

Upper Palatinate – tradition and culture in a unique setting

Marca Napurch was the name of the town of Nabburg astride the River Naab in the Oberpfälzer Wald at its founding at the turn of the 9th century.

By 1000 the town was a major stronghold for the counts of the Nordgau. The 15th-century town walls have been excellently preserved and much of the old town restored.

Legend has it in Upper Palatinate that Adam and Eve, the progenitors of the human race, had almost fifty children. One day God spoke unto Adam: "I wish to come and see your children". Eve, ashamed of having so many sons and daughters, set about hiding three dozen of them away. On God's arrival Eve showed him just twelve of her offspring, upon which God asked: "Are these all of your children?" "Yes", answered Eve. And God said: "Those you have brought me shall be blessed." Thus the world – or Upper Palatinate at least – was split into rich and poor.

Centuries of often bitter experience have prompted the people of Upper Palatinate – or the Oberpfalz, to give it its German designation – to count themselves among the latter. Unproductive soil in the "stony Palatinate" gave Eduard von Schenk, the fourth head of the local administration, cause to complain to his king in 1832 that the Upper Palatinate, "where mostly only oats, flax and potatoes grow", had been abandoned by Mother Nature. To boot, the climate was and still is not particularly favourable – although the local claim that winter lasts for nine months of the year and the other months are simply cold is perhaps something of an exaggeration. It's thus hardly surprising that such inclement terrain remained unpopulated almost until the dawn of the Middle Ages. Primeval forest covered the area well into the 5th and 6th centuries AD. Right up until 1000 Emperor Heinrich II is said to have come here to hunt bears and bison, otherwise extinct. And even today Upper Palatinate is relatively sparsely populated compared to other regions in Germany.

From Roman forts to the "Ruhr of the Middle Ages"

The only places inhabited by man in the Palaeolithic Age (c. 10,000 BC) are the river valleys of the Altmühl, Naab and Regen and the bend

in the River Danube near Regensburg. At the latter the Celts founded a settlement which they named Radasbona, now Regensburg or Ratisbon. At the beginning of 2006 Celtic graves from c. 400 BC were discovered in Regensburg not far from the walls of the Roman camp.

The Celts had left by the time the Romans conquered the northern foothills of the Alps and the Danube region in 15 BC where in the 2nd century AD under Roman emperor Marcus Aurelius they set up the legionary fort of Castra Regina. Impressive remains of the north gate, the Porta Praetoria, have been preserved in Regensburg's old town. The migration of the peoples during the 5th century precipitated the departure of the Roman army, with their fort being converted into a royal residence for the dukes of the Baiuvari Agilolfing dynasty.

Fear of the Asian Avars, who seized Bohemia and Moravia in the 6th century, brought Slavs from the forests of Bohemia scurrying to the region where they founded a number of small villages and hamlets. St Boniface established the bishopric of Regensburg in 739 and the area subsequently embarked on its conversion to Christianity.

Supremacy of the area changed hands frequently. The Agilolfings proved too rebellious for Emperor Charlemagne who deposed them in 788. The land to the west of what is now Upper Palatinate became part of the Frankish kingdom, known as the Nordgau. This gradually spread west, south and east to form the present Upper Palatinate region.

The general population rise during the 11th and 12th centuries meant that Upper Palatinate, too, was discovered by settlers. Place names ending in -reuth or -ried still refer to areas cleared of ancient forest to make way for new homes. Many monasteries and towns arose – and also castles, with Upper Palatinate long an important boundary guarded by formidable defences. The imperial fortresses first set up in Cham and Nabburg were soon supported by a network of smaller forts and strongholds.

People then began exploiting the natural resources of the land, earning Upper Palatinate the epithet of the "Ruhr of the Middle Ages". The number of mines and ore works mushroomed, particularly around Amberg, Sulzbach and Auerbach where there was plenty of wood and water available to fuel the industry. Mines were dug 100 to 200 metres (300 to 600 feet) into the ground. The region became one of the most lucrative principalities in Europe. Even at the turn of the 15th century one third of German ore was still mined in Upper Palatinate.

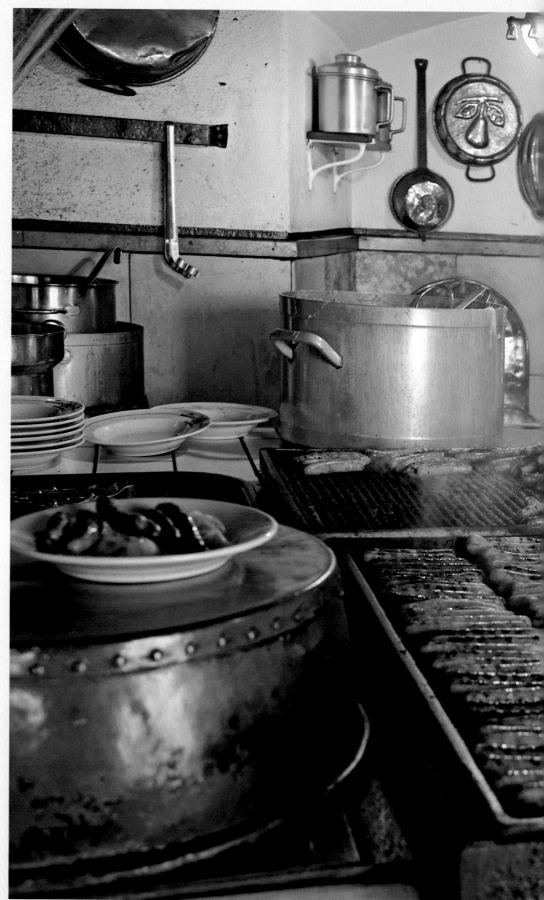

For over 500 years the historic Wurstkuchl, the oldest sausage stand in the world, has hugged the contours of the Steinerne Brücke. Once a welcome source of nourishment for Regensburg's hard-working stone masons and river labourers, today the sausages are still grilled over an open fire and served with sauerkraut matured in the kitchen's own cellars and mustard made from a traditional recipe.

Changing faces

In 1180 the Wittelsbachs became dukes of Bavaria and in the 11th century they set about reuniting the various isolated segments of the Nordgau. Wittelsbach emperor Ludwig the Bavarian later mortgaged a large section of it, the Egerland, to Bohemia. Under the Treaty of Pavia in 1329 Bavaria was divided, with Ludwig the Bavarian bequeathing the Nordgau to the descendants of his brother Rudolf, the Rhineland-Palatinate branch of the Wittelsbach family based in Heidelberg. The region was subsequently renamed "der Pfalz Land zu Bayern", the land of the Palatinate in Bavaria or, as it was geographically higher than Rhineland-Palatinate (Lower Palatinate), "die obere Pfalz": Upper Palatinate.

During the 14th century famine, natural disaster and the bubonic plague put an abrupt end to the region's ascendancy. Between 1422 and 1434 Hussites from Bohemia attacked the area on several occasions, forcing even small villages to erect costly fortifications which plunged them into financial ruin. The ravages of the Reformation and various other conflicts took their toll on Upper Palatinate time and again. Under Duke Ottheinrich von Pfalz-Neuburg the region officially converted to Protestantism in 1556, resulting in the dissolution of many of the local monasteries.

In 1628 Upper Palatinate fell to the Bavaria elector Maximilian I and was made part of the state of Bavaria. The Counter-Reformation then began its march of triumph, led by the Jesuit theological college in Amberg. Believers in religious reform and Lutheranism were forced to change their confession or leave; some of the monasteries managed to reopen.

Too close for comfort to Bohemia during the Thirty Years' War, Upper Palatinate was constantly traversed by marauding armies on both sides between 1618 and 1648. Towns and villages were plundered and laid waste, cattle stolen and farms razed to the ground. By the end of the war the local populace was almost totally annihilated and Upper Palatinate relegated to an insignificant Bavarian province totally reliant on agriculture.

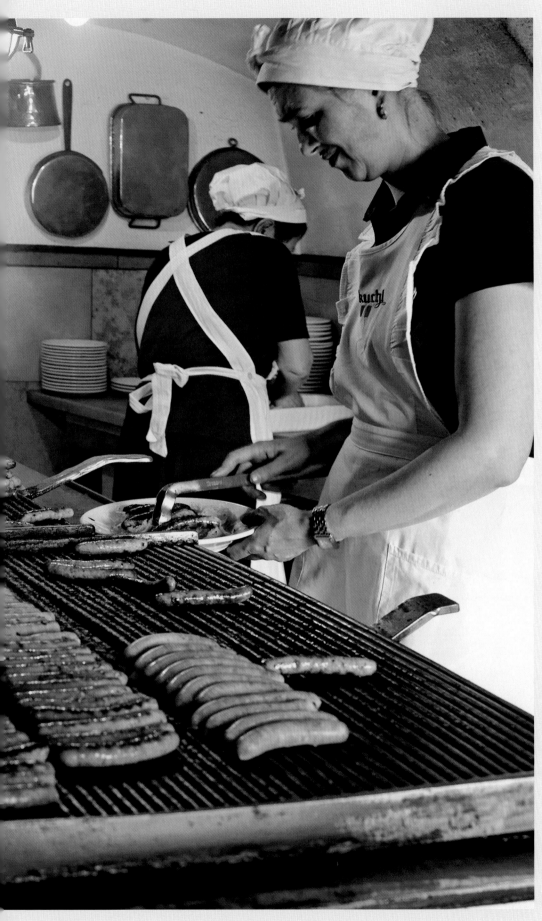

From 1663 to 1806 the Perpetual Imperial Diet of the Kingdom of Germany in the Holy Roman Empire was held in Regensburg, making the city the seat of numerous foreign embassies. The royal house of Thurn und Taxis was entrusted with representing the emperor's affairs in 1748 and also took up residence in Regensburg. Originally from Upper Italy, during the 16th to 18th centuries the family rose to fame and fortune through its postal service.

In the wake of Bavarian administrative reform, at the beginning of the 19th century Upper Palatinate was relabelled Regenkreis, with Regensburg inaugurated as the administrative capital on November 1, 1810. In 1837/38 King Ludwig I of Bavaria renamed the districts within his kingdom once again and the present designation of Oberpfalz was introduced. Today Upper Palatinate covers an area of 9,691 square kilometres (3,742 square miles) and has ca. 1,090,000 inhabitants spread out across seven rural districts and the three urban centres of Regensburg, Amberg and Weiden.

The way ahead

Up until the end of the 1980s the iron and steel industry in an otherwise largely rural area was a major economic factor. In its heyday the Maxhütte in Sulzbach-Rosenberg employed over 9,000, for example. After going bankrupt not once but twice the production of steel was finally stopped in 2002. Even agriculture no longer has a major role to play here.

Also during the 1980s the state government of Bavaria began planning a reprocessing plant for used nuclear reactor fuel rods in Wackersdorf in the district of Schwandorf. Following the last pit closure in 1982 unemployment had climbed to over 20%. For years the undertaking was hotly contested by anti-nuclear protestors and the majority of those living close by – even more so after the disaster in Chernobyl on April 26, 1986. The government finally shelved the project in 1989.

At the royal Bavarian firing range of Grafenwöhr, founded in 1908, the king's troops once tested their rifles; after the war the largest military training ground in Europe was commandeered by the US Army. Even today Schießplatz Grafenwöhr is one of the biggest employers in the region, providing ca. 3,600 jobs. In 2001 there was almost a very nasty accident here; on May 8 two misdirected tank grenades hit an infant school in the nearby village of Kirchenthumbach. When the missiles hit several children were playing outside and two adults were in the building but luckily only the roof was damaged.

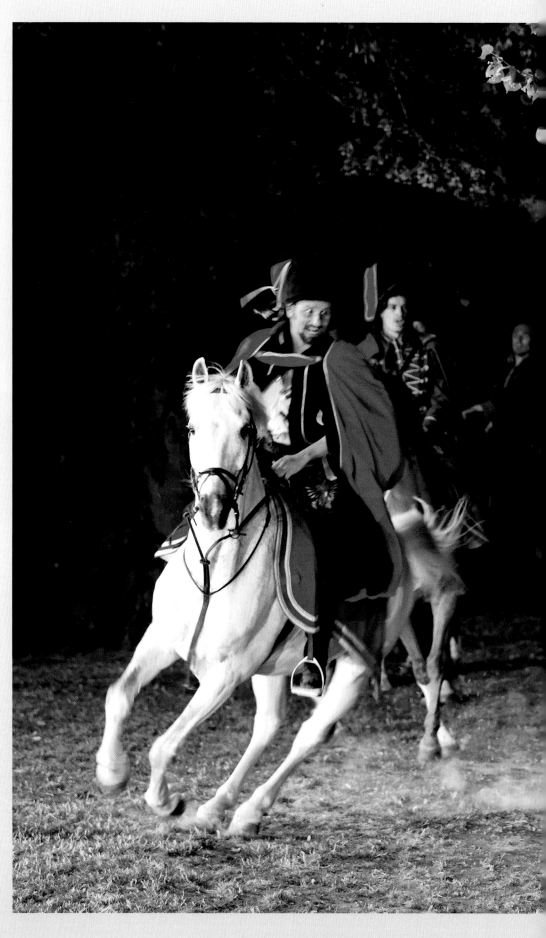

Also famous far beyond the boundaries of Upper Palatinate is its manufacture of porcelain and glass, its traditional sites of production dotted along the Bayerische Porzellanstraße or Bavarian porcelain route. After the Second World War various automobile, electrical and electronics companies set up shop in Upper Palatinate; Regensburg is also one of the biggest biotechnology centres in Germany. Particularly since the mid 1990s, in Upper Palatinate the number of those working in production has declined, with the number of employees in the service industry on the rise. Tourism has proved itself to be a major mainstay of the local economy. Today the region can look to the future with a cautious optimism.

From St Wolfgang to Dr Eisenbarth

Among those whose name is inextricably linked to Upper Palatinate are two Catholic saints: Wolfgang (924–994), who came from Württemberg and was made bishop of Regensburg at the end of 972, and Albertus Magnus (c. 1200–1280), who held the post from 1260 to 1262. In 975 Wolfgang founded a cathedral school in Regensburg with a choir which formed the basis of today's Regensburger Domspatzen. St Wolfgang is buried in the church of St Emmeram.

Many of the region's characters only became famous once they'd left Upper Palatinate, among them Don Juan de Austria or John of Austria (1547–1578), the illegitimate son of Emperor Karl V and Barbara Blomberg, the daughter of a Regensburg craftsman. As commander of the naval fleet of the Holy League, amassed by the Christian countries of the Mediterranean, in 1571 he quashed the Ottoman Empire at the Battle of Lepanto. A statue of him was erected on Zieroldsplatz in his native Regensburg in 1978.

In conjunction with those who merit attention in the field of science Johannes Kepler (1571–1630) should be mentioned – even if he had little to do with Upper Palatinate itself. The mathematician, astronomer and optician, born

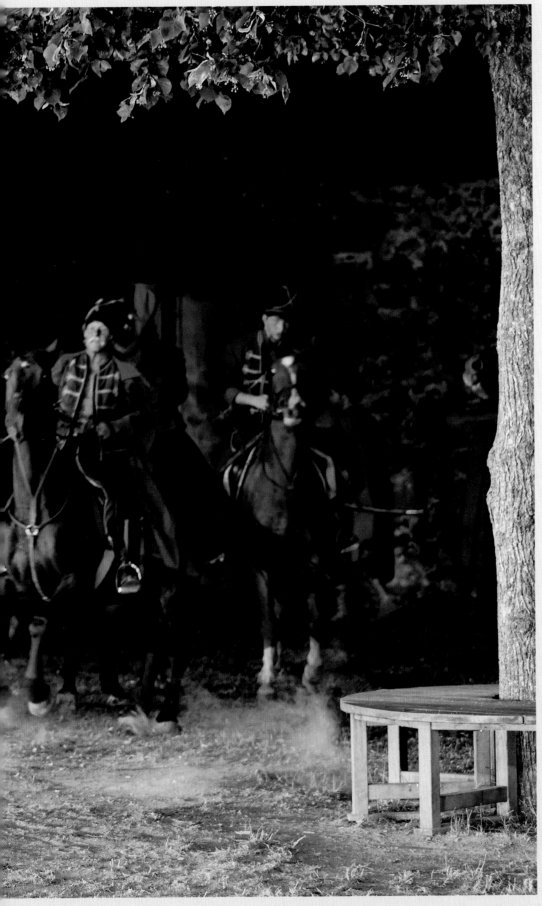

in Weil der Stadt in Württemberg, discovered the laws of planetary motion, introduced arithmetic with logarithms and helped substantiate the discoveries of Galileo Galilei. He moved to Regensburg where he died a few months later at the age of 59. His grave was lost during the Thirty Years' War yet his place of death remains. The inscription Kepler wrote for his own tomb is as follows:

Mensus eram coelos, nunc terrae metior umbras.
Mens coelestis erat, corporis umbra iacet.

(I have measured the heavens, now I will measure the shadow of the Earth. My spirit rises to the heavens, the shadow of my body rests here.)

Johannes Stark (1874–1957), born in Schickenhof (now part of Freihung in Amberg-Sulzbach), was awarded the Noble Prize for Physics in 1919. His anti-Semitism and National Socialist agitation have resulted in him now being largely forgotten – perhaps justifiably so. Another local of some renown was Ernst Schweninger (1850–1924), the personal physician of imperial chancellor Bismarck, born in Freystadt in Neumarkt.

The infamy of one of Schweninger's colleagues, a certain Doctor Eisenbarth from Oberviechtach, has proved more resilient over the passage of time. Able to reduce hernias and remove bladder stones and a surgeon and optician to boot, Johann Andreas Eysenbarth (1663–1727) was probably a good physician in his day and age. The fact that he was always on the move, however, accompanied by a self-appointed entourage who sang his praises loud and long, earned him something of a reputation as a quack, ridiculed in one local verse which claims he can make the blind walk and the lame see:

Ich bin der Doktor Eisenbarth,
Kurier die Leut nach meiner Art,
Kann machen, dass die Blinden gehn,
Und dass die Lahmen wieder sehn.

The creative minds of Upper Palatinate

Upper Palatinate has also provided a number of creative minds with both inspiration and a home. Sculptor Erasmus Grasser (1450–1518), for example, came from Schmidmühlen in Amberg-Sulzbach. Albrecht Altdorfer (1480–1538), Renaissance architect, copper engraver and painter, was born and died in Regensburg and is heralded by art historians as the founder of landscape painting; *Alexanderschlacht* or the Battle of Alexander at Issus, painted in 1528/29, is his most famous work. Johann Michael Fischer (1692–1766), the architect behind such well-known late Baroque monastic

churches as Osterhofen-Altenmarkt, Dießen am Ammersee, Zwiefalten and Ottobeuren, came into the world in Burglengenfeld in the district of Schwandorf.

Erasbach near Berching in the *Landkreis* of Neumarkt is the birthplace of operatic composer Christoph Willibald Gluck (1714–1787), active in Milan, Paris and Vienna and renowned as a reformer of the opera. Max Reger (1873–1916), composer, pianist and conductor, was born in Brand in the Fichtelgebirge in the Tirschenreuth district. He grew up in Weiden and left Upper Palatinate at the age of 18. The Weidener Musiktage festival is held in his honour every two years.

Amberg was where Hans Baumann (1914–1988) first saw the light of day. He initially wrote songs for the Hitler Youth but earned international reprieve and acclaim after the war as a writer of books for young adults and a Russian translator. Popular novelist Sandra Paretti (1935–1994) came from Regensburg, as did her literary colleague Georg Britting (1891–1964). The latter penned a number of narratives, plays and lyric poems and also wrote in the local Upper Palatinate dialect. In his *Der gemalte Sommer* (Painted Summer) he describes how: *"When, staying with relatives in the country for the holidays, I walked across the fields and watched the regular movements of the cutters, I never once saw anybody break away from the throng to sit down on the edge of the field and spoon soup from a bowl, nor anybody tired enough to lie down to sleep in the dark shade of an apple tree. … And never in my life have I seen a little girl kneel down beneath a crucifix with her hands folded in prayer."*

Places of culture and memorial

Tourist highlights such as Regensburg attract an international clientele. In 1928 poet Konrad Weiß called Regensburg "an inexhaustible city"; time and again Regensburg proves just how right he was.

Between 1830 and 1842 King Ludwig I had Leo von Klenze erect a national monument on top of Bräuberg Hill near Donaustauf, a good few

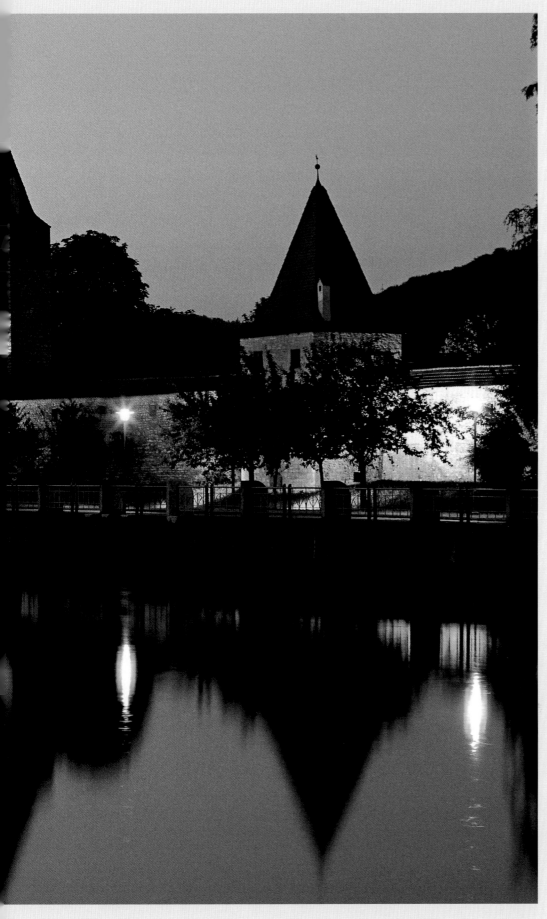

miles downstream from Regensburg. Based on the Parthenon in Athens, the neoclassical Walhalla was built as a hall of fame for the good and the great of Germany who are revered in busts of marble and commemorative tablets. The last image installed here in 2009 was that of German writer Heinrich Heine.

In the Oberpfälzer Wald or Upper Palatinate Forest on the border to the Czech Republic is Flossenbürg, site of a Nazi concentration camp between 1938 and 1945 where prisoners were forced to mine the hardest granite in the world. Fourteen days before the camp was liberated the Nazis murdered resistance fighters Dietrich Bonhoeffer, Wilhelm Canaris and Hans Oster here. The site is now a place of memorial.

Weiden boasts a much less gruesome attraction in its local parish church which is a positive orgy of Jugendstil design. The largest church in the diocese of Regensburg since the Middle Ages was built in just 18 months in 1899/1900, its twin spires still towering high up above the roofs of the old town. Not so long ago there were plans afoot to "modernise" the building. Luckily, funds were lacking; the works of Munich artist Franz Hofstötter (1871–1958) which adorn the interior would otherwise have been lost forever.

Amberg is also worth a visit. It was an important trading post for iron and iron ore during the Middle Ages and is today one of the best preserved medieval towns in Europe. One place of worship here which deserves a special mention is the baroque pilgrimage church of Maria Hilf, decorated by Cosmas Damian Asam in 1716.

Many other towns have managed to retain their medieval character, where huge churches and impressive town dwellings bear witness to the former wealth of their inhabitants. A thirst for culture can be slaked at the many museums. There are open-air museums and museums of folk culture; there are museums of fishing and the military, of schooling and archaeology – and in Bärnau in Tirschenreuth there is even a museum devoted to buttons, the Deutsches Knopfmuseum, opened in 1975.

Another anomaly is the Continental Drilling Programme in Windischeschenbach north of Weiden. Between 1987 and 1995 the biggest onshore drill apparatus in the world was used to investigate the contact zone of two Continental plates. The shaft house rises high up into the air; below ground the bore holes go down over 9,000 metres (29,500 feet). The GEO-Zentrum and underground observatory are now used primarily for educational purposes, complete with guided tours, films, exhibitions – and trips up the drilling rig.

The River Regen in Heilinghausen near Regenstauf. Called Regana by the Teutons, the Regen is made up of the two smaller rivers of the Weißer Regen and Schwarzer Regen and is one of Germany's most scenic waterways for small boats and canoes.

The upholding of traditions and customs is also important in Upper Palatinate. Festivals famous well beyond the region are the Drachenstich in Furth – Germany's oldest folk play has been performed for over 500 years here – the Trenckspiele in Waldmünchen and the Whitsun procession in Kötzting.

Wanderlust and wellness

With over 600 fortresses and palaces Upper Palatinate is Bavaria's number one hot spot for castle lovers. In the north of the Oberpfälzer Wald the Stiftland area near the monastery of Waldsassen not only boasts a number of cultural monuments and other attractions but also many hiking trails and natural springs. None other than Goethe was familiar with the healing properties of the waters of Upper Palatinate. Since the 1990s the region has had its very own (and only) spa in the Sibyllenbad near Neualbenreuth close to the Czech border. Containing both radon and carbon dioxide, the water is used to relieve various ailments.

If you like your peace and quiet, the sparsely populated reaches of Upper Palatinate provide a welcome respite. With its medium-range hills, forests, pools and lakes the region attracts hikers, walkers and cyclists. Together with the Bohemian Forest in the Czech Republic and the Bayerischer Wald, the Oberpfälzer Wald forms one of the largest swathes of woodland in Central Europe, often referred to as the "green roof of Europe".

Vilstal is a perfect example of successful natural restoration where much of the River Vils has now been returned to its original bed, making it popular canoeing territory. The Steinwald south of the Fichtelgebirge is unusual with its bizarre formations in granite; the Waldnaabtal, its river gentle and meandering and then suddenly wild and furious, is both romantic and exciting.

Author Norbert Elmar Schmid once called the River Naab the main aorta of Upper Palatinate, its source almost as difficult to pinpoint as that of the River Nile. His observations end with the comment: *"The waters of Upper Palatinate flow downstream along the Danube to the*

Black Sea, to Constantinople which is now Istanbul. And at some point maybe the waters of the Naab mix with those of the Nile. The land of the Naab is, however, not the hub of the universe, nor of Europe nor Germany nor Bavaria – at the most of Upper Palatinate."

Land in the heart of Europe

Visitors to the region can take home a number of keepsakes of their holiday: glass, tin and porcelain, smoked sausage and local schnapps, a CD by the Regensburger Domspatzen ... The most precious souvenirs, however, will be the memories you'll treasure of a very diverse and hospitable part of Germany. The only problems you're likely to encounter here are with the local vernacular; non-Bavarian Germans and even the various denominations of Bavaria themselves (the Franconians and the Upper and Lower Bavarians, for example) also do battle with the lingo – and northerners or "Prussians" don't stand much of a chance linguistically when the going gets tough. If your school German fails you, there's always sign language ...
Professor Ernst Emmerig, head of the regional district of Upper Palatinate from 1962 to 1981, once praised his place of work as "an old Bavarian land of unmistakable uniqueness, loved by those born here or who have grown into it." And added to this number are all those who have come to love Upper Palatinate as a place of vacation, returning for their holidays time and time again. Up until 1989 the Oberpfalz was on the very edge of (West) Germany, with the CSSR just beyond the heavily fortified Iron Curtain already part of the Eastern Block. Now Upper Palatinate has been returned to the very heart of Europe.

Page 22/23:
The Lamer Winkel in the northern Bayerischer Wald is surrounded by the wooded slopes of the Hohenbogen and Künisches Gebirge to the north and the Arberkamm and Kaitersberg to the south. This pleasant stretch of countryside is popular with holidaymakers.

Page 24/25:
A long flight of steps winds up through a wooded glade to the Rococo pilgrimage church of Maria-Hilf in Beratzhausen. Pilgrims can pause for though and reflect in prayer at the Stations of the Cross which line the route.

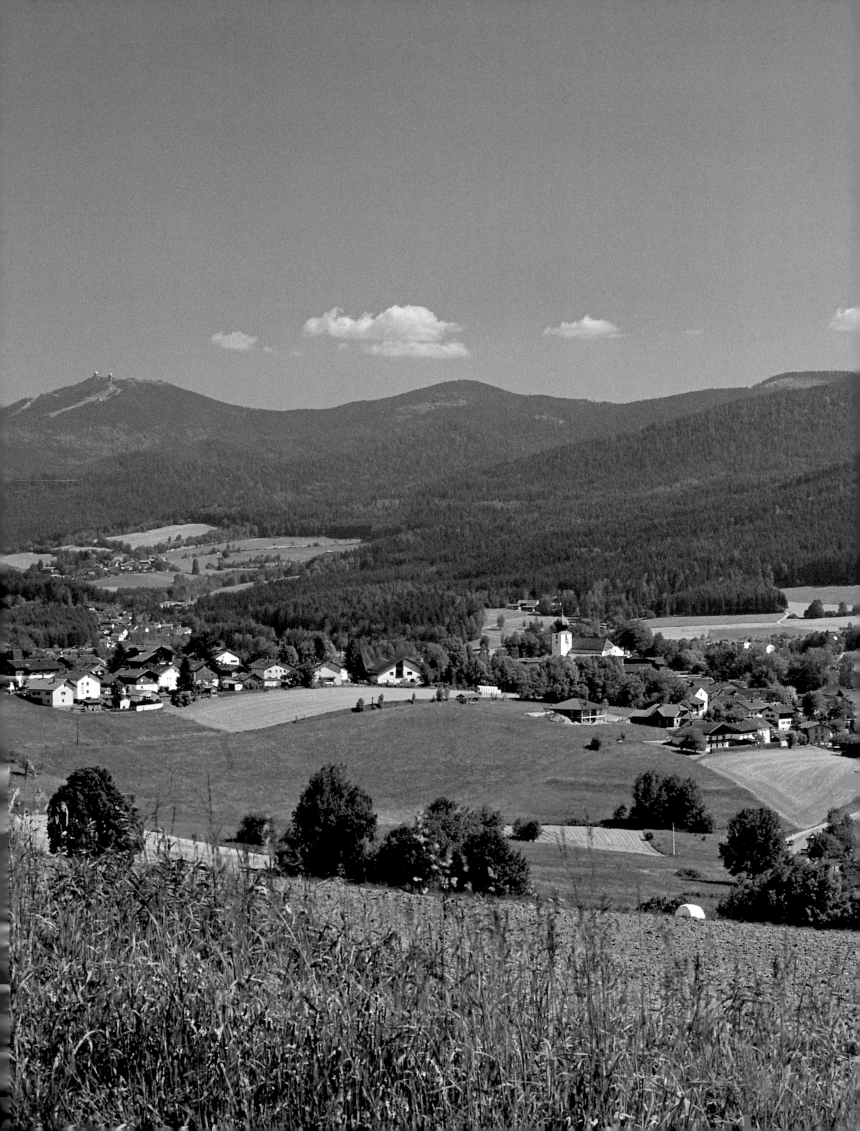

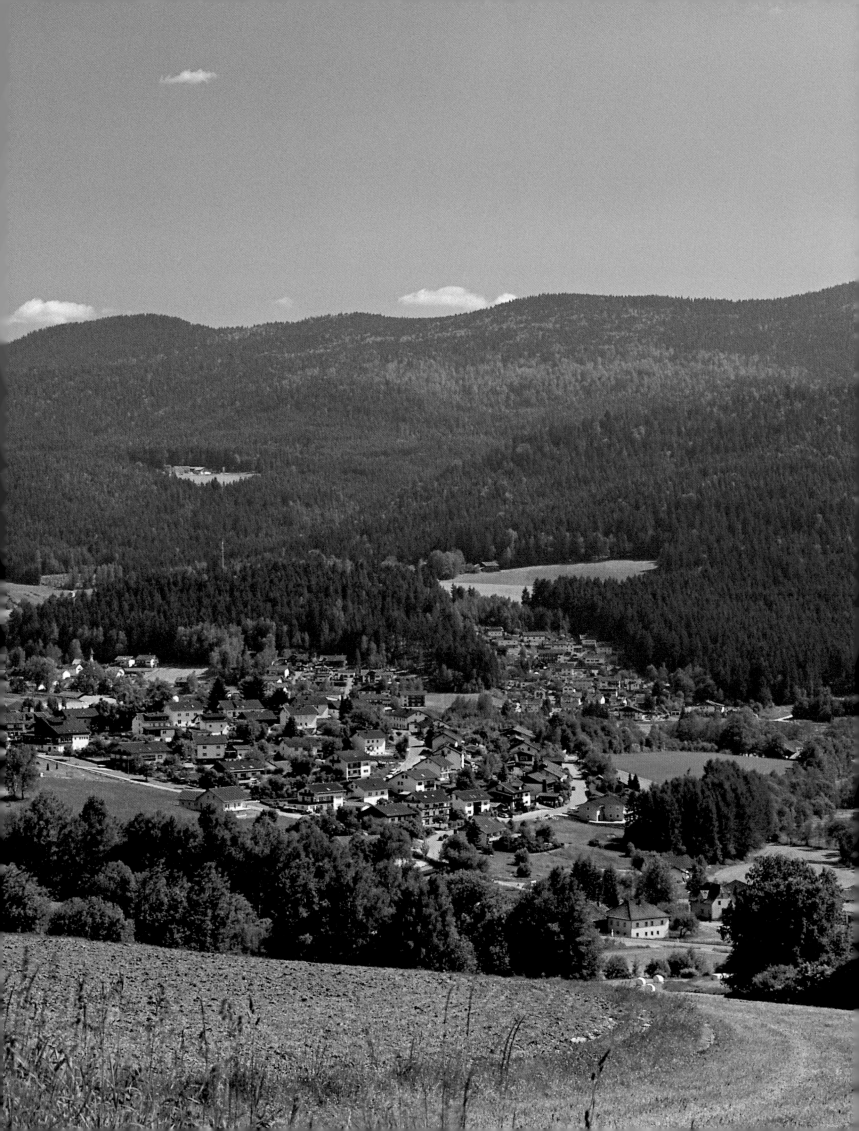

On the banks of the Danube and Regen – the south

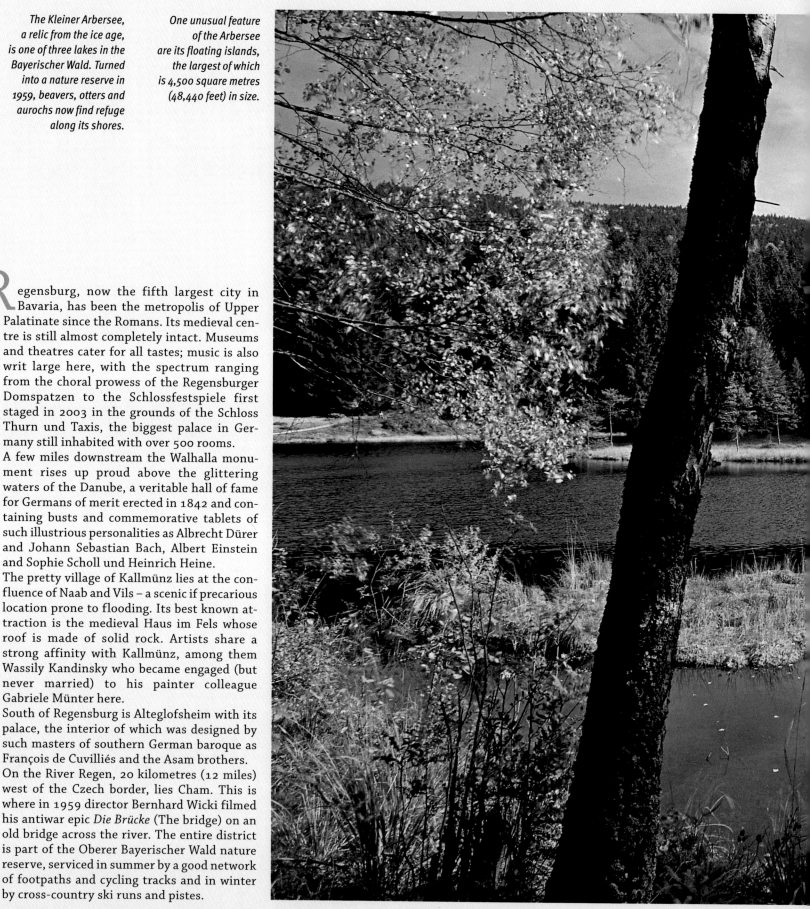

The Kleiner Arbersee, a relic from the ice age, is one of three lakes in the Bayerischer Wald. Turned into a nature reserve in 1959, beavers, otters and aurochs now find refuge along its shores.

One unusual feature of the Arbersee are its floating islands, the largest of which is 4,500 square metres (48,440 feet) in size.

Regensburg, now the fifth largest city in Bavaria, has been the metropolis of Upper Palatinate since the Romans. Its medieval centre is still almost completely intact. Museums and theatres cater for all tastes; music is also writ large here, with the spectrum ranging from the choral prowess of the Regensburger Domspatzen to the Schlossfestspiele first staged in 2003 in the grounds of the Schloss Thurn und Taxis, the biggest palace in Germany still inhabited with over 500 rooms.

A few miles downstream the Walhalla monument rises up proud above the glittering waters of the Danube, a veritable hall of fame for Germans of merit erected in 1842 and containing busts and commemorative tablets of such illustrious personalities as Albrecht Dürer and Johann Sebastian Bach, Albert Einstein and Sophie Scholl und Heinrich Heine.

The pretty village of Kallmünz lies at the confluence of Naab and Vils – a scenic if precarious location prone to flooding. Its best known attraction is the medieval Haus im Fels whose roof is made of solid rock. Artists share a strong affinity with Kallmünz, among them Wassily Kandinsky who became engaged (but never married) to his painter colleague Gabriele Münter here.

South of Regensburg is Alteglofsheim with its palace, the interior of which was designed by such masters of southern German baroque as François de Cuvilliés and the Asam brothers.

On the River Regen, 20 kilometres (12 miles) west of the Czech border, lies Cham. This is where in 1959 director Bernhard Wicki filmed his antiwar epic *Die Brücke* (The bridge) on an old bridge across the river. The entire district is part of the Oberer Bayerischer Wald nature reserve, serviced in summer by a good network of footpaths and cycling tracks and in winter by cross-country ski runs and pistes.

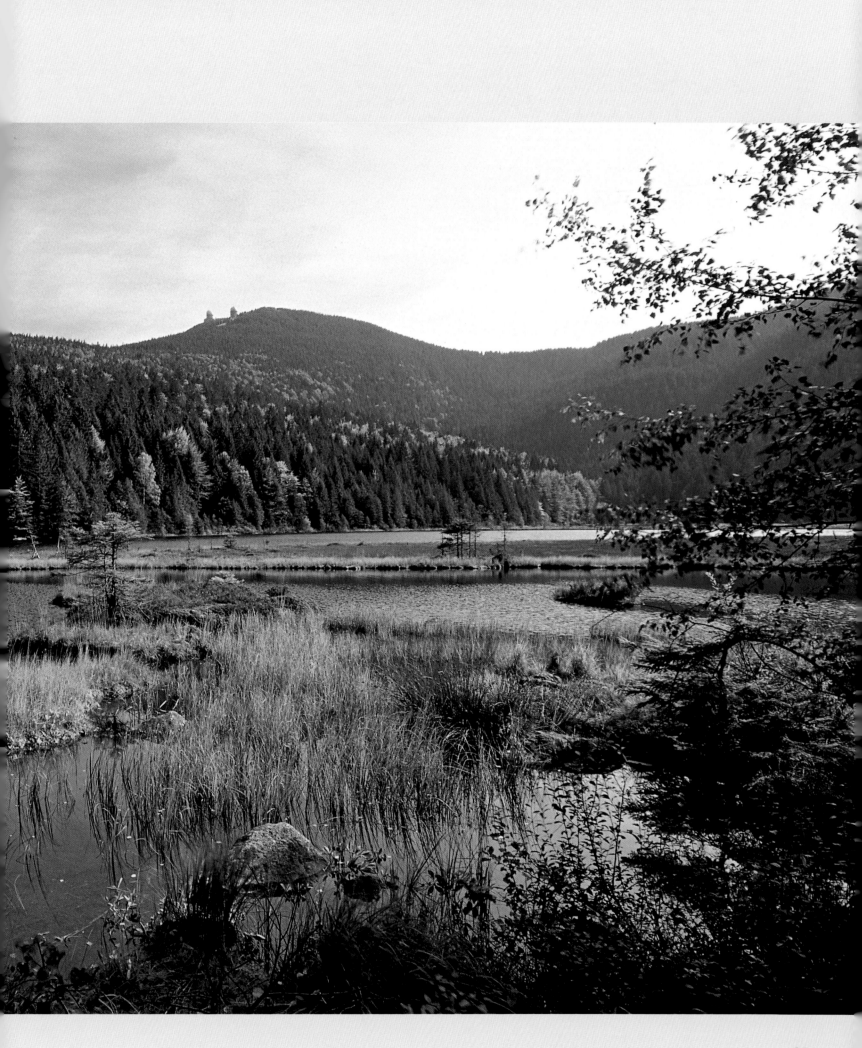

Below:
Lock on the Ludwigskanal near Dietfurt in the valley of the Altmühl. In the 19th and 20th centuries the canal, named after King Ludwig I of Bavaria, joined the Danube and Main rivers from Kelheim to Neumarkt in Upper Palatinate and from Nuremberg to Bamberg. It forged a direct link from the mouth of the Rhine at Rotterdam to the Danube estuary on the Black Sea.

Top right:
Well-built, relatively flat cycle tracks through beautiful scenery make the Altmühltal National Park paradise for cyclists. The most famous of these is the Altmühltal-Radweg, one of the most popular trails in Germany. 164 kilometres (102 miles) long, it runs along the entire valley from Gunzenhausen to Kelheim.

Centre right:
The tiny hamlet of Grögling is part of Dietfurt where in the Middle Ages the counts of Grögling-Dollnstein resided. Documents record a moated castle having been erected here in 1108. The church, picturesquely situated on the banks of the Altmühl, is dedicated

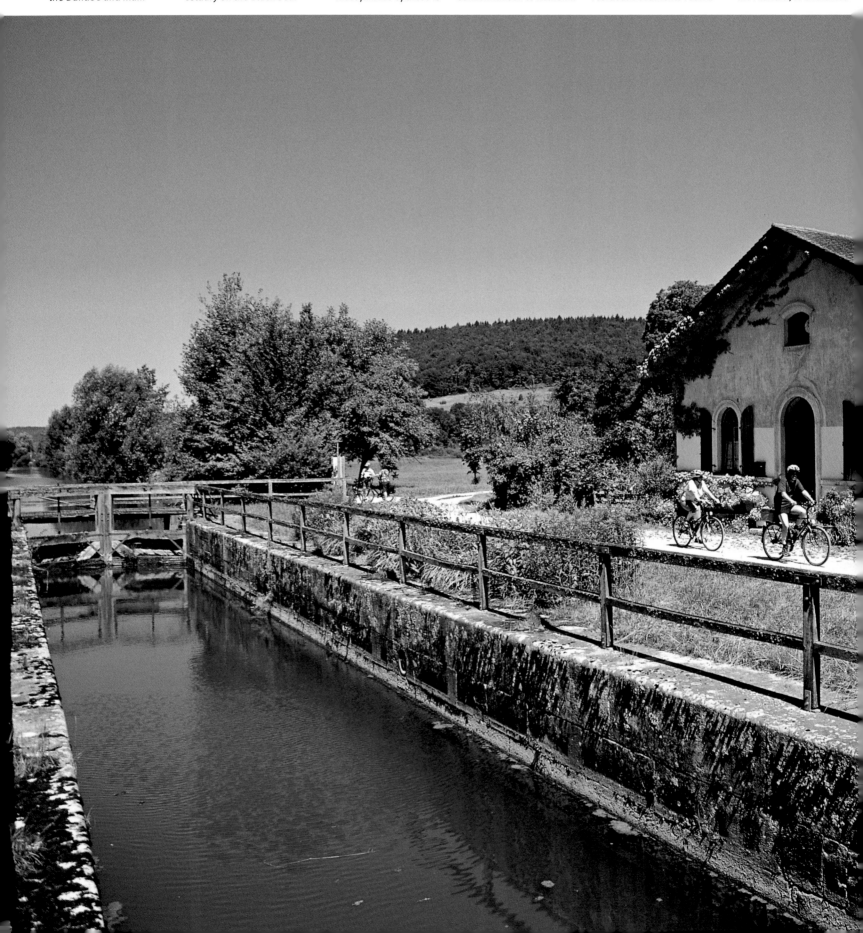

to the two martyred brothers John and Paul and has a simple high altar decorated with Nazarene paintings.

Bottom right:
Holidaymakers and daytrippers in search of peace and quiet can wind down along the Ludwigs-kanal near Richtheim.

Fishing is popular here too, with the canal well stocked with barbel, perch, carp, roach, tench and pike-perch.

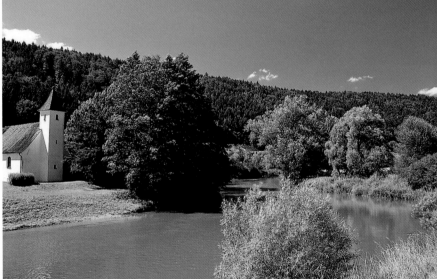

29

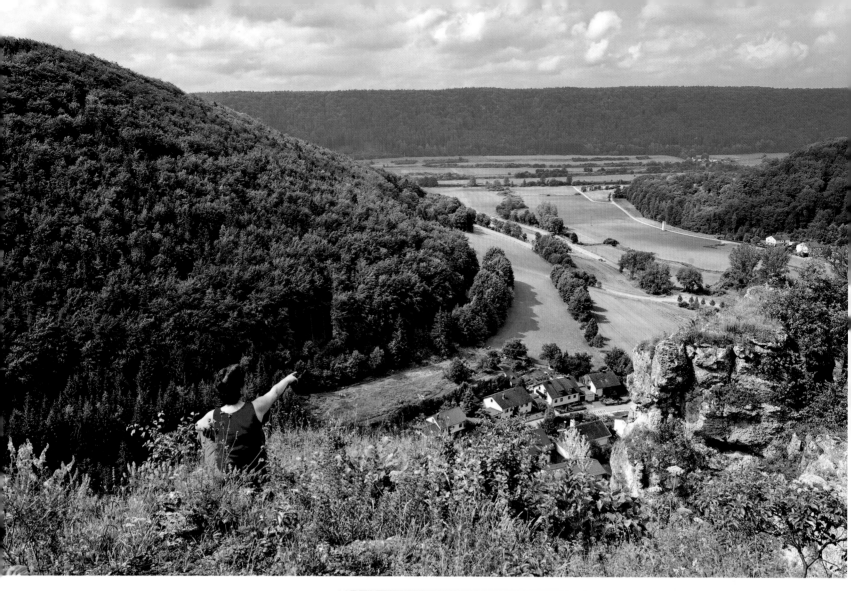

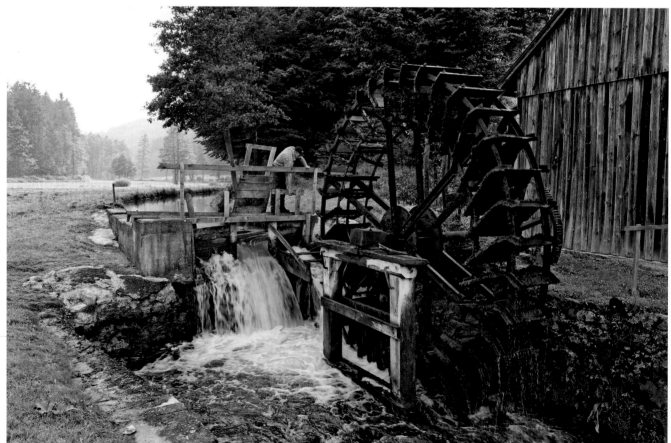

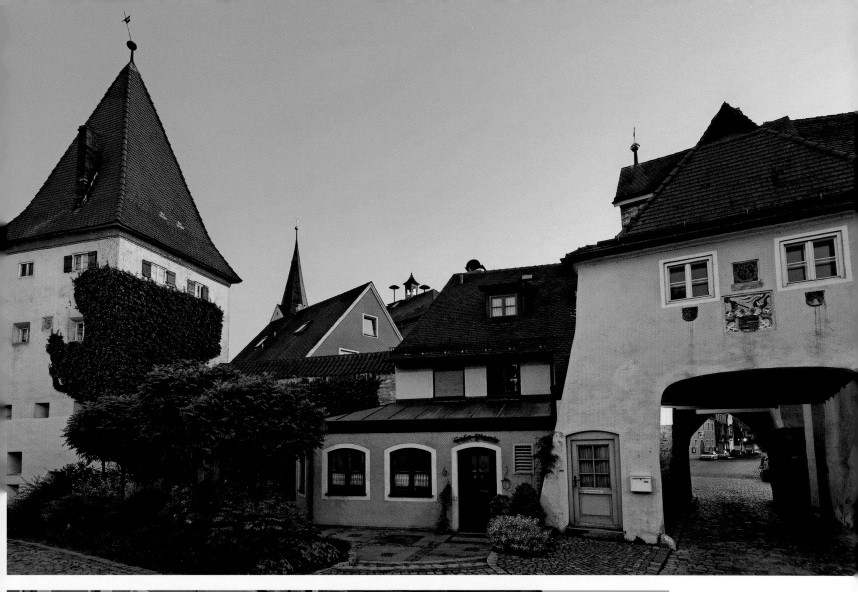

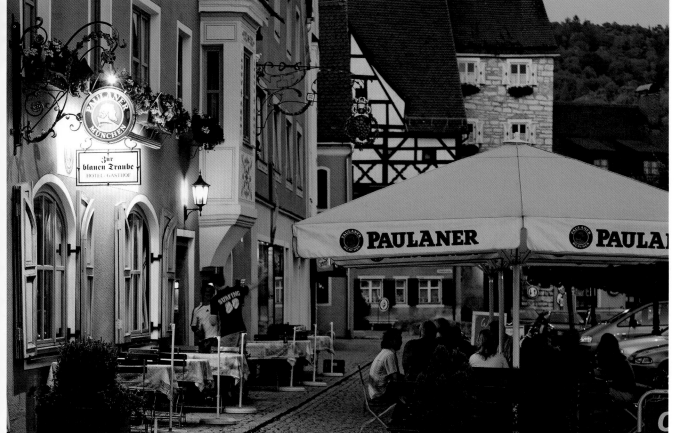

Above:
Hardly any other town in Bavaria has such a splendidly intact medieval centre as Berching. Thirteen towers, four town gates and a set of 15th-century walls lend the 1,100-year-old town its unmistakeable character. A listed historical monument, the entire town of Berching is a perfect work of art in itself. Here, the Vortor to the Mittlerer Tor gates.

Left:
Pettenkoferplatz in Berching holds promise of a great summer's evening. The square is named after the Pettenkofer wine-trading family who owned many houses and much land in Berching. They came into great wealth in the 17th century and started many charitable foundations as patrons to the town.

31

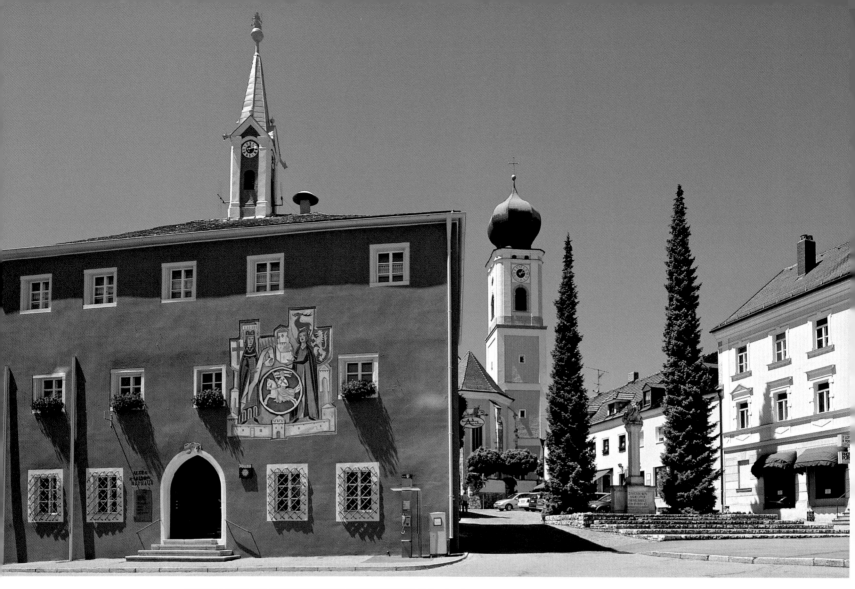

Above:
The Altes Rathaus in Hemau which in 2005 celebrated its 700th anniversary. The town clings to a forest ridge between the Altmühl and Schwarze Laaber west of Regensburg which late medieval sources refer to as the Tangrintel, hence the epithet "town on the Tangrintel".

Right:
Schloss Wörth on the Danube, perched atop its mound in the middle of town, is visible far and wide. The castle was first mentioned in 1264 and turned into a fortified palace during the 17th century. In the wake of the secularisation of Germany it fell to the house of Thurn und Taxis and has been an old people's home since 1978.

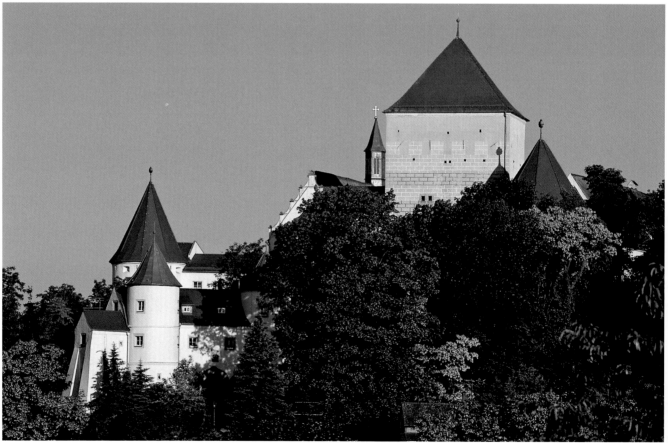

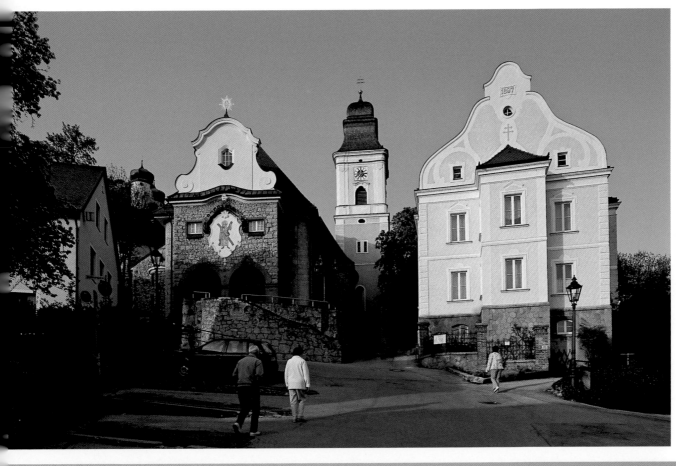

Left:

Schloss Parsberg in the Upper Palatine Jura. Impressively situated high up above the town, the fortress is something of a local landmark. The Oberes Schloss was rebuilt in c. 1650 following its destruction during the Thirty Years' War, the Unteres Schloss erected before 1700. The castle has been used as a museum since 1981.

Below:

The market town of Lupburg clings to a Jurassic peak high up above the valley of the Schwarze Laaber. The small town has a long history and was first mentioned in 960. Its castle is probably from the mid 12th century and was one of the biggest in southern Upper Palatinate.

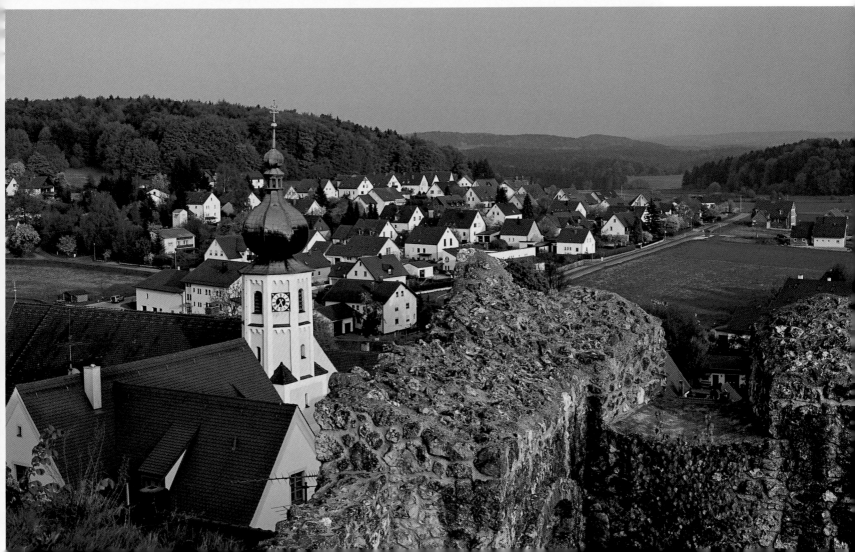

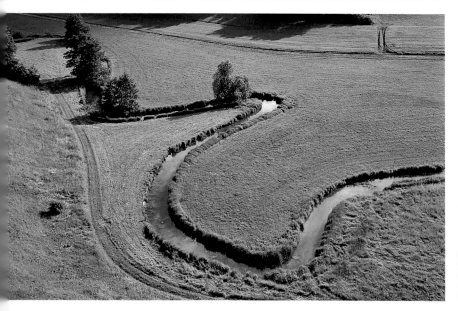

Top left:

Rocks like this one near Schönhofen in the valley of the Schwarze Laaber are popular with both amateur and more experienced climbers. From February to July access is limited, however, to protect nesting birds.

Centre left:

Just 70 kilometres (44 miles) long, on its course from the peaks of the Jura in western Upper Palatinate to where it flows into the Danube the Schwarze Laaber winds its way through scenery both halcyon and barren. The route is lined with castles, churches, mills and tiny villages, with industry and larger towns banished to more urban extremities.

Bottom left:

The community of Seubersdorf perches on a high ridge in the central Fränkische Alb between the rivers of the Schwarze and Weiße Laaber.

Below:

The pretty town of Kallmünz lies at the confluence of Naab und Vils, with its ruined castle gripping a rocky spur up high above the houses set into the castle mound. The biggest tourist magnet here is the "house without a roof" on Vilsgasse.

Page 34/35:

With 2,000 years to its name, Regensburg's historic past and exuberant present draw visitors from all over the world. For centuries the city has been the heart of the entire region, with its ancient stone bridge providing solid access to the architectural wonders of the old town.

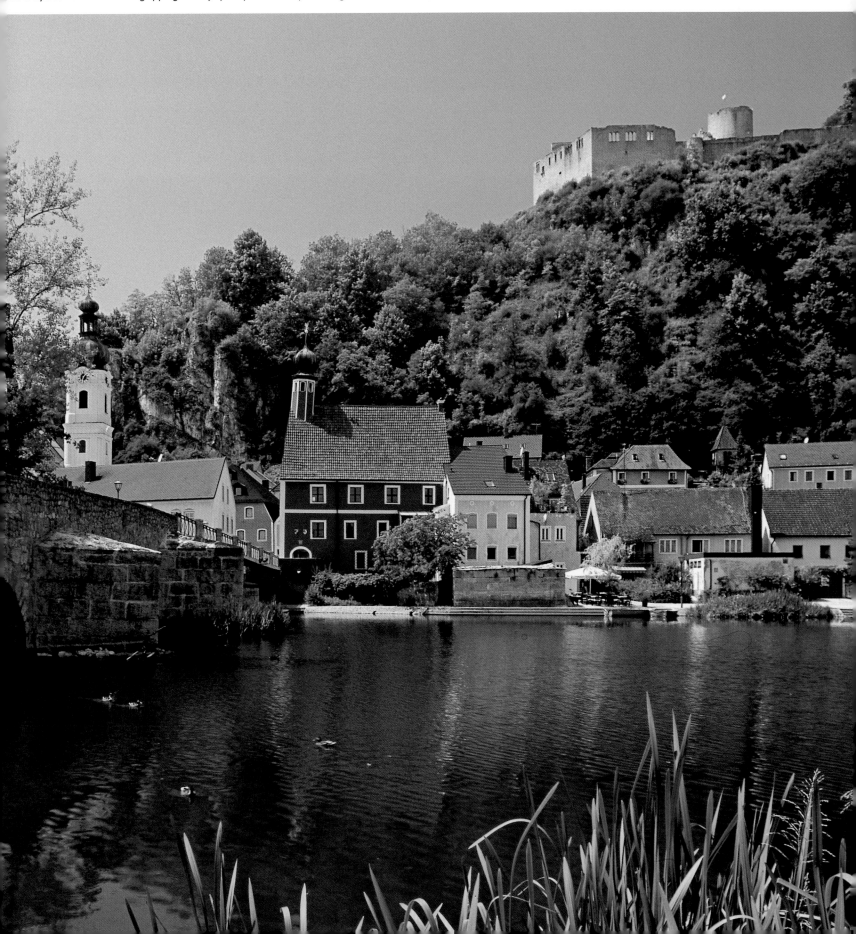

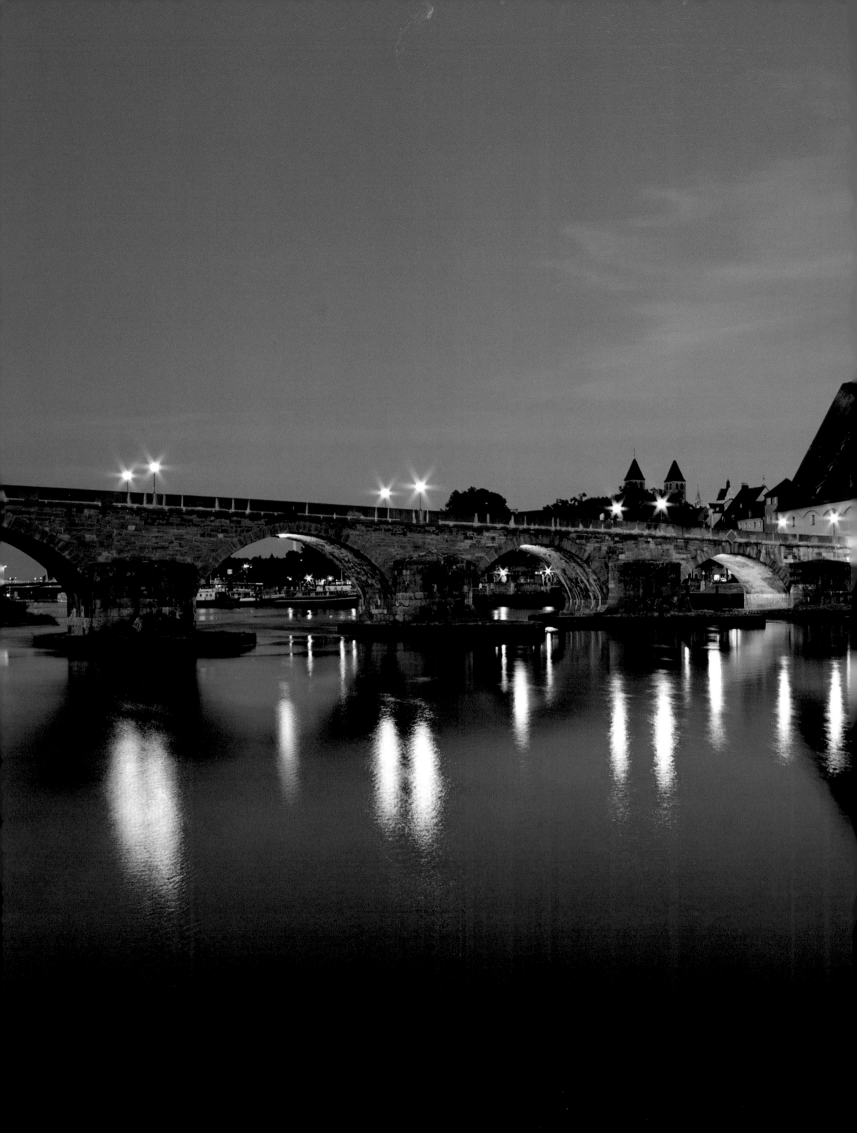

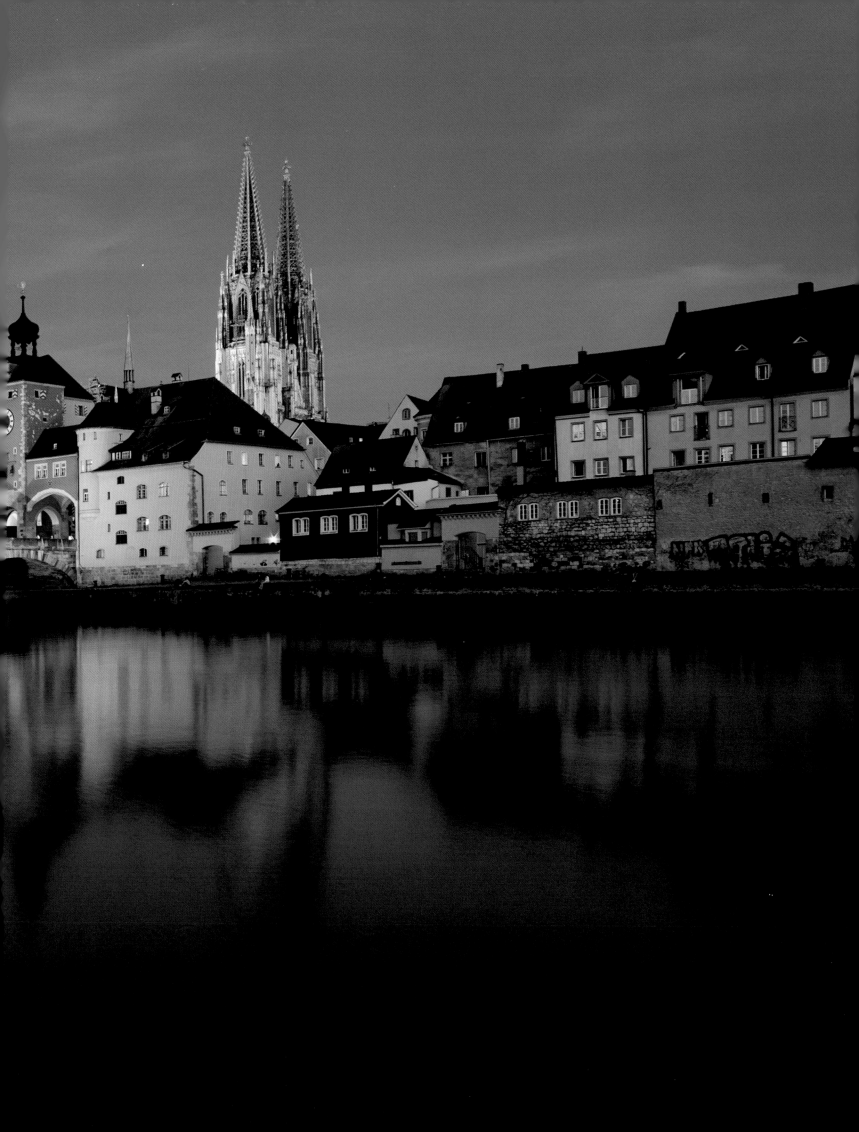

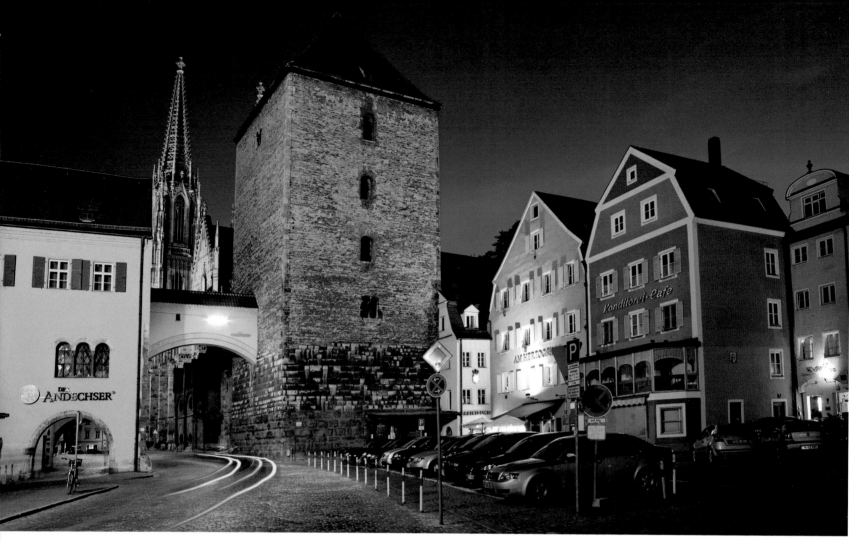

Above:
Römerturm, the Roman tower also known as the Heidenturm or heathen's tower, is on Kornmarkt in Old Regensburg. The tower belonged to ducal Palatinate and is linked to the Herzogshof or ducal palace by an arch. The foundations of the tower date back to the post-Carolingian and Staufer periods; it is also assumed that stone from the old Roman fortifications was used in its construction.

Right:
One fixed date on the cultural calendar in Regensburg is the summer Jazz Weekend when swing, Dixie, Latin and the like fill the city's squares, courtyards, pubs and bars.

Left:
There's plenty to discover on a wander through the old town, whatever the time of day. Here, the Goldene-Bären-Straße on a warm summer's evening.

Below:
In summer Regensburg has a distinct feel of the Mediterranean about it. Open squares and narrow streets furnished with bistro tables and wicker chairs provide the stage upon which locals and visitors alike play out their lives.

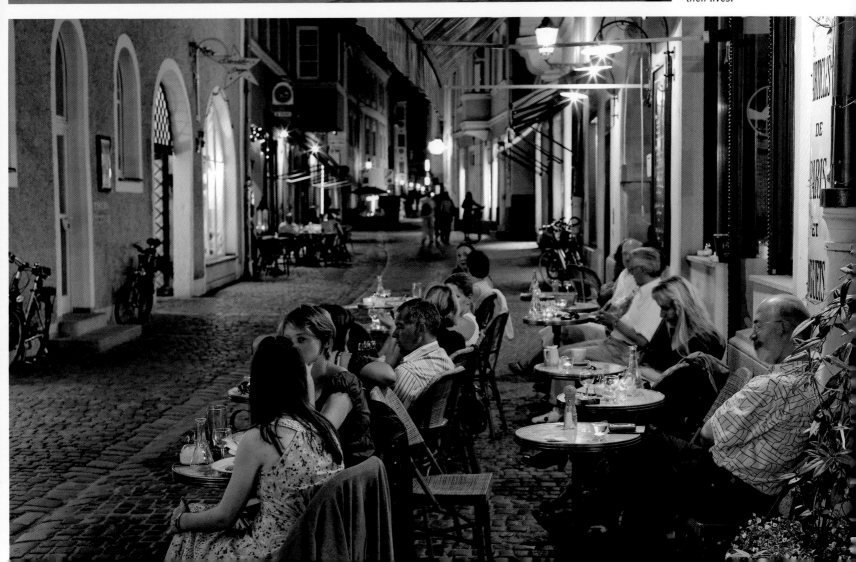

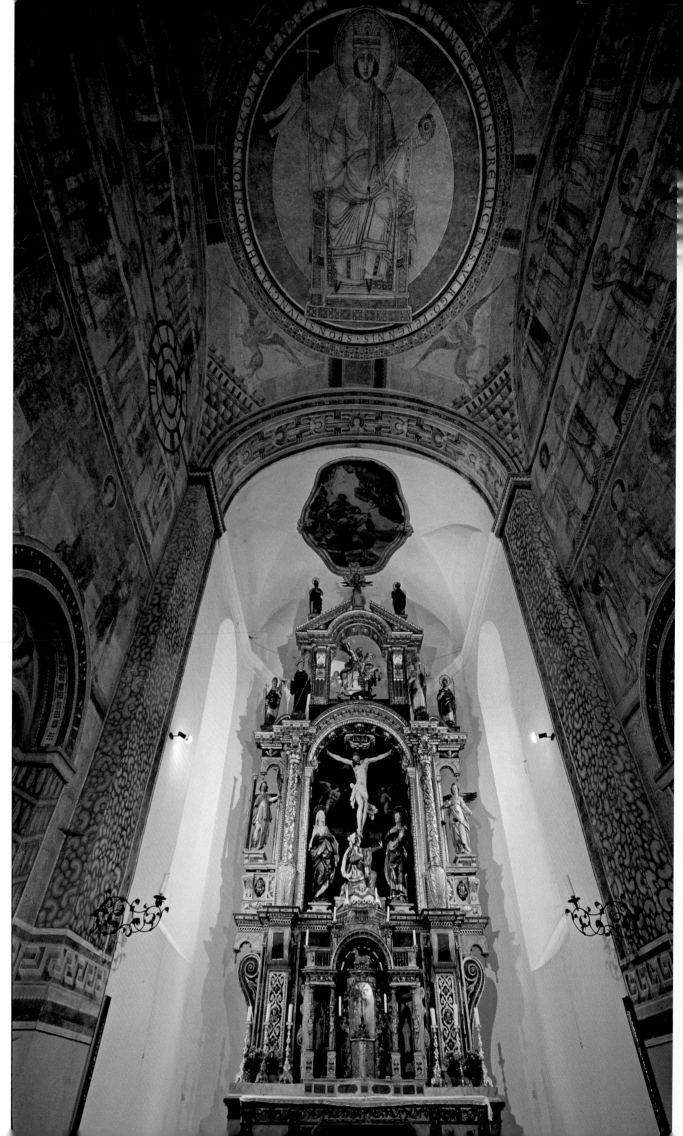

Page 40/41:
It's said that Regensburg is the most Italianate of all of Germany's cities. And you really do feel as if you're in Northern Italy when you stroll along the narrow streets of the old town (here Tändlergasse), taking a leisurely peek in shop windows before having an espresso or glass of wine at one of the many cafés and bars.

On the western outskirts of Regensburg is the former Benedictine monastery of Prüfening, now owned by Thurn und Taxis. The spirit of the medieval age haunts the aisled and pillared basilica of St Georg, consecrated in 1119. Its architecture was to act as a model for later Romanesque churches built in and around the city.

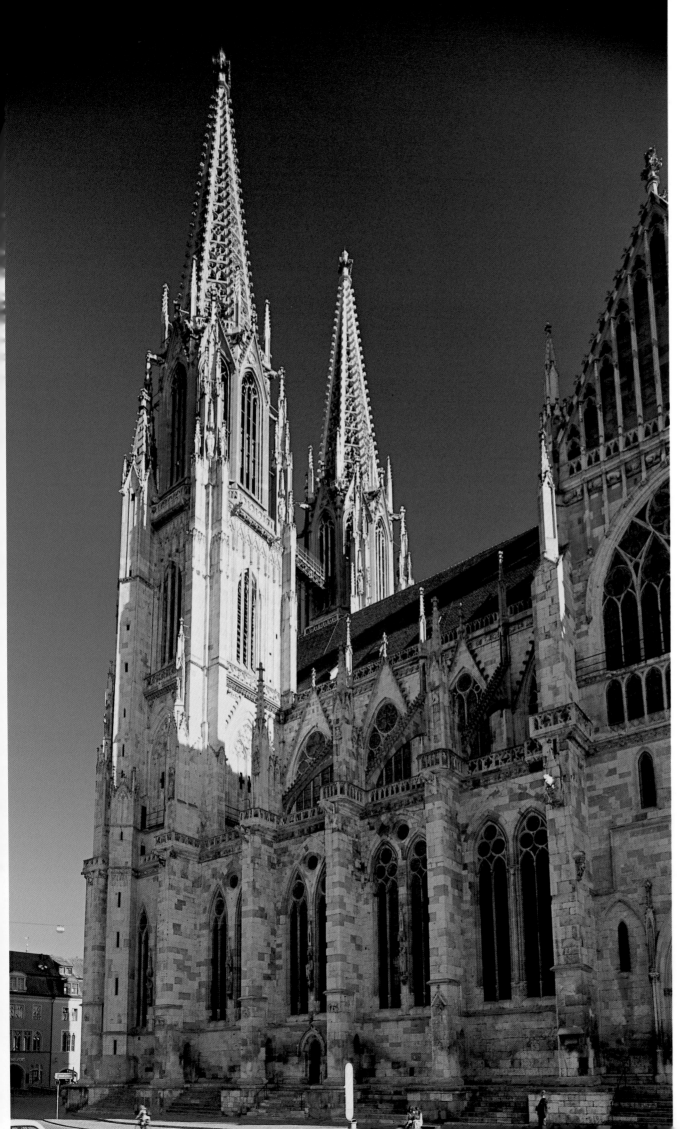

"There are sadly too many clerics, monks, priests and nuns here", bemoaned Ernst Moritz Arndt in 19th-century Regensburg. Although the number of clergy and monastic brethren has since diminished there's still a bishop at the cathedral of St Peter's. Regensburg's religious presence suddenly mushroomed, however, when in September 2006 Pope Benedict XVI visited the city where he had once taught as professor.

43

Regensburg –
the metropolis of Upper Palatinate

Its centre almost unscathed by the air raids of the Second World War, Regensburg is the only medieval city in Germany to have remained largely intact. Its old town was subsequently made a UNESCO World Heritage Site in 2006. Its thousand or so listed buildings include craftsmen's dwellings, tower houses, patrician palaces and sacred edifices such as the Dom, the only French Gothic cathedral east of the Rhine. Around 130,000 people live in modern Regensburg. In summer the streets and squares are a hive of activity, with locals and visitors alike soaking up the Mediterranean flair which has earned it the epithet "northernmost city of Italy".

Regensburg is one of the oldest cities in Germany. The area surrounding the northernmost stretches of the River Danube was first inhabited in the Palaeolithic Age. Celtic graves unearthed here date back to the 3rd century BC. In 79 AD the Romans set up a castellum housing 500 to 1,000 men which was destroyed around 90 years later by the Marcomans. In return Emperor Marcus Aurelius then had the legionary fort of Castra Regina erected on the banks of the river the Teutons called Regana, able to accommodate an army 6,000 strong. This fort on the River Regen came into service in 179 AD; its foundations are still traceable in the layout of the streets of Old Regensburg.

At the point where a number of international trade routes once intersected, the town rapidly flourished to become one of the largest and richest cities in the Carolingian empire. In 739 Boniface made Regensburg or Ratisbona, to give it its Latin name, a bishopric; the Carolingians used it as a place of assembly. Between 917 and 920 Duke Arnulf of Bavaria had the west-lying Vorstadt surrounded by walls which also defended the expansive complex of St Emmeram, a Benedictine abbey; for centuries the fortifications safeguarded the city's interests and character. Firmly ensconced in their urban stronghold, between the 11th and 14th centuries the ruling classes of Regenburg – the patricians – had medieval high rises built which still dominate the skyline and endowed a number of churches and monasteries. Regensburg was also the seat of the first Jewish community in Bavaria, one of the most significant in Europe during the late Middle Ages.

The eighth wonder of the world

During the first half of the 12th century the erection of a bridge across the Danube posed both a financial and architectural challenge to the city fathers of Regensburg. For the first time the techniques of the Ancient World were used in its engineering, making it a model for many other great bridges of Europe, such as the Charles Bridge in Prague. For centuries the Steinerne Brücke was the only stone river crossing between Ulm and Budapest. In its day it was heralded as the eighth wonder of the world.

In May 1189 Emperor Friedrich Barbarossa mustered his troops in Regensburg before setting off to the Holy Land on the Third Crusade. In 1207 Regensburg was made an imperial city. In 1471 envoys from across Europe met for a grand Christian summit to discuss how to react to the seizure of Constantinople by the Ottoman army in 1453. At an assembly of the empire in 1541 the famous religious debate between Philipp Melanchthon and Johannes Eck was staged here on the possible avoidance of a split in the church. In 1663 the Perpetual Imperial Diet of the Kingdom of Germany in the Holy Roman Empire was established in Regensburg. This political medium prevailed, bringing Regensburg fame and fortune, until the final decision dividing up Napoleonic territories in Germany was made in 1803.

On the dissolution of the Diet the city became decidedly provincial. Regensburg has since shrugged off its backwater taint and now enjoys international twinnings with several cities across the globe. A pillar of the local economy and tourist magnet, the city is now booming. Visitors flock to concerts by the Regensburger Domspatzen, to the abbey church of St Emmeram so lavishly adorned by the Asam brothers and to the annual city marathon. In 2006 the city was even a place of pilgrimage when 230,000 people came to welcome an honorary citizen of great renown: professor of theology at Regensburg University Dr Joseph Ratzinger – or Pope Benedikt XVI.

Left:
The Romanesque frescoes from the second half of the 12th century are one of the main attractions at the parish church of St Georg in Prüfening.

Top left:
Ornate facades bear witness to the former wealth of the patricians of Regensburg, such as number 3 here on Watmarkt.

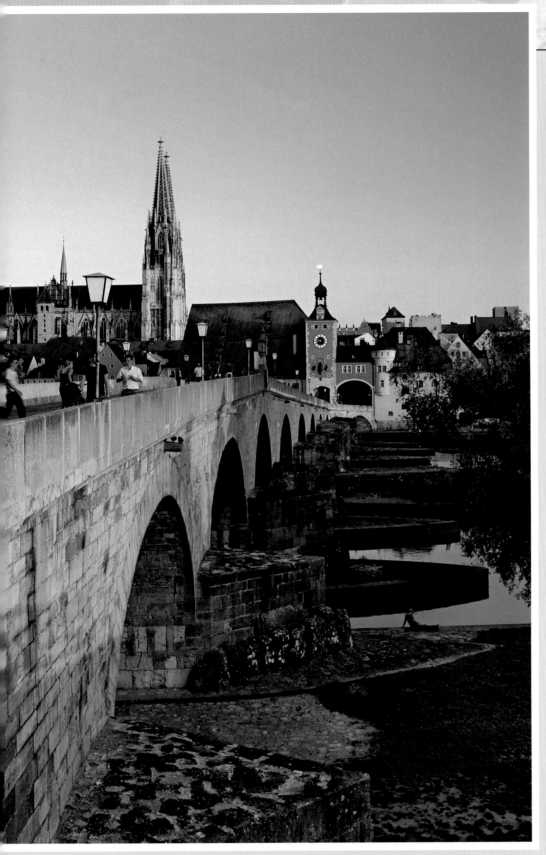

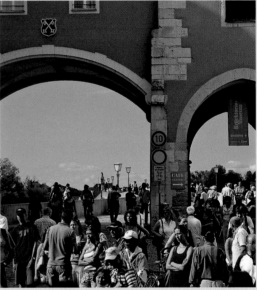

Above:
Photographed millions of times, by day and night, in summer and winter the Steinerne Brücke and cathedral beyond it are still popular motifs.

Top right:
The Brücktor on the Steinerne Brücke is the only one of three gatehouses to have survived. It's now a museum devoted to the bridge and Danube shipping.

Right:
"Sinister walls, black beers [and] dark conceit" is what author Ludwig Lang once came across in Regensburg.

With bright shop windows to light your way, an evening stroll through the old town is no longer such a threatening experience

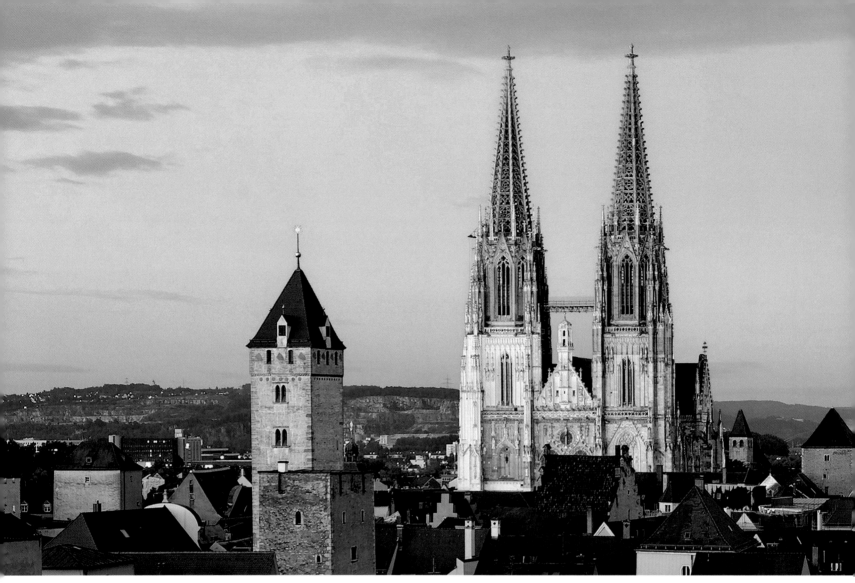

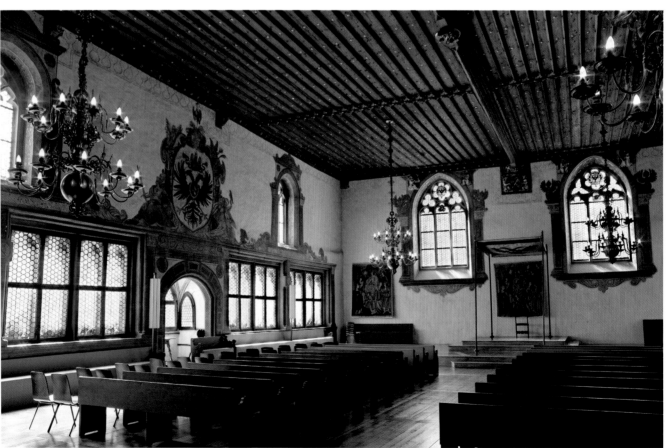

46

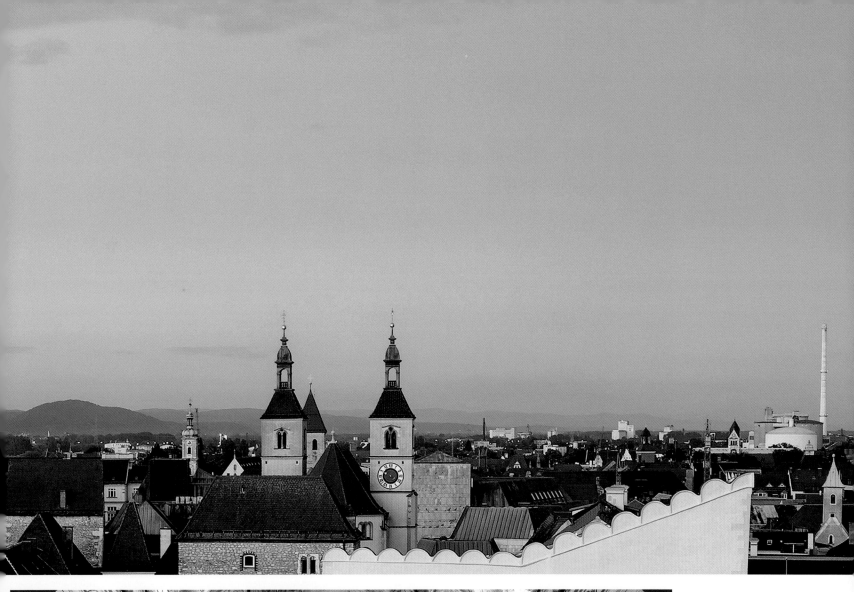

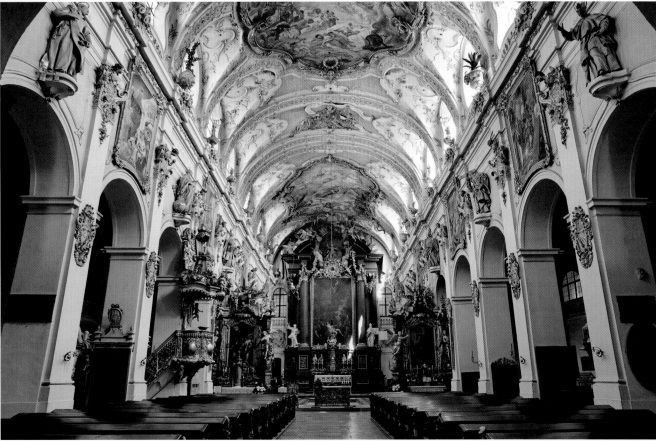

Left:
*Martyred Bishop
Emmeram came to
Regensburg in the
7th century; his remains
are kept in the sumptuous
monastic church of
St Emmeram. Built
between 1050 and 1060,
the aisled, pillared
basilica, later
baroqueified, is
considered to be the
largest pre-Romanesque
church building in
Southern Germany.*

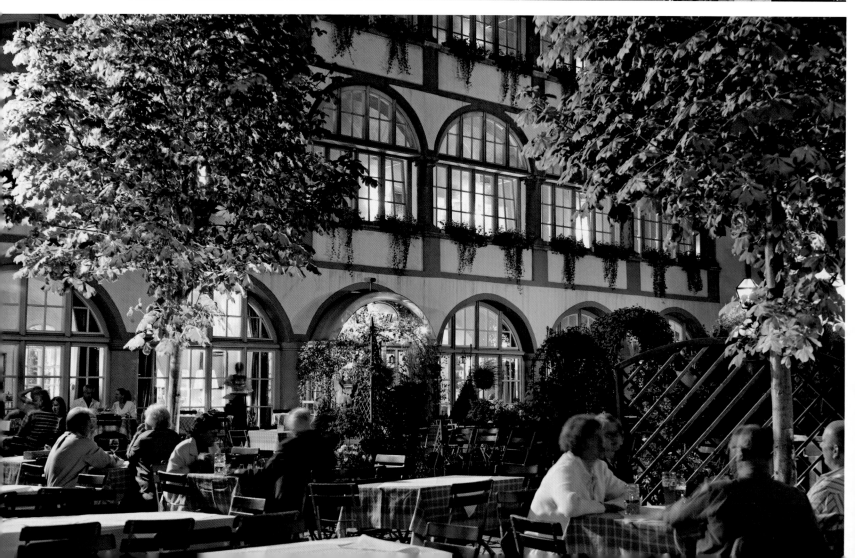

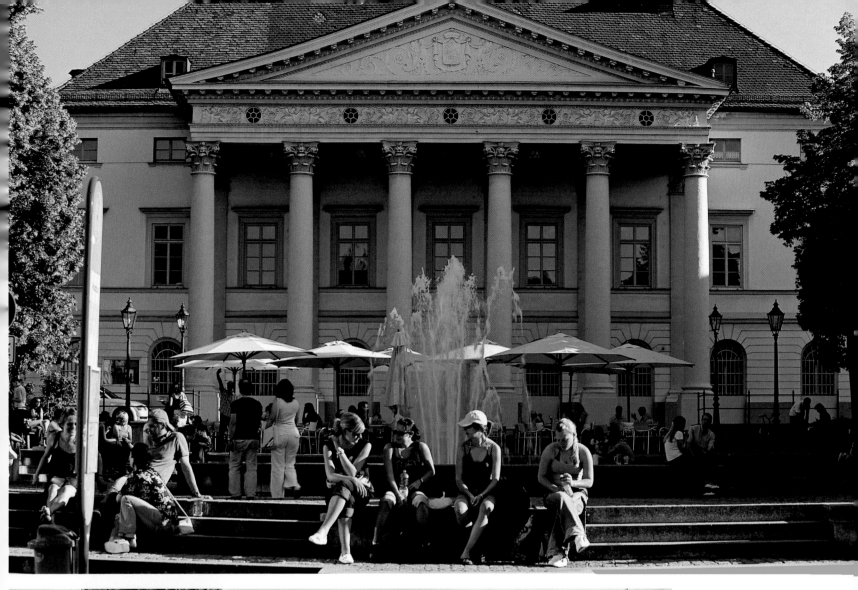

Above:
The Präsidialpalais on Bismarckplatz, built in 1805 by Emanuel Herigoyen, pays homage to neoclassicism. Once the seat of envoys from France, the palace is now used by the police.

Left:
For centuries the city council and administrators of the free imperial city of Regensburg were based at the Altes Rathaus which was also the seat of the local court and prison. From 1663 to 1806 this was where the Perpetual Imperial Diet was held, during which Regensburg played host to the major players in the political arenas of Germany and Europe.

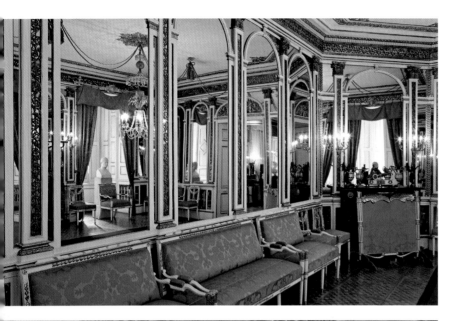

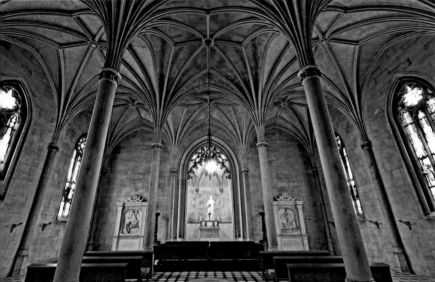

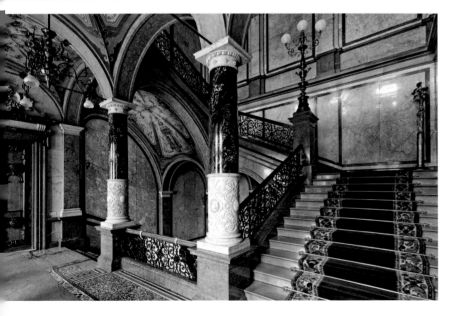

Top left:
In conjunction with the dissolution of the monasteries the house of Thurn und Taxis acquired the monastery in 1810 and began turning it into a
royal residence. Guided tours of the palace give visitors a good impression of what life is like if you're a member of one of the biggest noble dynasties in Europe.

Centre left:
Between 1835 and 1841 Prince Maximilian Karl had a chapel of rest built in the medieval cloisters. It's heralded as the most significant neo-Gothic royal mausoleum of the

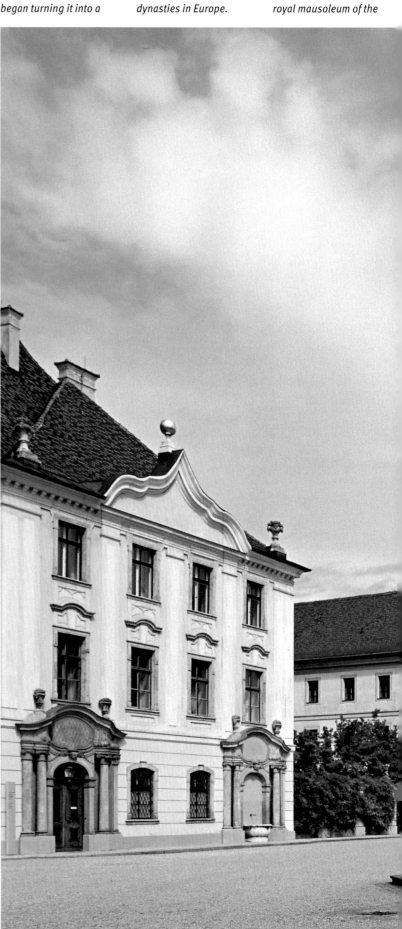

German Historicist period. The chancel features a statue of Jesus fashioned from white Carrara marble by southern German sculptor Johann Heinrich Dannecker.

Bottom left:
The palace's marble staircase. Owner Princess Gloria von Thurn und Taxis welcomes visitors to her website with the following words: "It is our desire to unite the past and present through living tradition. Come and see how our palace is preserved and maintained with private means and great attention to detail."

Below:
Schloss Thurn und Taxis in Regensburg grew out of the former monastery of St Emmeram, founded in c. 739. It's one of the largest inhabited palaces in Europe. In summer the splendid inner courtyard is the perfect venue for concerts."

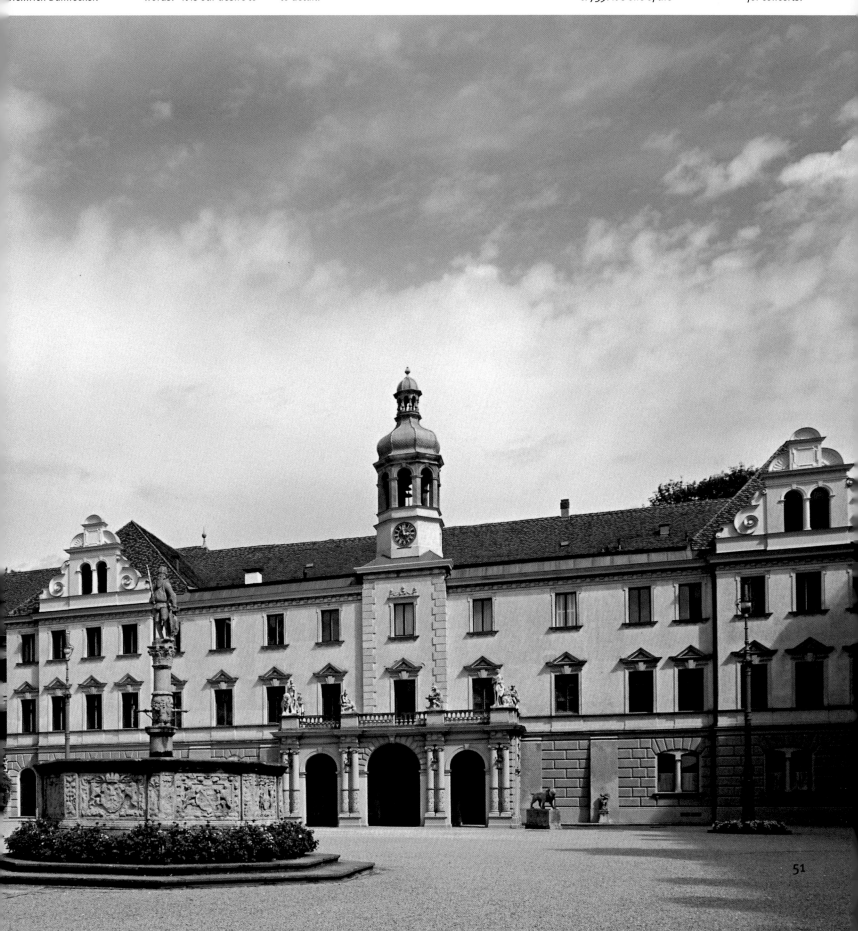

51

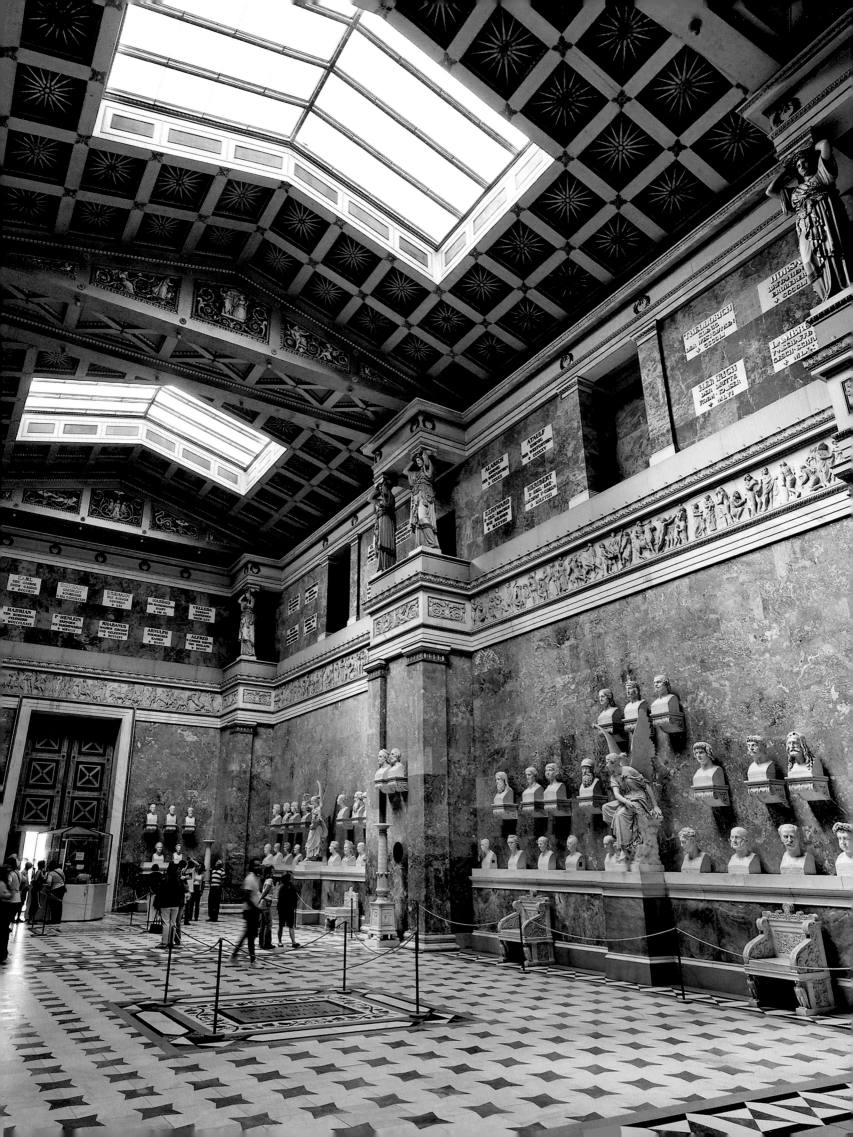

The inside of the Walhalla is clad in pink and yellow marble and has an ornate, equally colourful ceiling adorned with figures from German mythology. The Walhalla was conceived as an open monument. This means that the group of personalities it honours is added to sporadically, with the latest faces to be included in the hall of fame Albert Einstein (1990), Konrad Adenauer (1998), Sister Gerhardinger (1999), Johannes Brahms (2000), Sophie Scholl (2003) and, most recently, Heinrich Heine (2009).

Left:
The Walhalla was built as Greek temple modelled on the Parthenon at the Acropolis in Athens. On entering the hall you find yourself in a veritable mausoleum devoted to the famous names in German and European history, immortalised in 130 marble busts and 64 commemorative tablets.

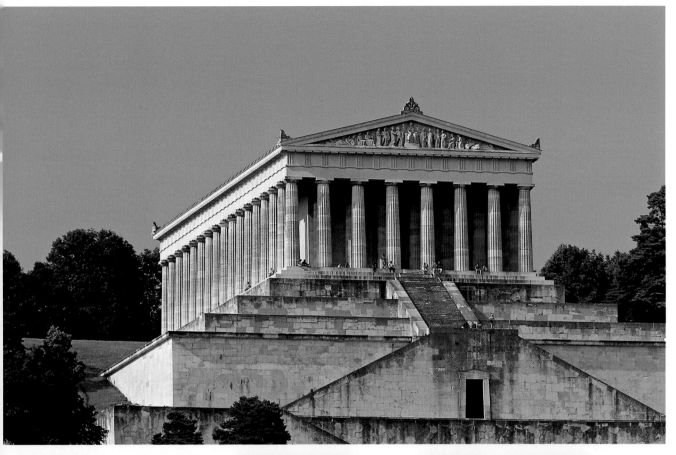

It was the desire of Ludwig I that no class be omitted and women also be included in his hall of fame: "Equality exists at the Walhalla, for Death abolishes any earthly differences."

Page 54/55:
View from the Walhalla out over the Danube and village of Bach-Demling. Architect Leo von Klenze built the temple between 1830 and 1842 for King Ludwig I of Bavaria. In German mythology Valhalla is the hall of the brave and fearless slain in battle.

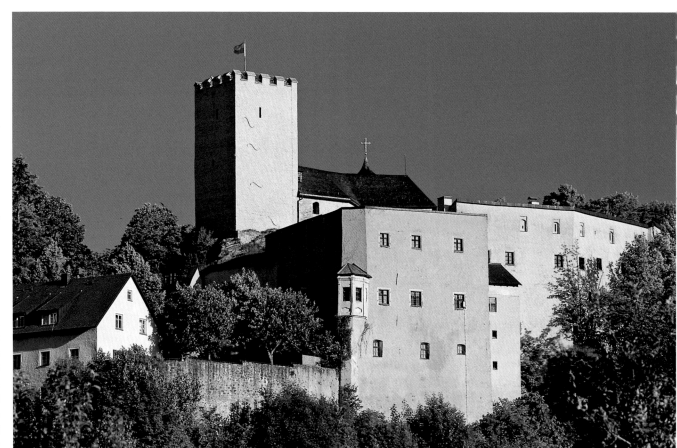

Right:

Burg Falkenstein straddles an enormous granite slab high up above the health resort of Markt Falkenstein. First mentioned in 1074, it was erected as a defence and siege castle by the Hochstift Regensburg. On a clear day from the top of the keep you can see as far as the Großer Arber in the east and the Alpine foothills.

Below:

The River Regen in Ramspau near Regenstauf. In September 1786 Johann Wolfgang von Goethe noted in his diary: "As the day began to dawn I found myself between Schwanendorf and Regenstauf and now I noticed the change for the better in the soil of the fields."

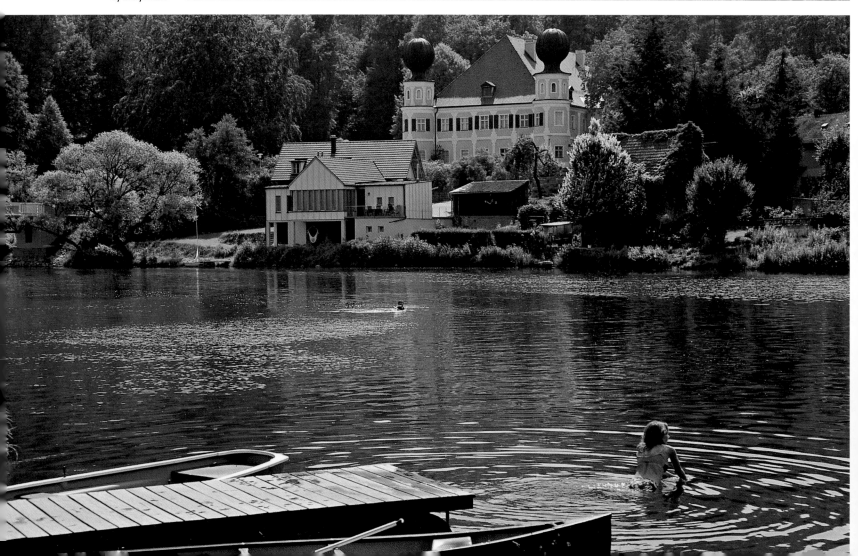

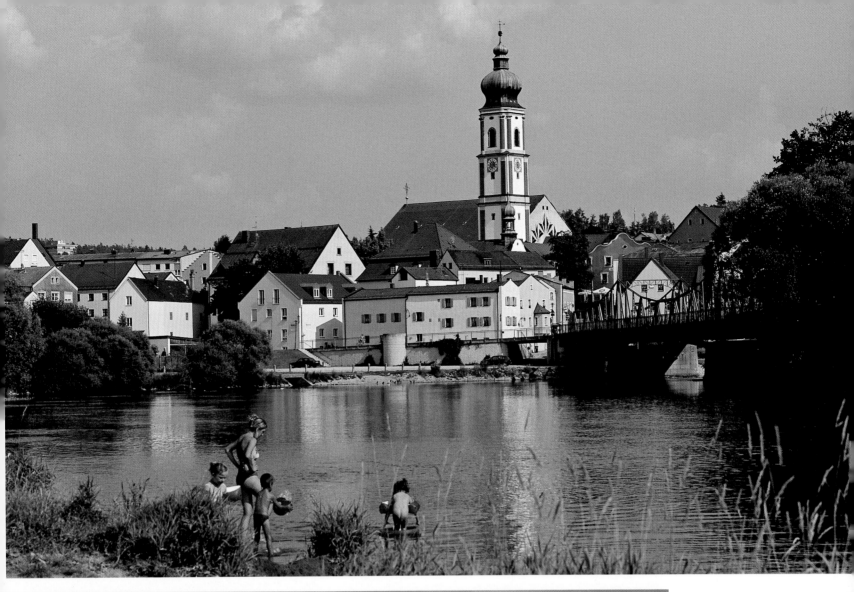

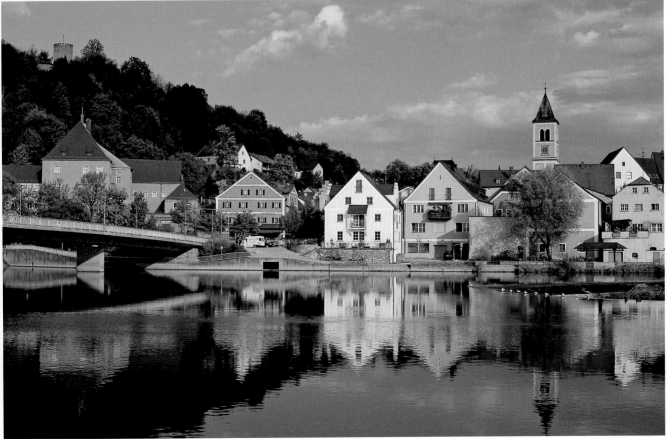

Above:
Roding enjoys a scenic
setting in the Vorderer
Bayerischer Wald
National Park.

Left:
In 1986 the small town
of Burglengenfeld on the
River Naab spiralled to
international fame when
following the Chernobyl
disaster demonstrations
against the planned
reprocessing of nuclear
waste at Wackersdorf
reached a frenetic climax.
Ca. 100,000 visitors
flocked to the town for the
Anti-WAAhnsinns-Festival,
at which famous artists
and bands such as Herbert
Grönemeyer, Udo
Lindenberg, Wolfgang
Ambros, BAP and the
Biermösl Blosn played
and 600 journalists from
10 countries attended.

57

Below:
This region was once a remote valley; the Lamer Winkel has since been "discovered" and is now good hiking country with several peaks to be climbed. These include the Großer Arber, at 1,456 metres (4,777 feet) the highest mountain in the Bayerischer Wald.

The valley also has many good trails, used by walkers and cyclists in summer and cross-country skiers in winter.

Top right:
One of the most beautiful and unspoilt lakes in the Bayerischer Wald, the Kleiner Arbersee karst was formed during the last ice age at the base of the Kleiner Arber. Its remote location (it can only be reached on foot) and unadulterated scenery make it popular with hikers.

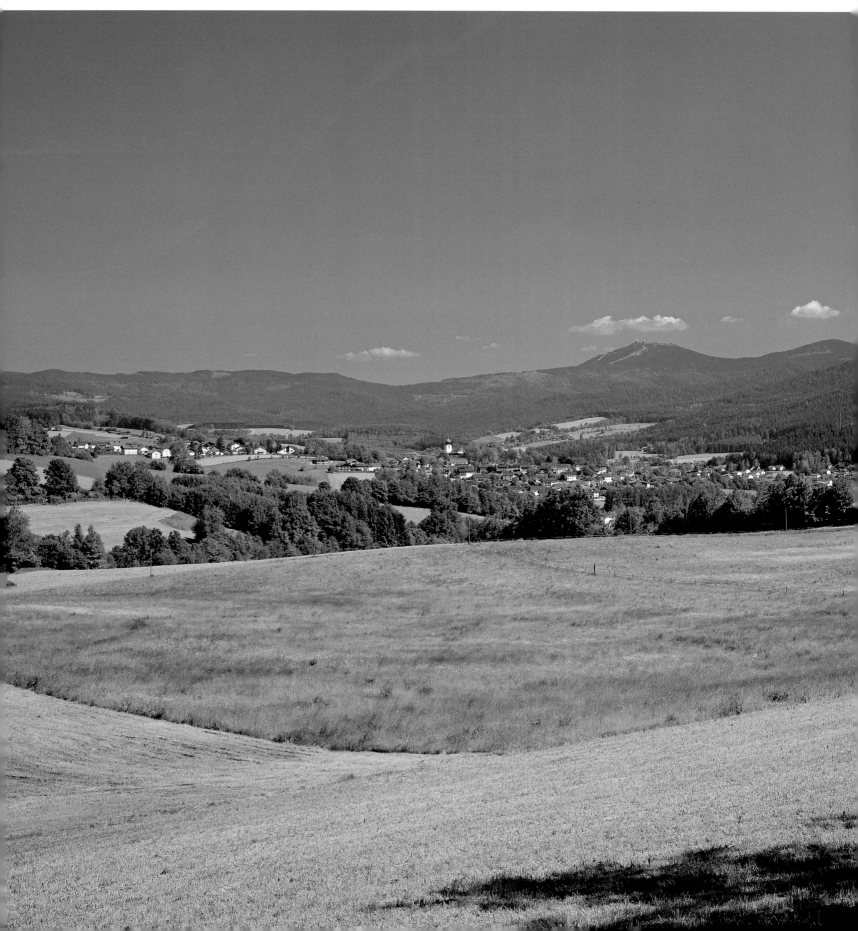

Centre right:
The Kleiner Arbersee is also paradise for botanists and naturalists. The deep moorland which hugs its shores boasts a wide range of bog plants and even a sparse covering of trees.

Bottom right:
And if you need a break from rooting around in the soil with your wild plant guide in your hand, the Seehäusl pub on the Kleiner Arbersee offers a welcome respite. It has fantastic views of the lake and mountains and boat hire facilities for the more adventurous.

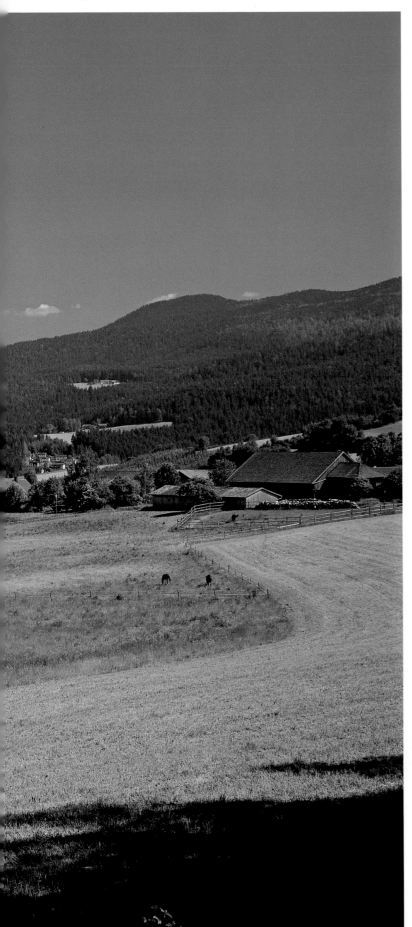

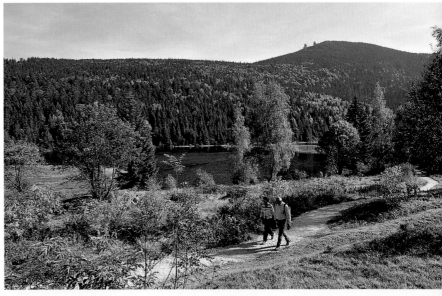

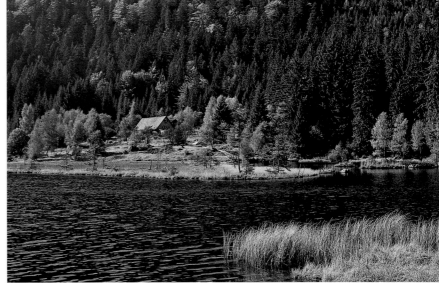

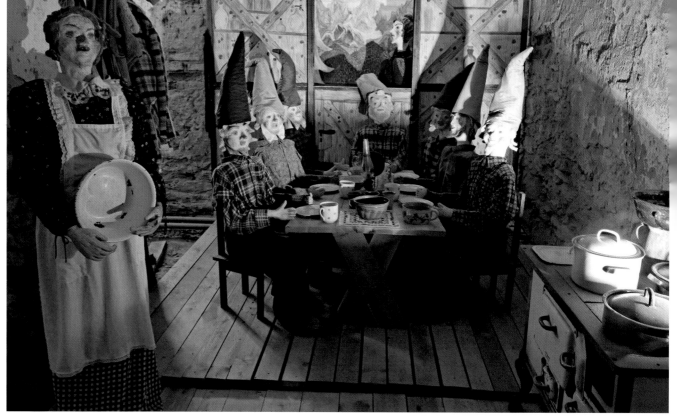

There's hours of fun to be had at the (haunted) fairytale castle of Lambach! You can meet the frog prince, admire the emperor in his new clothes, feel sorry for Cinderella and count the mattresses between the princess and that infamous pea. Set in a glorious Jugendstil villa from 1905, the castle has a different fairytale installed in each room with figures whose heads, hands and feet have all been modelled from clay and painted by hand. The clothes are new or have been assembled from collections. Special fairytale hours, puppet theatre shows and arts and crafts afternoons are guaranteed to keep you and your little visitors happy and content.

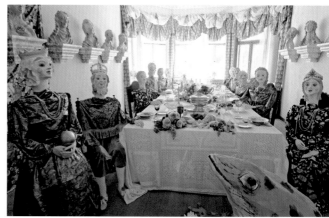

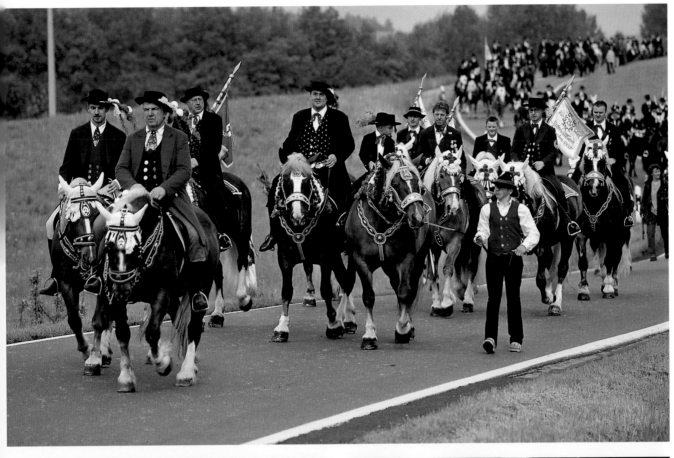

The Pfingstritt in Bad Kötzting is one of the biggest rogation processions on horseback in Europe. It dates back to a vow made in 1412 when the local priest was called to attend to a dying man in the village of Steinbühl a few miles away. As he was afraid to ride there alone, the young lads of Kötzing agreed to go with him. On their safe return they promised to repeat the journey each year. Since then every Whit Monday over 900 riders in traditional costume have set out along the Zellertal to Steinbühl on their elegantly dressed mounts.

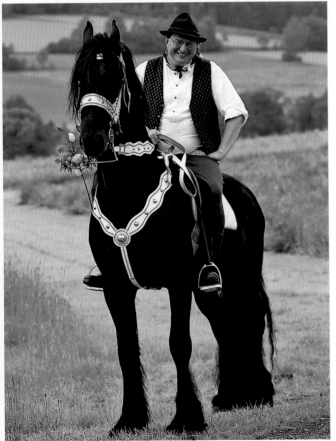

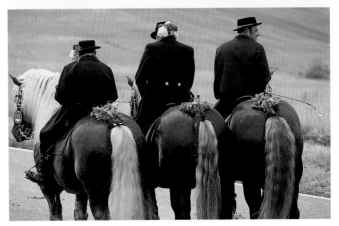

Right:
The market place in Cham. Although the town lies on a bend in the River Regen its name is derived from the River Chamb, the longest tributary of the Regen. The Celtic word "kambos" means "bent" or "winding".

Right page, top and bottom:
Churpfalz-Park Loifling is a (commercial) garden and theme park. It boasts an enormous summer garden with 860 fountains and equally huge heather, dahlia and English gardens. There are over 20,000 roses in all colours of the rainbow planted in the Rosarium. 6 kilometres (4 miles) of pathways wind through the complex.

Right:
The Biertor, formerly the Burgtor, probably dates back to the 14th century. Cham Castle once stood on the adjoining site. When in the 17th century its original defensive function was deemed superfluous an electoral brewery for wheat beer was put up in its place. Hence the Burgtor (castle gate) became the Biertor (beer gate).

Far right:
The minster in Cham (Marienmünster) is said to be the mother church of the Oberer Bayerischer Wald. Its roots can be traced back to 739 when monks from Regensburg founded a subsidiary monastery here. Two Romanesque fonts from c. 1200 and c. 1300 document the church's early history.

Page 64/65:
Kloster Walderbach enjoys an idyllic setting on the River Regen. It was consecrated in 1130 and taken over by the Cistercians in 1143, making Walderbach one of the oldest twelve Cistercian monasteries in Bavaria.

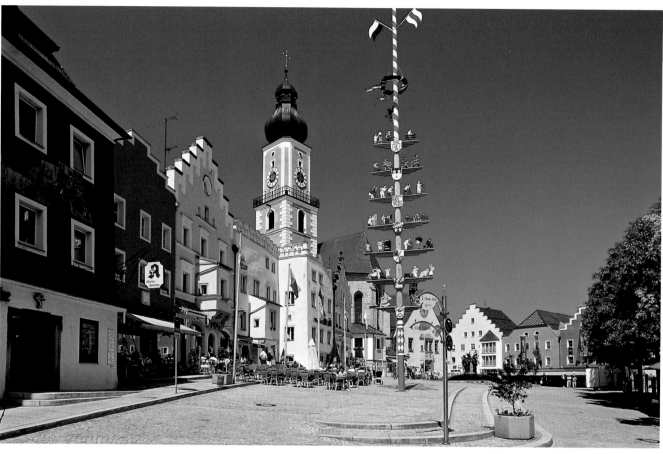

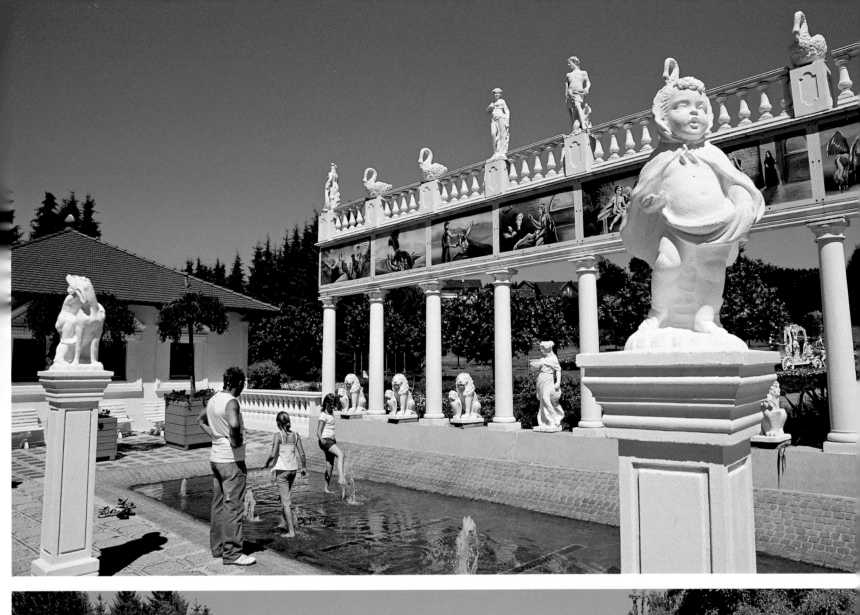

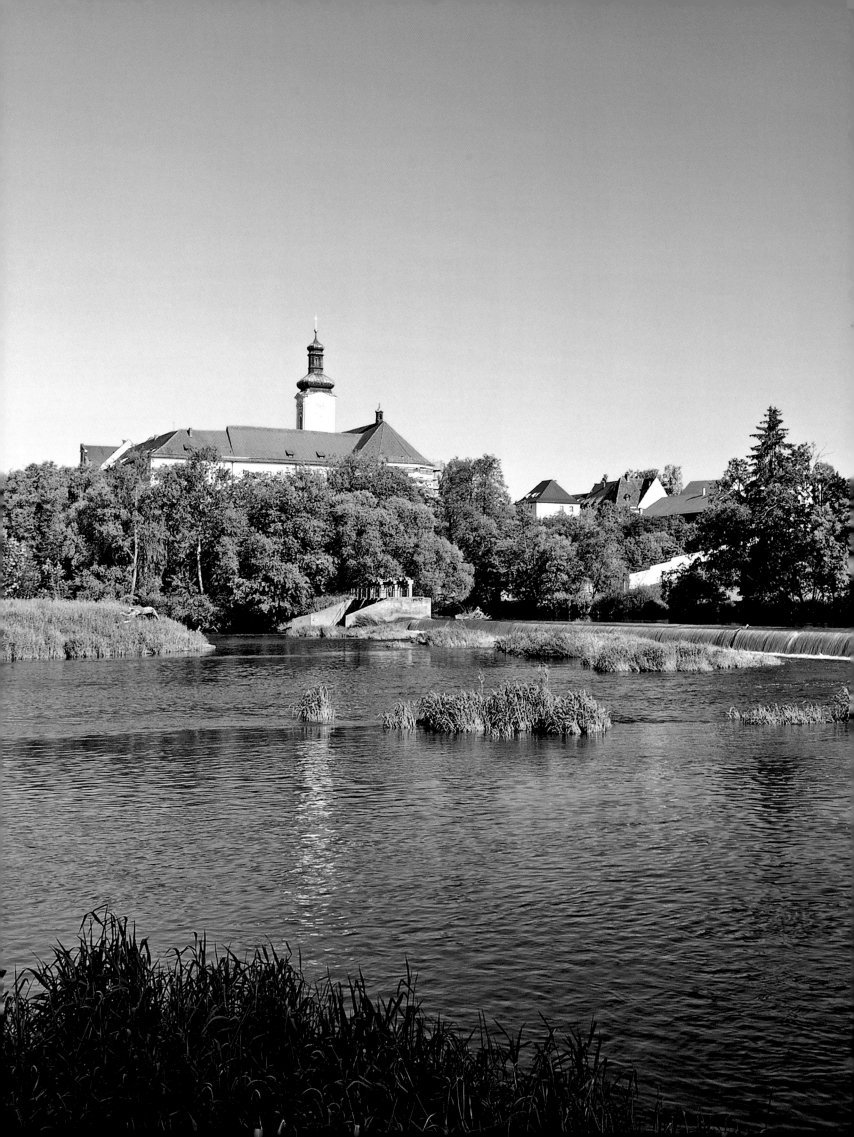

Manifestations of faith – churches and monasteries in Upper Palatinate

Upper Palatinate is a predominantly Catholic region. Over 60% of the population today are confessed Roman Catholics; this number was as high as 80% during the 1980s. Countless places of worship attest to this religious tradition from the mighty cathedral of St Peter in Regensburg to the parish churches in the towns and villages to the little chapels servicing tiny hamlets and farmsteads. Mostly founded in the 12th and 13th centuries, the area's monasteries and places of pilgrimage were respected well beyond the local boundaries. In Upper Palatinate alone monasteries were established by the Benedictines, the Cistercians, the Augustinians, the Premonstratensians, the Franciscans and many other orders. They were usually endowed by rich nobles wanting to secure the salvation of their souls – an undertaking they hoped to guarantee by having monks and nuns include them in their daily prayers. During the 16th century a multitude of these houses of God were dissolved in the wake of the Reformation, their land and property falling to local potentates. During the 17th century some of Upper Palatinate's religious foundations were rebuilt – only to be disbanded again following the dividing up of Napoleonic territories in Germany in 1803. Only a handful survive and are still functioning today.

One of the most famous is Kloster Waldsassen, founded in the 12th century. It rose to become the cultural hub of the Upper Palatine Stiftland. After a history which can only be described as turbulent, the former monastery was taken over by Cistercian nuns in 1863. The convent basilica, one of the best baroque churches in Bavaria, was built between 1682 and 1704. The library is particularly worthy of a visit, its interior lavishly festooned by Italian stucco artists and German woodcarvers between 1724 and 1726. Around a hundred thousand art enthusiasts a year flock to its hallowed halls.

Centres of scholarship and culture

Waldsassen jostles for first place among the monastic institutions of Upper Palatinate with St Emmeram in Regensburg. For over a thousand years the former Benedictine abbey was the city's centre of scholarship and culture. The library houses costly medieval books and manuscripts. From 1731 to 1733 the Asam brothers set about turning the monastic church into an orgy of baroque magnificence. In the wake of the secularization of Germany St Emmeram fell to the house of Thurn und Taxis in 1808. Kloster Seligenporten west of Neumarkt is little known outside the region although it has been one of the richest religious houses in Upper Palatinate since

c. 1500. The medieval fabric of the former Cistercian convent church has been largely preserved. Kastl Abbey, founded in 1103, even initiated a reform in 1380 to which around 30 other Benedictine monasteries subscribed until 1500. The reform called for a more elaborate celebration of the liturgy and more diligent adherence to the vows of obedience, silence and poverty.

Now a ruin but impressive none the less, there is little left of Kloster Gnadenberg north of Neumarkt. During the 15th century the site was run by the Birgittine Order – one which included both men and women. None other than Albrecht Dürer was among those prevailed upon to assess the state of the roof truss of the mighty church. The monastery-cum-convent was closed in 1556; in 1635, in the midst of the ravages of the Thirty Years' War, the Swedes set fire to the church which was thereafter ruinous.

One of the most famous places of pilgrimage in Upper Palatinate is the Kappl chapel of the Holy Trinity near Waldsassen. Its theological sentiments are echoed in its architecture where the number three is prevalent in all sections of the building. Three spires and three roof turrets adorn the church which was built for the Jesuits between 1685 and 1689 by royal architect Georg Dientzenhofer.

The pilgrimage chapel of Mariahilf in Freystadt attracts both worshippers and art enthusiasts with its frescoes, painted by Johann Georg Asam and his sons Cosmas Damian and Egid Quirin. In Griesstetten the faithful have prayed to three 'foreign' saints since the 12th century, two of them Scottish Benedictines. The most popular patron saint of the bubonic plague in Upper Palatinate was St Sebastian to whom the pilgrimage church near Breitenbrunn is dedicated. The number of pilgrimages as a whole may have declined since the Second World War; here in Upper Palatinate this traditional manifestation of personal faith continues to thrive.

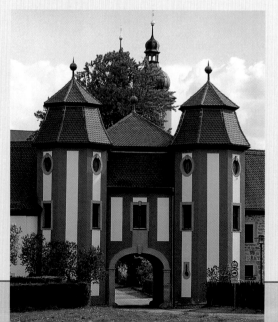

Left:
Up until 1803 this gateway was the only entrance to the monastic village of Speinshart. The abbey was founded in 1145 and dissolved in 1556 and in 1803. Holy brethren moved back in here in 1921.

Above:
The focal point of the monastery of Speinshart is the abbey church built by Wolfgang Dientzenhofer from 1691 to 1695.

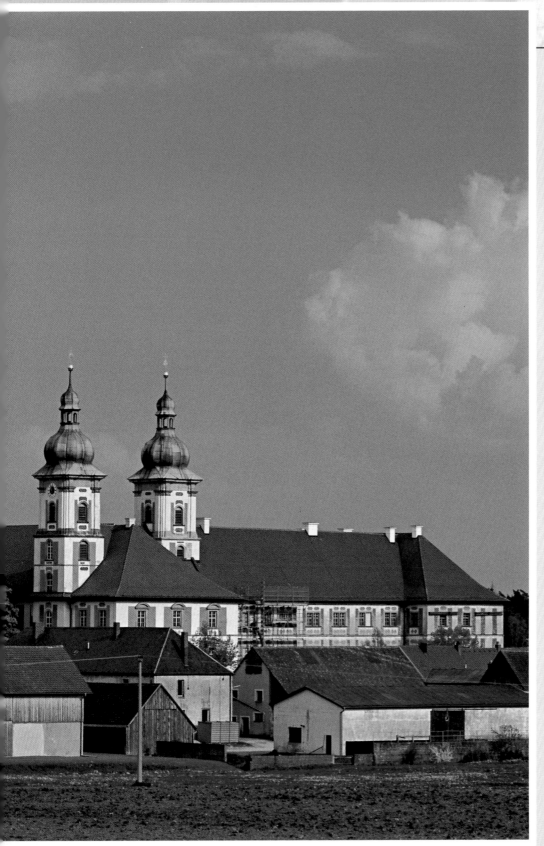

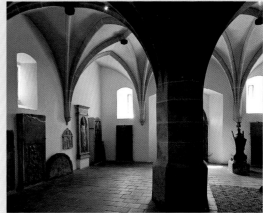

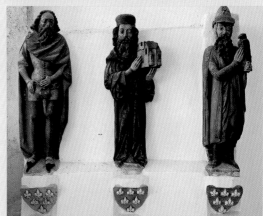

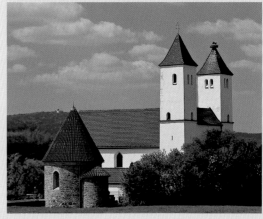

Right from top to bottom:
Kastl has had a turbulent history; over the years the abbey has been a monastery, court of jurisdiction and school. Only the church has always been used for its original religious purpose.

Gothic statues of the (human) forces behind Kloster Kastl. Count Berengar I von Sulzbach (right) founded the abbey in 1103 with Friedrich (centre) and Otto (left), counts of Kastl-Habsberg.

The elaborately carved pulpit in the monastic church of Plankstetten is a gift from Austria presented at the end of the Thirty Years' War (1655).

Right:
The church of St Peter and Paul in Perschen has a carnal house which can be visited. The Romanesque roundhouse with its pointed roof is famous for its colourful cupola fresco from c. 1165/70.

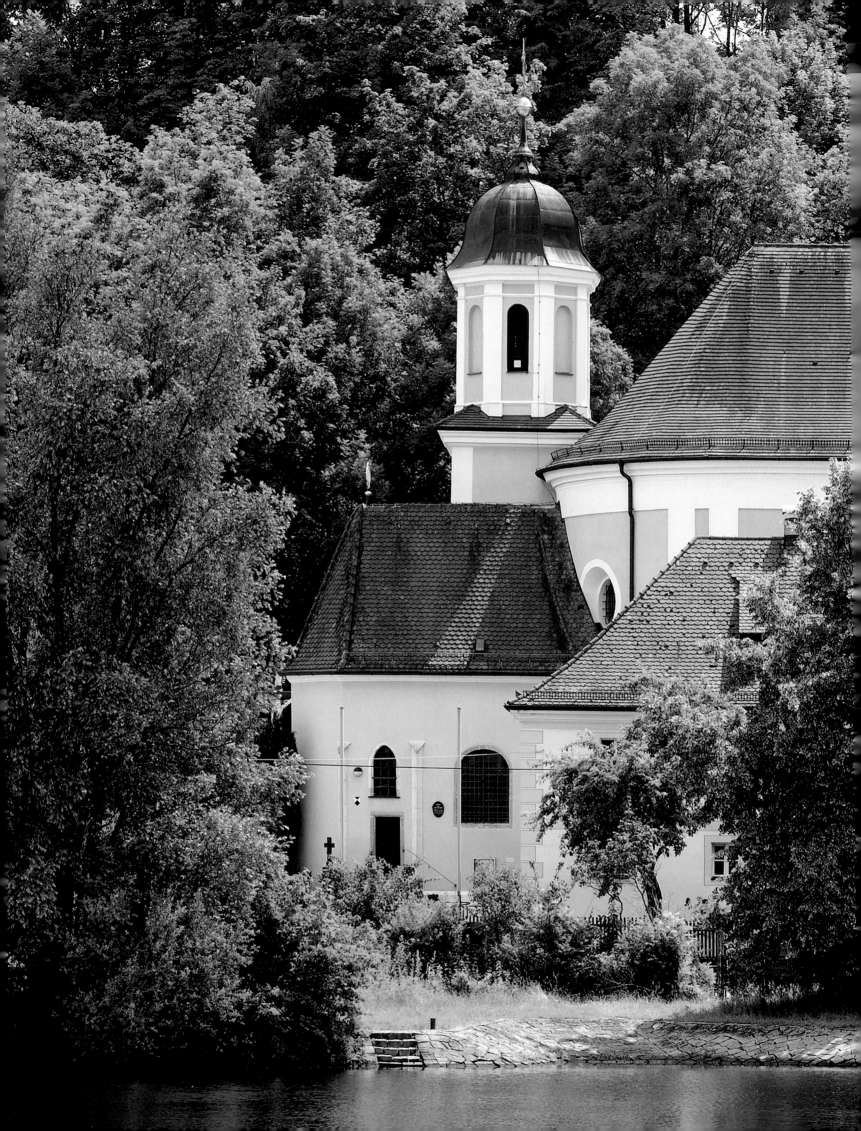

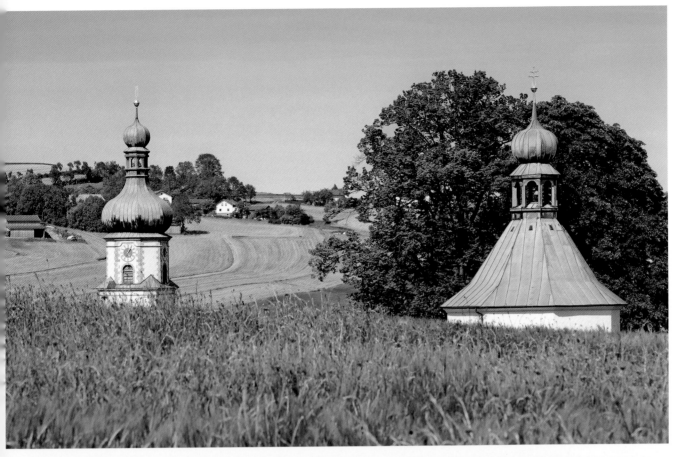

The baroque pilgrimage church of Mariä Geburt in Neukirchen beim Heiligen Blut lies in a wide valley, its onion dome visible for miles around. For centuries the journey in veneration of the Neukirchen Madonna has been one of Bavaria's major pilgrimages, one that forged special ties with neighbouring Bohemia right from the outset.

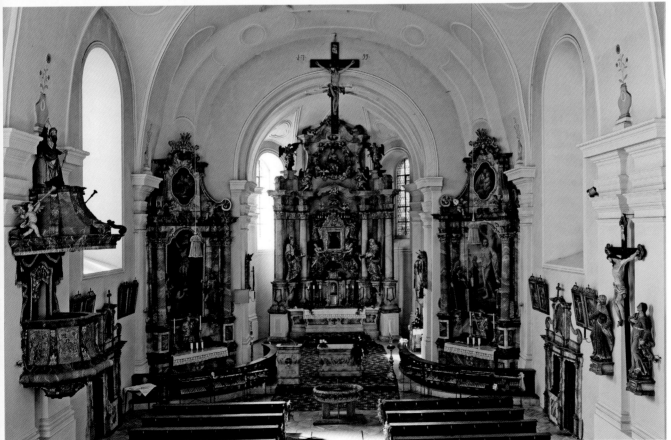

Left page:
The pilgrimage church of Mariaort hugs the banks of the Naab shortly before the river flows into the Danube. Popular for baptisms and weddings, the church attracts pilgrims all year round from as far afield as Franconia and the Czech Republic.

Nor far from Roding, high up above the River Regen, is the pilgrimage church of Heilbrünnl. It was built in the Rococo fashion in 1730. The marble basin in the centre of the nave collects water from the Heilbrünnl spring that is said to have miraculous powers of healing, particularly beneficial to people with eye complaints. The holy picture on the high altar is a copy of an icon of the Virgin Mary painted by Albrecht Altdorfer, the original of which is in the Alte Kapelle in Regensburg.

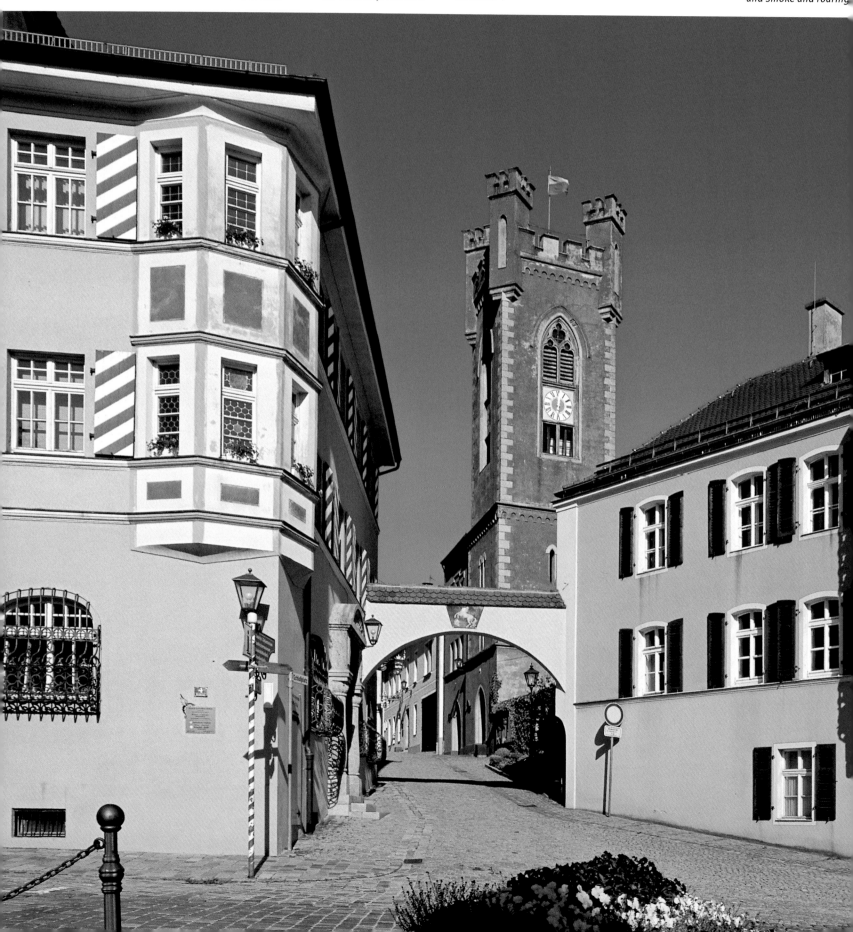

Below:
Carillon on the corner of the district court in Furth im Wald. The border town is encircled by the Bayerischer Wald mountains of Gibacht (934 m/3,064 ft) and Hoher Bogen (1,073 m/3,520 ft) on the Bavarian and Cerchov (1,032 m/3,386 ft) on the Bohemian side of the boundary. The river valleys of the Chamb and others wind their way through the Furth Basin, the "national gateway between Bavaria and Bohemia".

Small photos, right
For centuries a dragon has 'terrorised' the inhabitants of Furth im Wald. With his mouth wide open and teeth bared, spouting fire and smoke and roaring

terribly he is the epitome of evil. This dreadful beast has suffered brutal defeat at the annual Further Drachenstich festival for over five centuries – only to again raise its head the following year and be struck down anew. 1,400 actors in historic costume take part in what is Germany's oldest folk theatre, aided in their dramatic endeavours by over 250 horses and replicas of medieval wagons, barouches and canons.

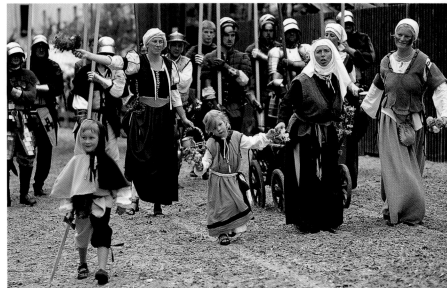

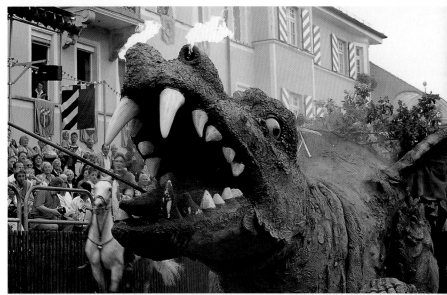

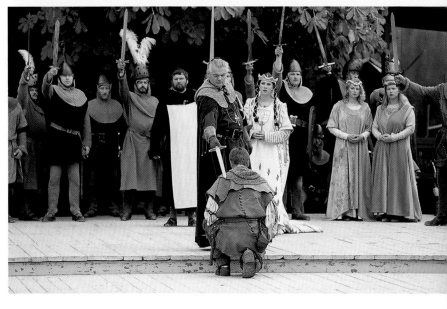

71

Between the Fränkische Alb and Oberpfälzer Wald – middle Upper Palatinate

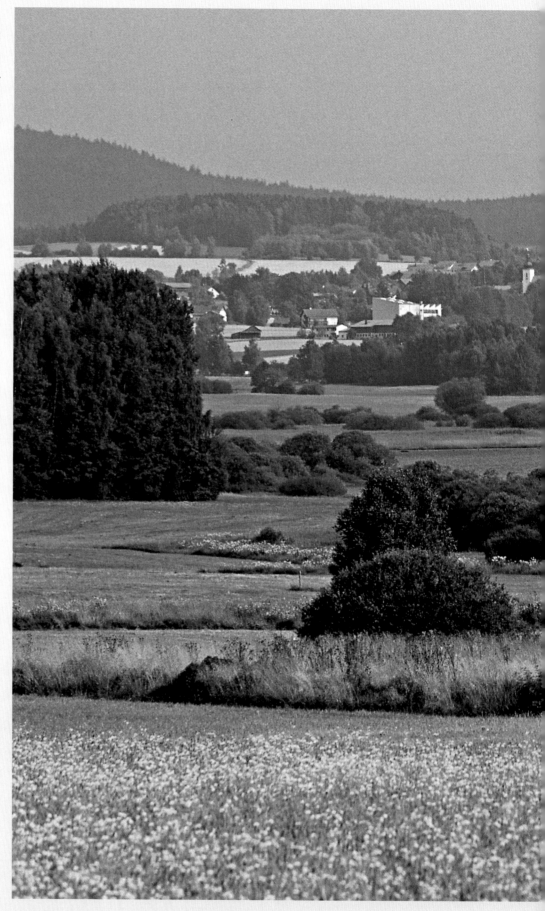

An absolute eldorado for water babies: the Silbersee in the community of Tiefenbach. The unspoilt character of the reservoir has been retained and its shores provide plenty of shelter for the local wildlife, making the lake popular with nature lovers. Here you can sail, fish, surf and swim to your heart's content – and also enjoy the many traditional festivals and customs roundabouts.

During the Middle Ages Amberg was an important centre of trade for iron and salt and up until 1810 the capital of the "obere Pfalz". Amberg's defensive walls have been preserved in their entirety, as has much of the medieval town within. The pilgrimage church of Maria Hilf on the hill of the same name, embellished by Cosmas Damian Asam, attracts thousands of worshippers each year from the surrounding area.

Northwest of Amberg, on the eastern edge of the Fränkische Alb, is Sulzbach-Rosenberg which boasts the largest palace complex in the northeast of Bavaria. The castle hill was fortified as early as in the 9th century. Another local landmark is the Maxhütte steel works, closed down a few years ago.

The economic and cultural heart of western Upper Palatinate is Neumarkt, a royal seat in the 15th and 16th centuries. Situated on the Ludwigskanal joining the Main and Danube rivers, during the 19th century it was a bustling harbour. The canal fell into disuse after the Second World War and is now popular with hikers, cyclists and nature lovers.

Schwandorf lies in the valley of the Naab. A major railway junction, it was badly destroyed during the Second World War. The last remnant of the medieval defences is the Blasturm, painted by Carl Spitzweg. In the 1980s the village of Wackersdorf east of Schwandorf became famous for its anti-nuclear protestors contesting the planned building of a nuclear reprocessing plant.

The southern Oberpfälzer Wald has many recognised spas and health resorts. Oberviechtach is one of them; the town's most famous inhabitant, the travelling physician Doktor Eisenbarth, is immortalised in the town fountain and a yearly festival held in his honour.

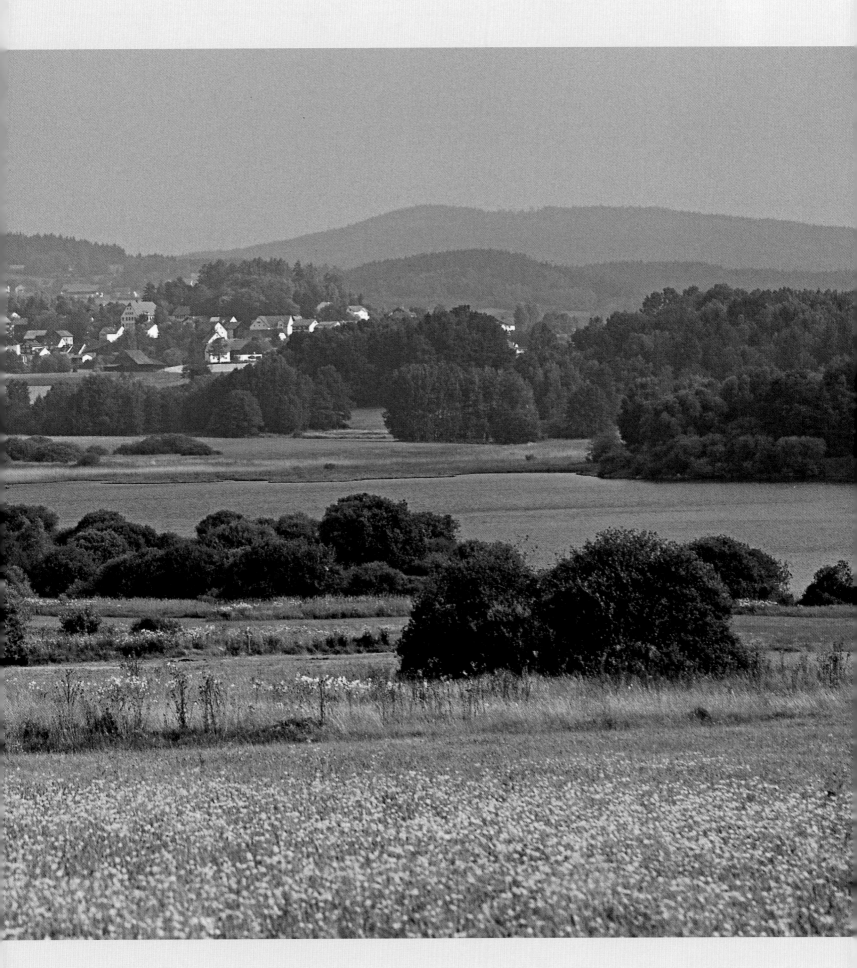

Below:
Neumarkt in Upper Palatinate – known locally as "Neimack" or "Neimoark" – is the economic and cultural

centre of western Upper Palatinate. The town dates back to c. 1100, booming during the 15th and 16th centuries when Neumarkt was the royal seat of

the Palatine Wittelsbachs. Neumarkt's significance later dwindled until the Industrial Revolution took hold during the 19th century.

Top right:
The historic Rathaus is one of the many sights in Neumarkt. Built in c. 1430 as a Gothic town hall, it was painstakingly reconstructed during 1956

and 1957 following its destruction in 1945. The old town is surrounded by town walls, which like the moat have only survived in part.

Centre righ
The long market along th main drag of the old tow of Neumarkt is split into a upper and lower section b

the Rathaus. On warm days the many pavement cafés invite you to sit down and take a break.

Bottom right: *The pilgrimage church of Mariahilf in Freystadt was erected by Giovanni Antonio Viscardi in the shape of a Greek cross between 1700 and 1710. With its four corner turrets and lantern rotunda it's one of the most significant high baroque central-plan buildings in Bavaria. The frescoes of the life of the Virgin Mary were painted by Johann Georg Asam and his sons.*

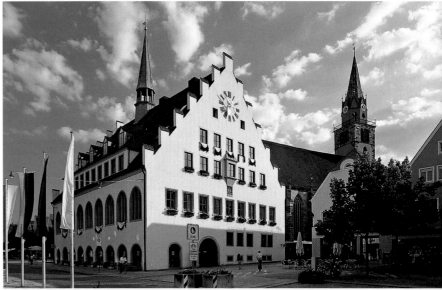

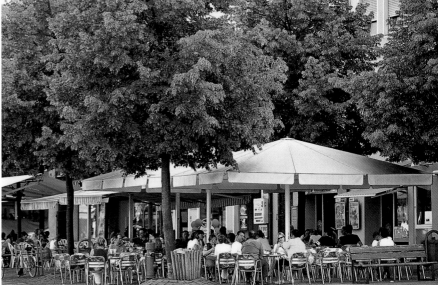

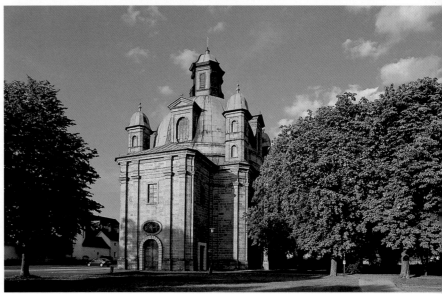

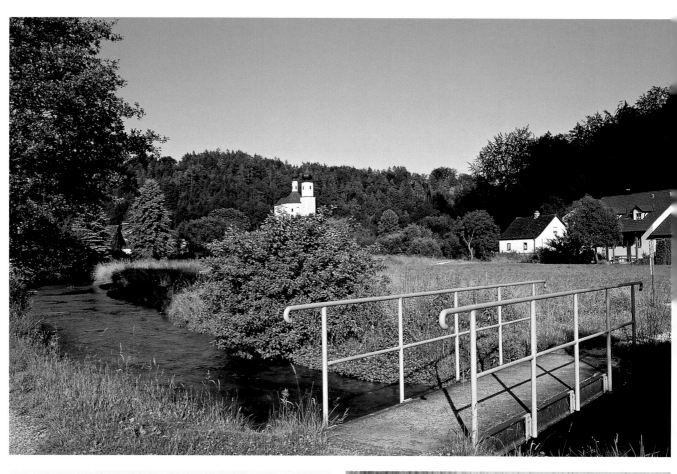

Right:
The health resort of Breitenbrunn lies in the heart of Bavaria in the national park of the Altmühltal. On the outskirts of the town is the pilgrimage church of St Sebastian from the 14th century, at the foot of which is a healing natural spring.

Top right page:
Almost no other town in Bavaria has such an intact, unspoilt medieval centre as Berching. Classified as a historical monument, Berching is a perfect example of artistic medieval town planning.

Bottom right page:
Plankstetten with the Benedictine monastery of the same name is part of Berching. Founded in 1129, the church of Mariä Himmelfahrt is Romanesque. Despite its turbulent history the abbey has survived, now well known for its conference centre, dedicated youth work and organic farming.

Right:
Karl Kempf is a shepherd in the Neumarkt district. Sheep farming has a long tradition in Upper Palatinate and was originally concentrated in areas which otherwise promised poor yields.

Far right:
A fawn near the Weiße Laaber at Berching. Most fawns are born as twins weighing just 1.2 kilos (2.6 pounds) apiece. At just three hours old the kids are able to stand and take their first wobbly steps.

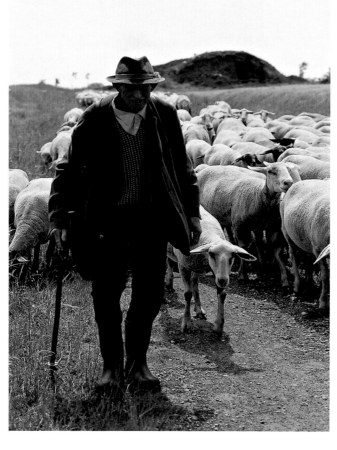

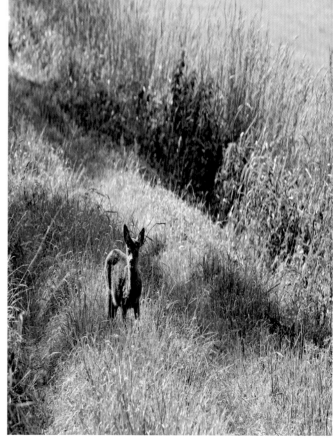

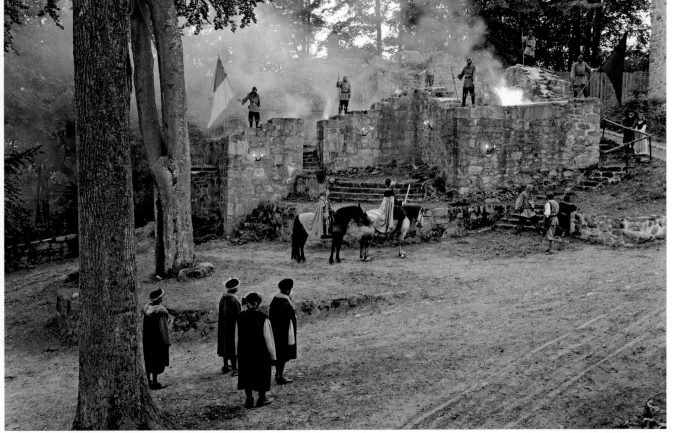

The picturesque ruin of the Schwarzenburg is the perfect theatrical backdrop for "Der Guttensteiner". In a dramatic final scene Heinrich von Guttenstein is run out of his own castle, defeated by the knowledge that the might of the aristocracy has been lost to the power and influence of the imperial cities and that any delusions of noble sovereignty will be crushed by the new-found confidence of free citizens.

Above:
Schönsee is in the national park of the Oberpfälzer Wald, not far from the Czech border. This idyllic area of dark forest attracts many spa visitors who come here to relax in natural surroundings and make use of the many sport and leisure facilities the little town has to offer.

Right:
The tiny parish of Böhmischbruck, number-ing just 500 inhabitants, lies in the north of Upper Palatinate. It is positively dominated by the 18ᵗʰ-century parish church of Mariä Himmelfahrt, now a listed monument. The many wayside crosses dotted about the area testify to the deep sense of faith harboured by the locals of Böhmischbruck.

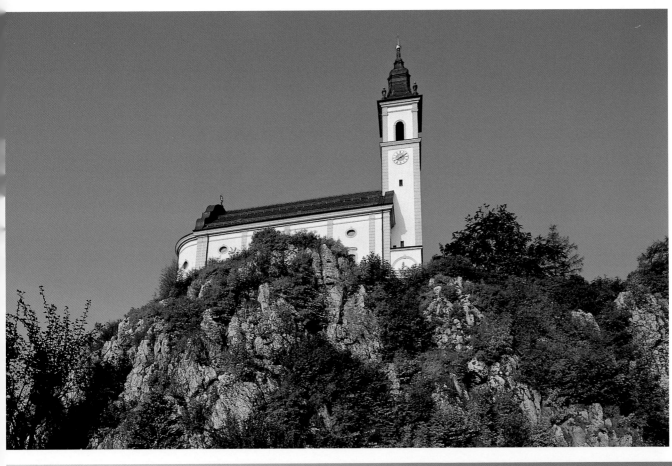

Left:

A huge mound of rose quartz rises tall above the village of Pleystein. The Kreuzbergkirche was placed at its pinnacle in 1814 in place of the ruinous 13th-century castle. The village has been ravaged by fire several times in its history. The church and a crucifix said to have miraculous powers were also destroyed in 1901; the present edifice is from 1908.

Below:

Lupins by Moosbach. Lupins are used in farming to return nitrogen to the soil and as animal fodder. In 2007 Moosbach celebrated its fifth Heimatfest or festival of local culture which is held here every ten years.

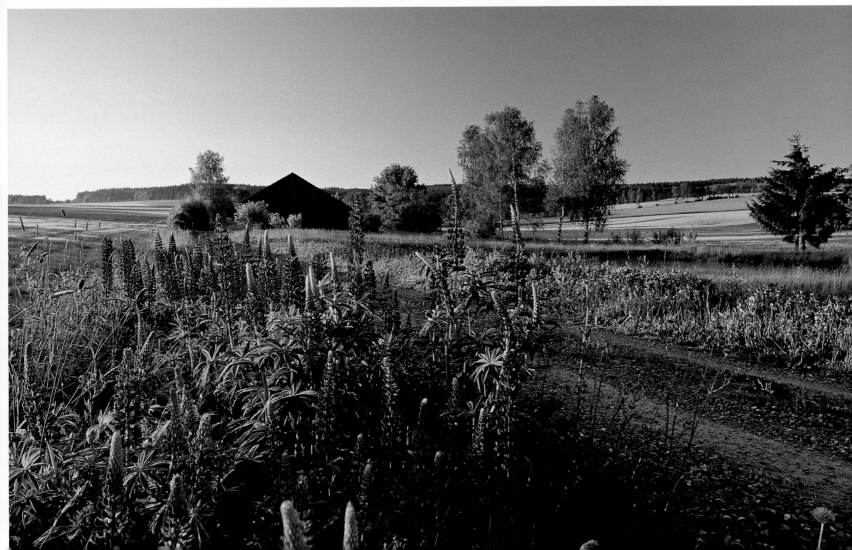

Page 82/83:
Leuchtenberg in the town of the same name is the biggest and best preserved ruined castle in Upper Palatinate. It clings to the top of Leuchtenberg Mountain (537 m/1,762 ft) and is one of the most popular viewpoints in the region. The ruins are now used as an open-air venue and to stage the yearly castle festival, where plays of various genres are performed and literary readings held.

Vohenstrauß is situated in the Vorderer Oberpfälzer Wald. A war memorial stands outside the stately Rathaus on the generously proportioned market square. The town's local landmark is the Renaissance palace of Friedrichsburg, erected between 1585 and 1589. The Edelsteinmuseum with its collection of precious stones is also worth a visit.

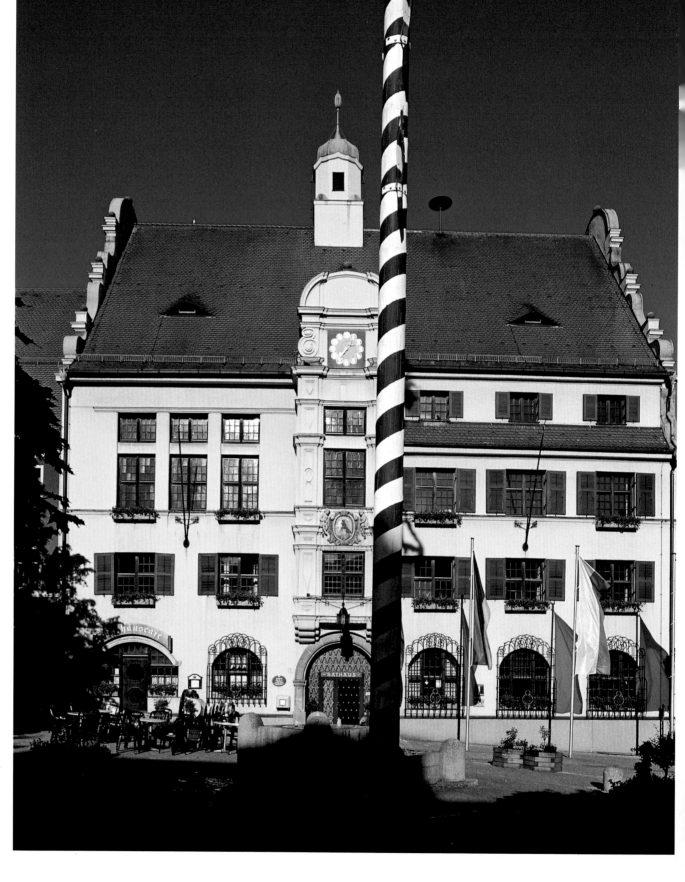

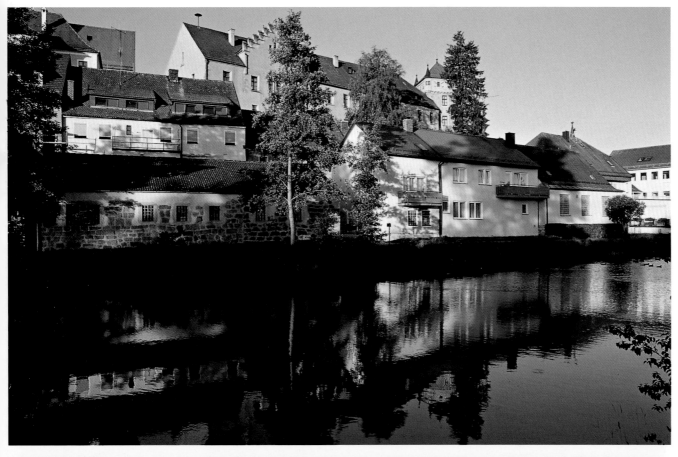

At the point where the
Oberpfälzer Wald runs into
the Bayerischer Wald lies
the town of Neunburg
vorm Wald on the River
Schwarzach. The old town
is characterised by its
towers, gateways, steps,
walls and steep gabled
roofs, all remnants of a
less secure former age.
On summer weekends
Neunburg is a hive of
activity, frequented by
several thousands of
visitors keen to see the
Hussite War play
performed here under
an open sky.

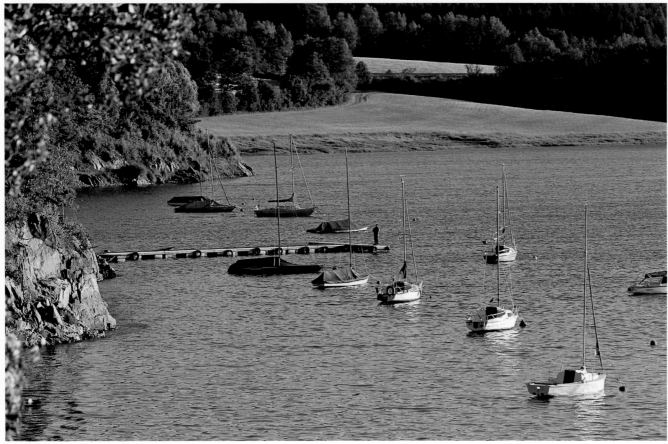

Between 1972 and 1976
the River Schwarzach was
dammed by a huge wall
over 6 kilometres (4 miles)
long. Embedded in
beautiful countryside, the
resulting Eixendorf
reservoir near Neunburg
vorm Wald is a suitably
scenic spot for the pursuit
of various sporting
activities.

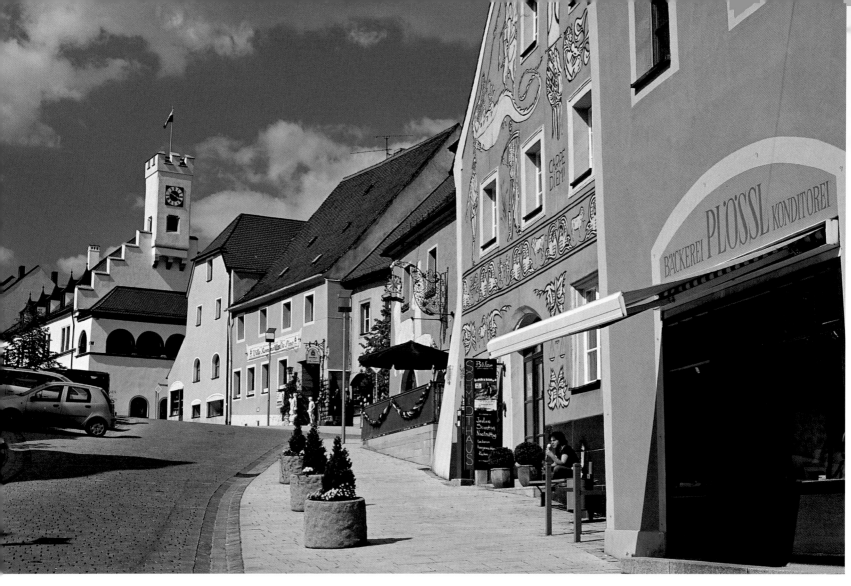

Above:
The town of Nabburg on the River Naab enjoys a pleasant setting in the middle of the Oberpfälzer Wald National Park. The Pfahl begins just outside Nabburg, a long ridge of quartz 150 kilometres (93 miles) long. High up above the river is the old town which is over 1,000 years old.

Right:
Excellently preserved, the town walls of Nabburg were strong enough to withstand an onslaught by the Hussites in the 15th century. Today they still seem to zealously guard the tightly packed dwellings within, with the Oberes Tor or upper gateway visible here.

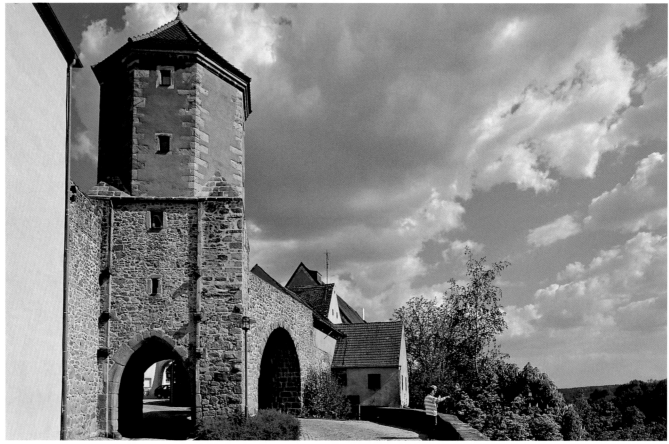

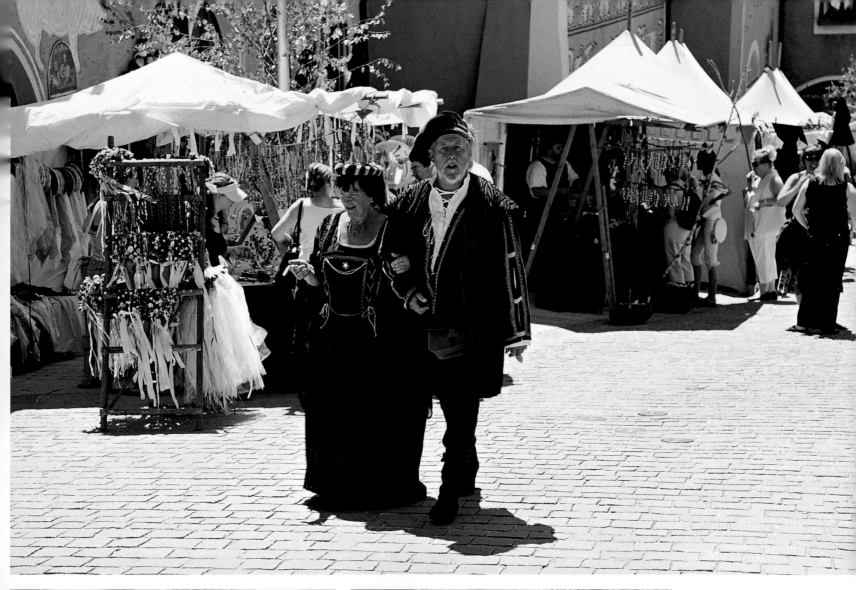

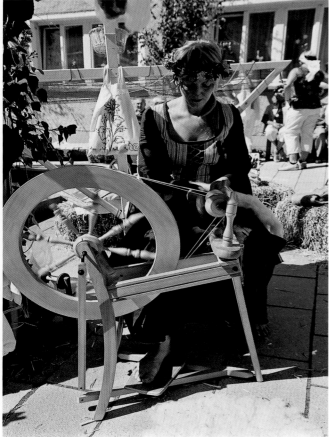

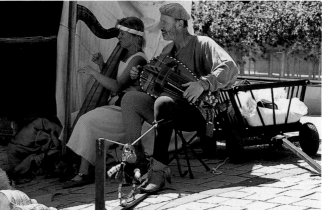

Nabburg opens its gates for the medieval market for two days each summer. At the opening the mayor, dressed in historic costume, reads out the market regulations for 1527. You can watch craftsmen and women plying ancient trades at the many stalls and booths dotted about the town. Travelling entertainers and minstrels amuse the crowds and medieval dances are performed. The market has been staged every two years since 1990.

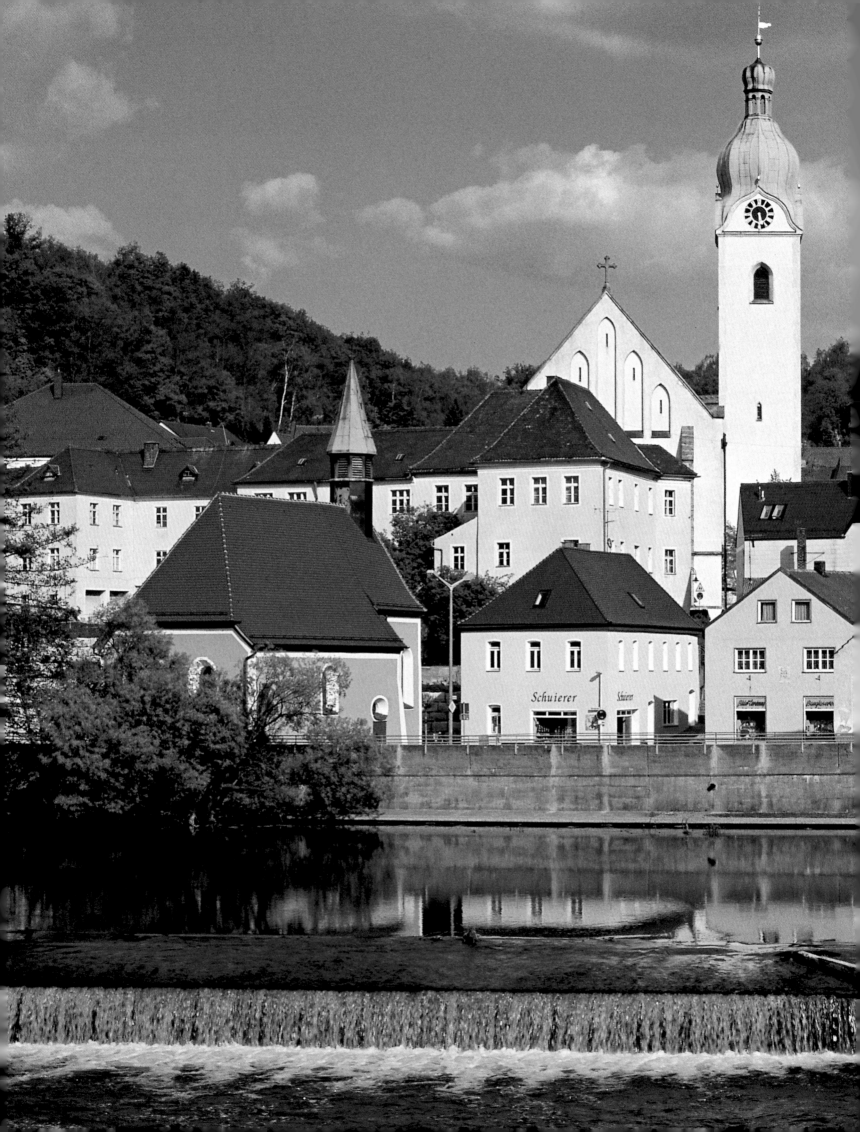

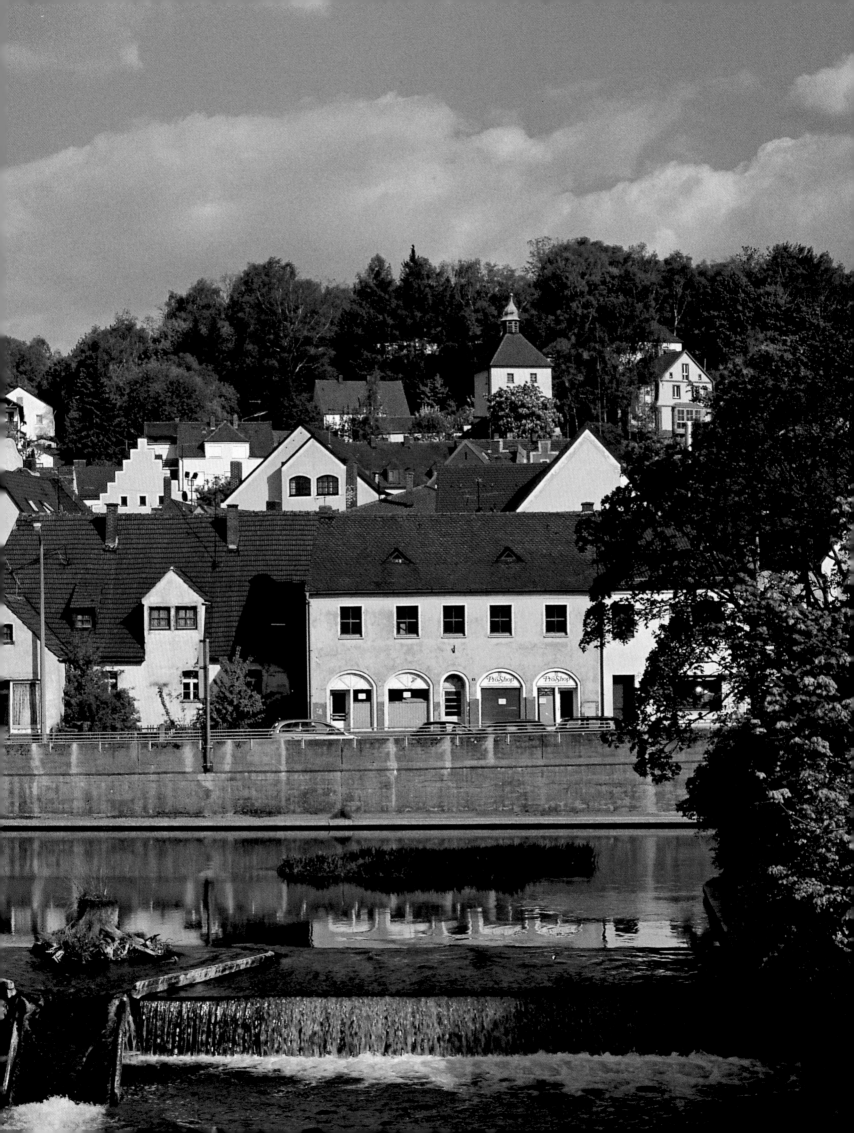

Page 88/89:
The area around Schwandorf was inhabited over 1,000 years ago; a Bronze Age fishing hook has also been found in the gravel at the bottom of the River Naab. Shortly before the end of the Second World War the major railway junction was bombed and 70% of it destroyed. Not much of the historic town thus remains. The Blasturm, a remnant of the medieval defences, has managed to survive half a millennium more or less unscathed.

Pond by Schwandorf. Brown coal was once mined to the east of the town; the pits have since filled up with water to create a wonderful lake district. The largest pools are used by tourists for a number of activities.

Purple loosestrife loves damp places, such as this pond near Schwarzenfeld in the Oberpfälzer Seenland. Caterpillars from the Saturniidae moth family feed on loosestrife which is also a source of nectar for butterflies.

Right page:
The little market town of Kastl lies between Amberg and Neumarkt in the narrow valley of the Lauterach with its steep side valleys and expanses of forest. For over 900 years the town has been dominated by Kastl's imposing fortified monastery which was a Benedictine abbey up until 1556. This impenetrable complex with its Romanesque church, rich in art treasures, is an impressive sight indeed.

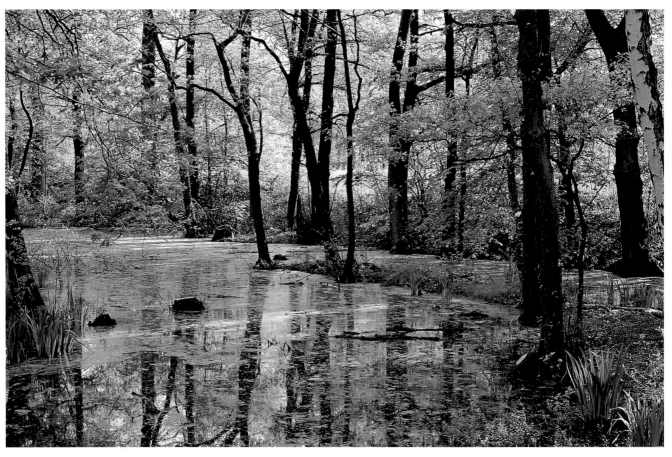

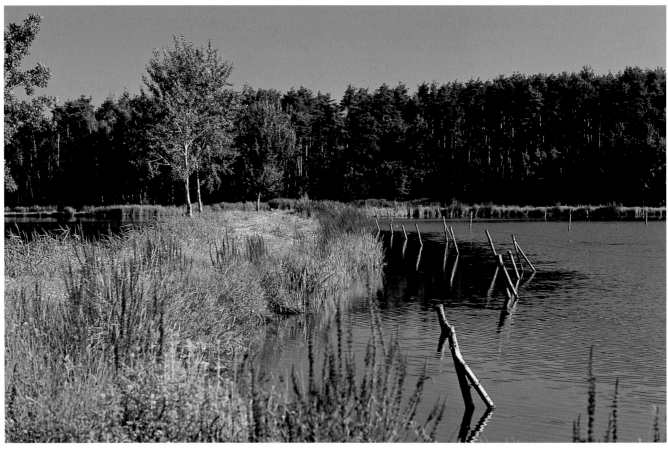

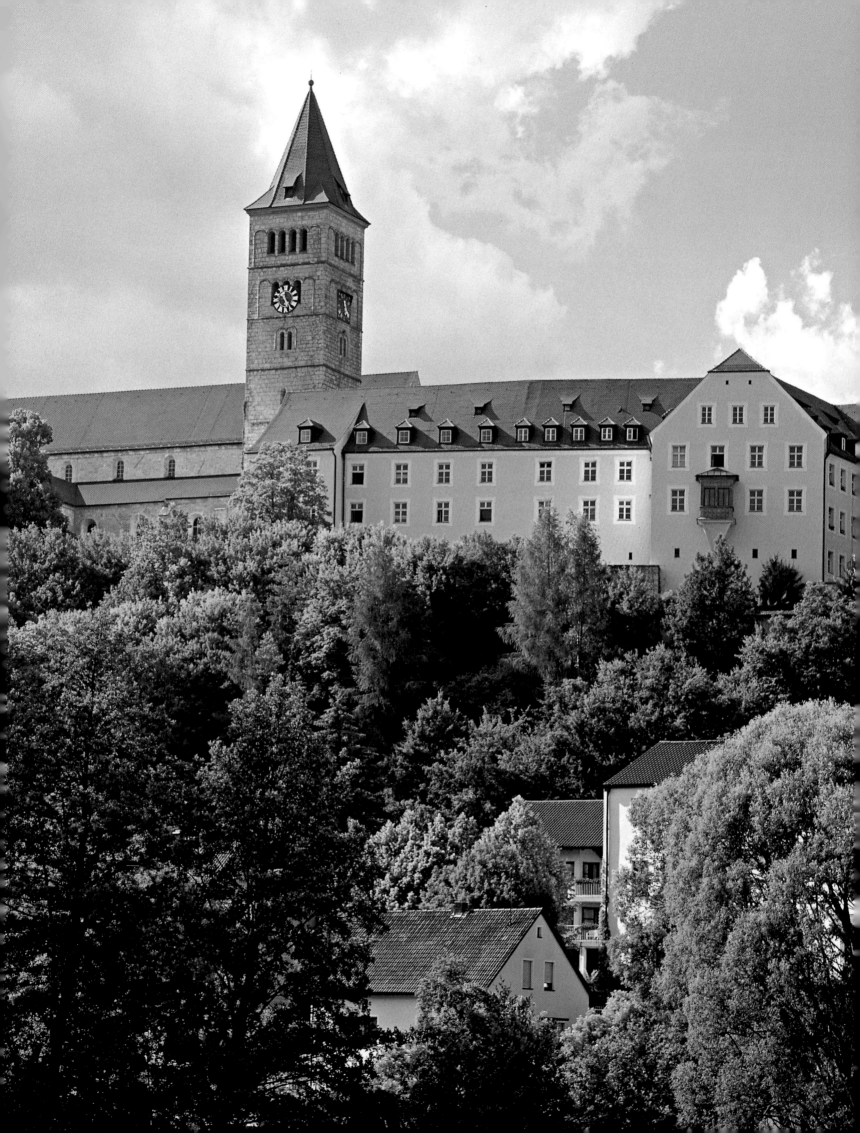

The tradition of building elaborate Christmas cribs is upheld to this very day in Upper Palatinate. A private crib museum in Plößberg pays homage to the painstaking work of local crib carvers.

Above and below right:
The museum in Theuern has devoted its energies to the history of mining and industry in Eastern Bavaria. The exhibits include a forge, a glass cutting and polishing works, a museum of electricity and a miners' pit.

Above and below far right:
The Deutsches Knopfmuseum in Bärnau explores all facets of the button industry here, with thousands of buttons made of 26 different materials from four centuries on display. The clothes worn by Bärnau's pearly king and queen in 1996 are particularly impressive, decorated with no less than 18,500 buttons and fastenings.

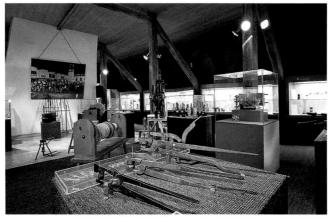

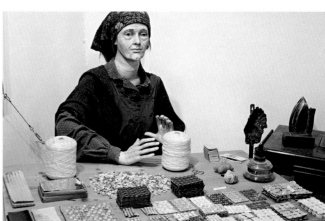

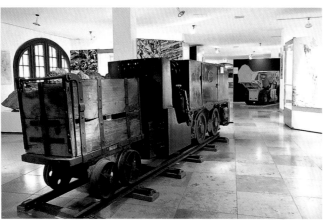

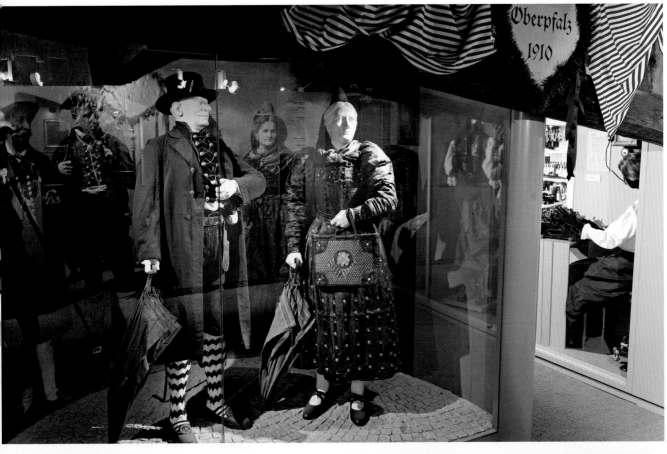

The city museum in Amberg not only features traditional Upper Palatine dress but also archaeological exhibits, town history, local crafts and industry. One section of the museum is dedicated to local artist Michael Mathias Prechtl (1926–2003), famous the world over for his book and magazine illustrations, posters and caricatures.

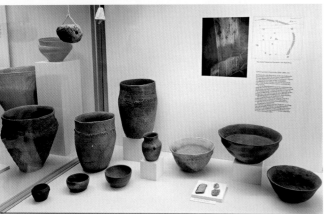

Far left:
The Upper Palatine museum of archaeology in Amberg presents the history of the settlement and culture of the entire region from the Stone Age to the Middle Ages.

Above and below left:
With almost 2,000 objects the Stadtmuseum in Amberg has the biggest collection of Amberg faïence and pottery in Bavaria. It also has a section on clothing down the ages, documenting fads and fashions from the Biedermeier period to the present day.

Below far left:
There are several museums of glass in Upper Palatinate. The one in Plößberg has a wide range of select industrial items on display.

FROM *AUSZOG'NE* TO *ZWIRL* – THE CUISINE OF UPPER PALATINATE

Our local cuisine is in great danger!" warned Adolf J. Eichenseer in 1977, editor of the cookbook *Oberpfälzer Kost* (Upper Palatine Cuisine). His desperate claim now seems exaggerated; despite the internationalisation of German menus regional specialities have managed to proudly assert themselves. Influenced by the neighbouring kitchens of both Bohemia and Bavaria, for centuries Upper Palatine cooking was unable to make a name for itself; soil poor in humus yet rich in stones also didn't yield good crops. Today, however, the region has much to offer in the way of local culinary delights.

In the past work on the farm began at four o'clock in the morning. The farmers' first meal of the day when they returned home at around seven was soup. A good hearty meal here still starts with soup; there's a northern Upper Palatine saying which goes: "The strongest soup is a watery soup, for it is water which drives the mill wheel". The most typical of these is Brennsuppe, where onions are sweated in lard and then boiled in meat stock. Other delicious broths include those made with cabbage, mushrooms, beer or buttermilk – with tasty potato soup also a hot favourite.

Speaking of potatoes ... Upper Palatinate used to be called "potato Palatinate" for its prolific cultivation of the root vegetable, first planted here in the 18th century. Humble it may be; no self-respecting menu would now be without it. Its historical significance was at its greatest during the Bavarian War of Succession between Austria and Prussia in 1778/79. Famine racked the land, meaning there were potatoes for breakfast, lunch and tea – "for all eternity!", as one contemporary saying goes. The potato was an indispensable staple, dished up as *Sterz* (mash), *Zwirl* (strudel made from cooked potatoes), *gewuzelt* (fat fingers of potato pasta), *Goaßbratl* (potato gratin) – and of course in the form of the inevitable dumpling. The potato filled the empty stomachs of the poor; it was a grand occasion indeed if a few scrawny fish or a scrap of meat were found to accompany the omnipresent victual ...

Roast pork, dumplings and cabbage are the Holy Trinity of Bavarian cuisine. Pubs and restaurants naturally also serve a range of local dishes. If you're ever in Regensburg, for example, you simply must try the traditional sausages sold at the age-old Wurstkuchl next to the equally ancient Steinerne Brücke. There is also an impressive variety of freshwater water to be had here, with the original Upper Palatinate carp top of the list, bred in thousands of fishpools throughout the land and prepared in many different ways: *au bleu*, fried or baked or dribbled with a delicious assortment of sauces.

Sweet delights and cold platters

Sweet dishes which today appear on menus as pancakes or *Auszog'ne* (pastries made with fat) were often eaten on Fridays when Catholic tradition forbade the consumption of meat. Another sugary creation is the horrific sounding *Scheiterhaufen* (funeral pyre or stake), in effect a (quite harmless) bread pudding made from stale rolls with apples, sultanas, milk and eggs. *Hollerküchle*, elderflower blossoms fried in pancake mix, are also popular when in season.

In the evening, or when a light meal is required, the locals like their *Brotzeit* or cold platters. These usually include salted, smoked belly of pork (*Gselchtes*), liver sausage and black pudding, brawn and *Obatzter*, a spread made of soft cheese, onions and spices. Radishes, *Radi* (white radish) and a good farmhouse loaf round off the meal.

Nowadays beer is considered to be the simpler of the two when it comes to the hop or the grape yet this wasn't always the case. In the Middle Ages the poor man's drink was wine; with its elaborate production process, beer was the tipple of the wealthy royal courts and monasteries. Up until the 16th century a mild climate enabled widespread cultivation of the vine in Upper Palatinate; the region does still make wine in some places but only in small quantities. The range of local beers, on the other hand, is impressive. In Amberg, the former capital of Upper Palatinate, every citizen once had the right to brew (or have brewed) his or her very own supply of ale.

Left:
There are many breweries still active in the region. Chocolate-coloured Alt-Berchinger has been drunk here since 1826.

Above:
Dampfnudel Uli in Regensburg's Baumburger Turm is where Bavaria fans, tourists and locals alike tuck into a typical yeast dough "Dampfnudel" or an apricot strudel.

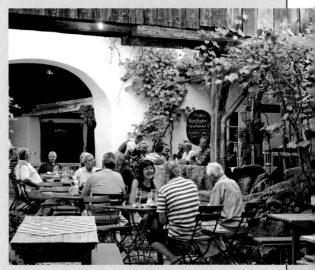

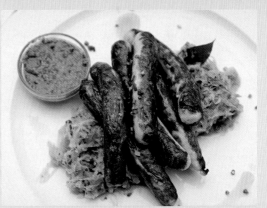

Far right, top down: "Fingernudeln" or "Schupfnudeln" are made from a dough of cooked potatoes, eggs, butter, a little flour and a pinch of salt, rolled into finger-sized pieces (hence the name) and then fried in fat.

Claiming to be one of the pleasantest pubs in the area, the historic Gasthof Stirzer near Dietfurt with its idyllic beer garden is certainly a grand place to spend a long lunchtime or warm summer evening.

A speciality of Regensburg: small, thin sausages, sauerkraut and mustard. Simple but delicious!

The white radish is called a "Radi" in Bavaria and usually eaten with bread and butter. Just one of these elongated vegetables provides an adult with his or her daily ration of vitamin C.

95

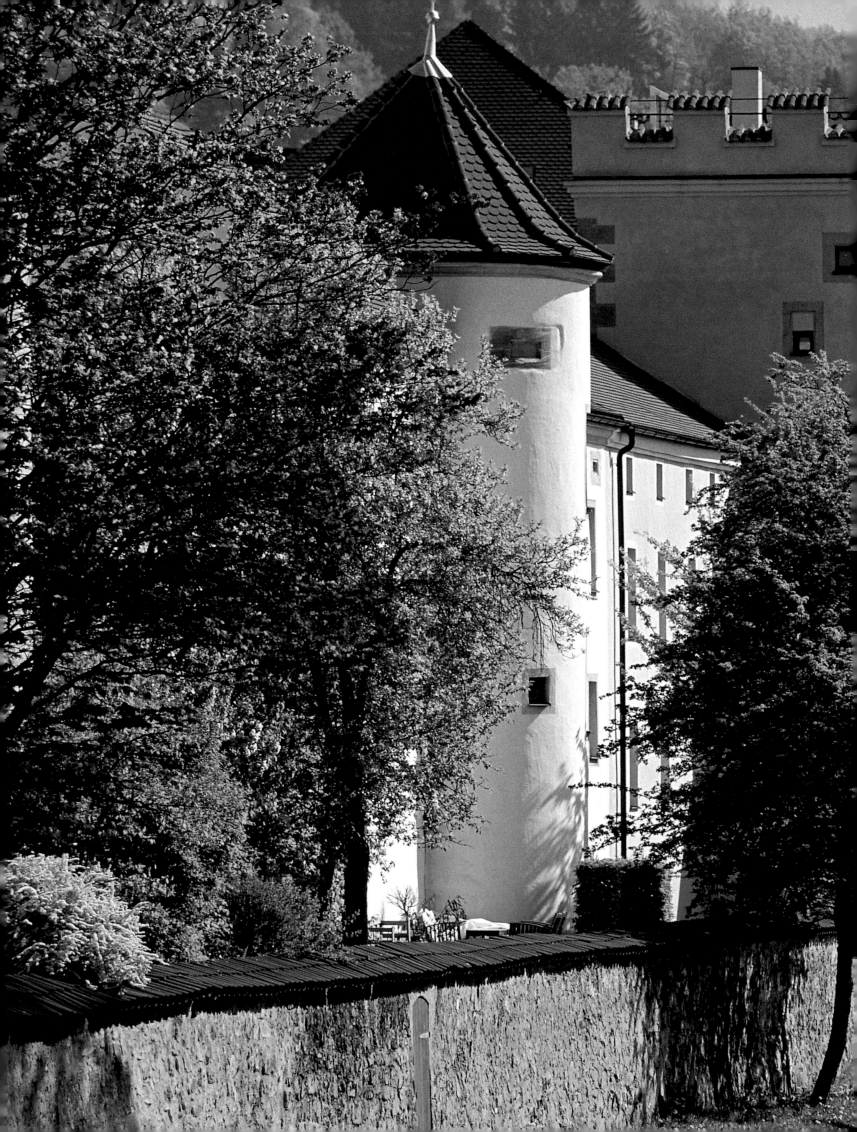

Page 84/85:
The town walls of Amberg. Author Eckhard Henscheid, born here in 1941, passes a harsh judgement on his native town: "The heads of our citizens are full of brutality, infamy and a hundred percent desire to do nothing." Henscheid was nevertheless awarded Amberg's prize for culture in 2005; he duly donated the money to his old school.

Right:
The electoral palace or Neues Schloss in Amberg was the seat of the counts palatine. Elector Ludwig III had it erected in 1417; Elector Friedrich I later turned it into a fortress. The complex is now used by the local administration.

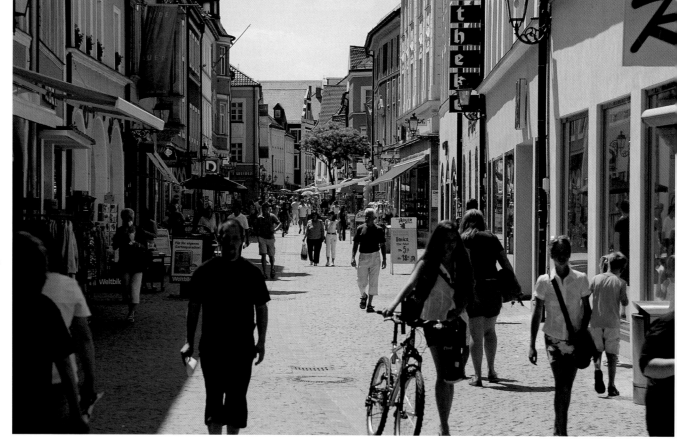

Shops on Georgenstraße in Amberg. "Amberg arose from ore, built on a layer of tinder and slag, [it has] blossomed and become strong through ore; it is justifiably a town of iron", Ricarda Huch once claimed in her "Städtebilder". The extraction of metal ore which brought the town prosperity has paved the way for its present good economic status.

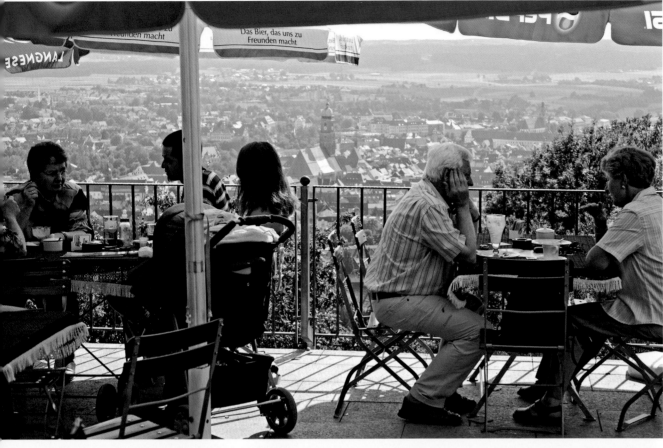

Up on Maria Hilf Berg high above Amberg a baroque pilgrimage chapel from 1711 extends a warm welcome to all visitors. The ceiling frescoes are by Cosmas Damian Asam. There are lovely views of the town and surrounding countryside from the church tavern.

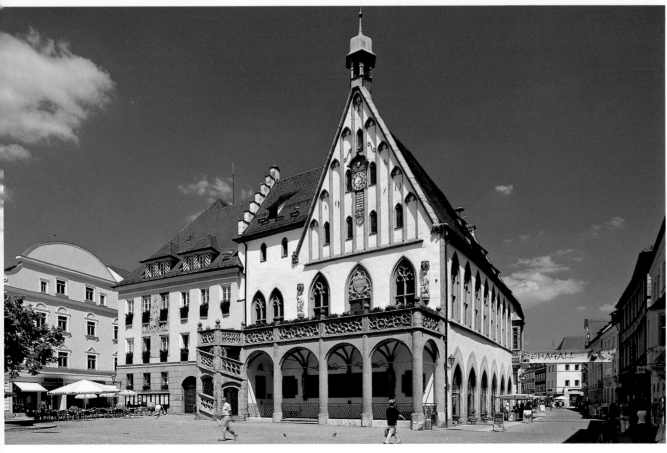

The Rathaus in Amberg was first mentioned in documents in 1348, with the oldest sections dating back to the Late Gothic and Renaissance. A grand balcony borne on sturdy stone pillars adds a note of prestige and importance.

99

Sulzbach-Rosenberg clings to the eastern slopes of the Fränkische Alb in the Upper Palatine Jura. The double name comes from the amalgamation of two smaller towns in 1934. The historic centre of Sulzbach, perched high up on a rock, boasts the largest palace complex in the northeast of Bavaria. This massive neo-Renaissance building from 1905 was once the seat of the local court and now houses a literary archives.

Right page:
During the 14th century Emperor Karl IV, king of Bohemia, created the territory of New Bohemia from the lands belonging to Sulzbach between Nuremberg and Prague, making Sulzbach the capital. He made the people of Sulzbach exempt from taxes in all cities of the empire and in the kingdom of Bohemia and granted them the right to open mines across the Sulzbach region. The splendid Gothic Rathaus is a product of this period.

Schloss Sulzbach has its roots in the 9th century. The parts of the old castle which have survived (such as the castle chapel and various other buildings) have now been swallowed up by the present palace edifice and are barely discernible.

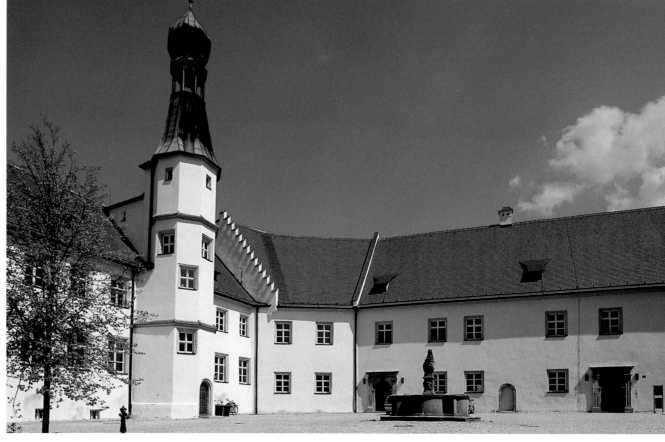

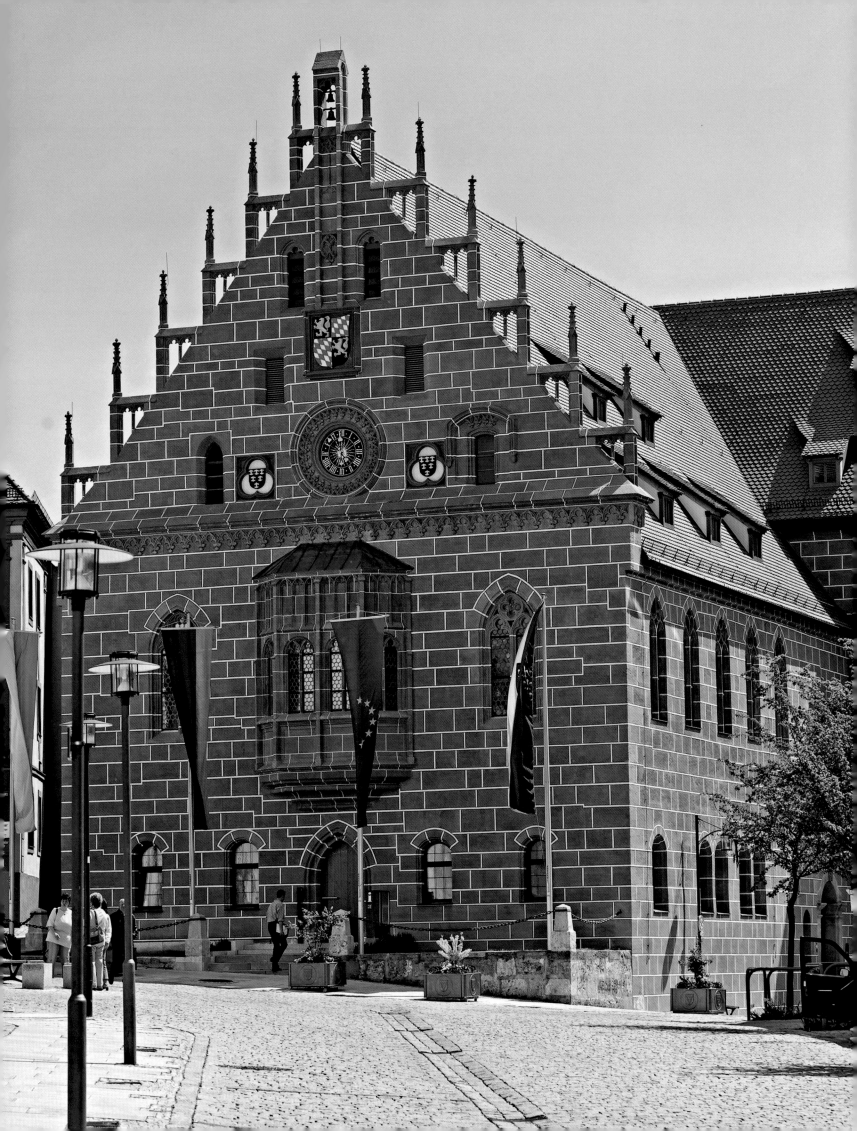

Below:
Visible for miles around, the Mont Blanc of Hirschau, a.k.a. Monte Kaolino or Weißer Riese, is a huge

mound of fine quartz sand, a waste product deposited by the kaoline mines around Hirschau.

Small photos, right:
If you fancy some boarding without having to wrap yourself up in thick skiwear, come to Monte Kaolino! In the 1960s the town set up

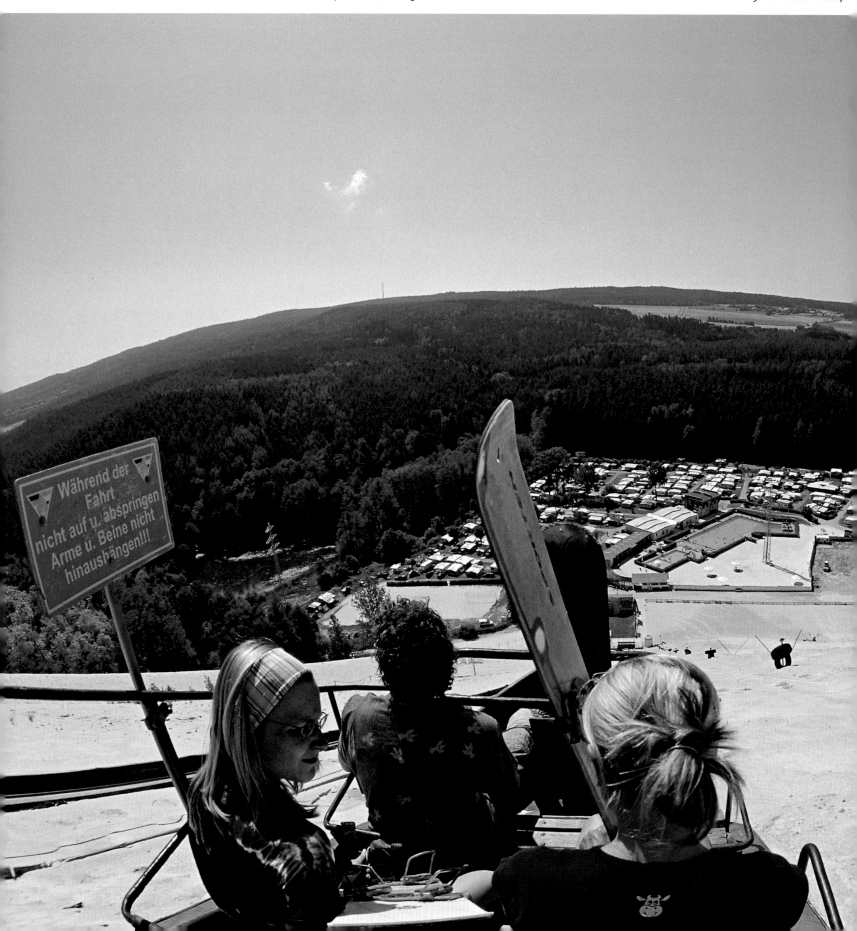

Während der Fahrt nicht auf u. abspringen Arme u. Beine nicht hinaushängen!!!

a leisure park on the south slope of the slag heap, complete with swimming pool, restaurant, children's playground and campsite. It's also the only sand dune in the world to have its own ski lift, the Monte-Kaolino-Bahn, from the top of which you can whiz down an impressive piste on rented skis or snowboards. The skiing is so good international sand skiing and sandboarding competitions are even held here.

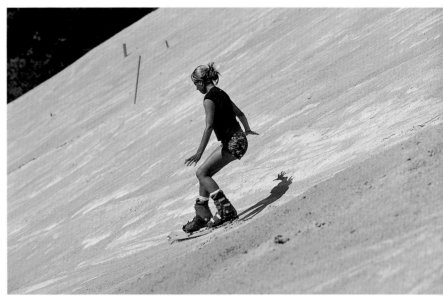

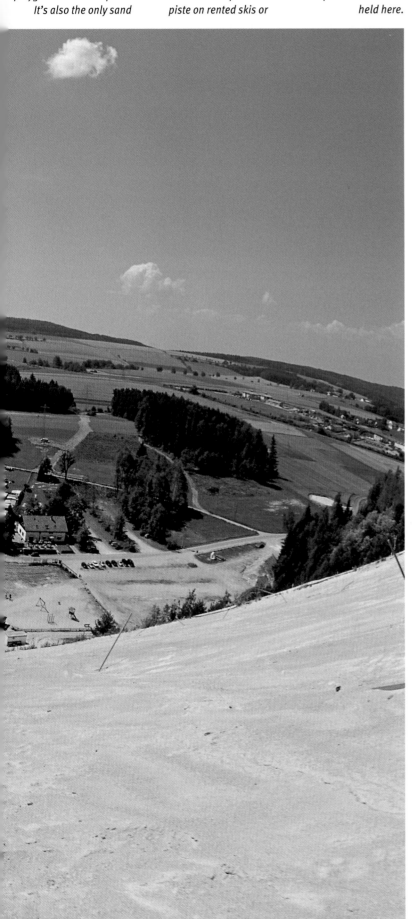

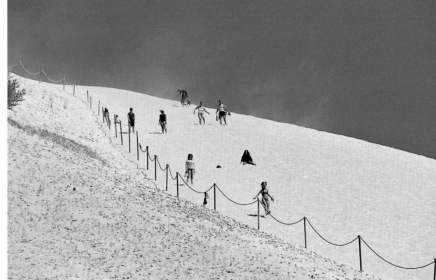

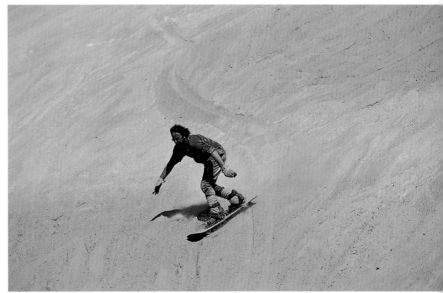

Right:
The old town hall and school house in Luhe (with roof trusses dating back to 1546/47) rounds off the late medieval market place. Beyond it is the parish church of St Martin.

Below:
From the keep of Burg Wernberg you can cast your gaze out across the rolling hills of the Oberpfälzer Wald National Park. The old castle was turned into a hotel in 1998.

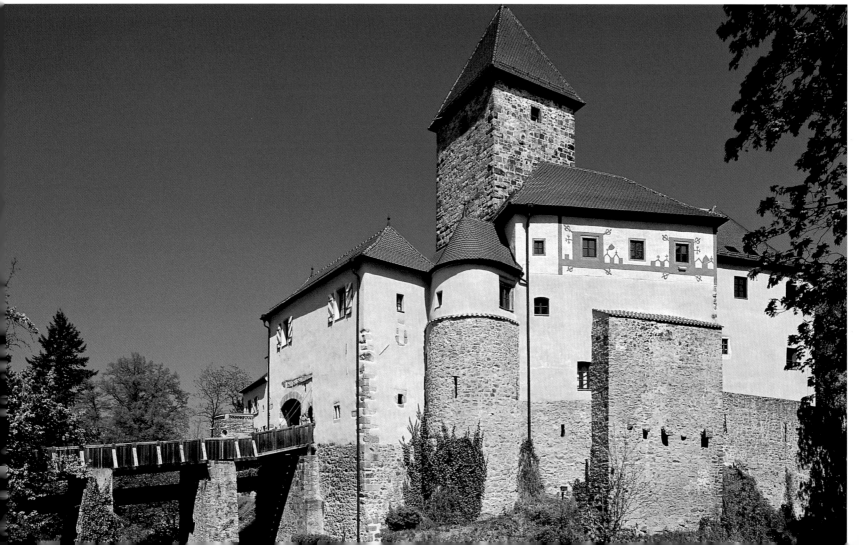

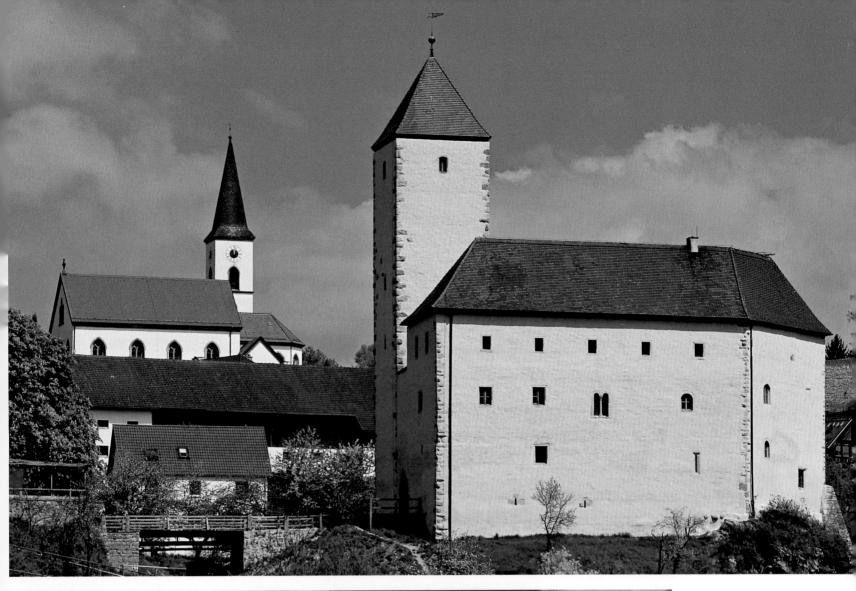

Above:
Fans of all things medieval mustn't miss this one: Burg Trausnitz on the edge of the idyllic little town of the same name. The splendid stronghold in the midst of the Oberpfälzer Wald is now used as a youth hostel.

Left:
The Axtheider Schlössl in Vilseck is from the 16th century and was once managed by the bishop of Bamberg's castellan. It was completely restored between 1985 and 1991.

The recognised health resort of Neualbenreuth lies embedded in the wonderful parkland of the Oberpfälzer Wald. To date the Sibyllenbad, opened in 1990, is the only spa in Upper Palatinate, boasting the most powerful source of radon in Germany.

With over 42,000 inhabitants Weiden is the biggest city in the north of Upper Palatinate, situated in the valley of the Waldnaab on the edge of the northern Oberpfälzer Wald and famous far and wide for its porcelain. This is where composer Max Reger grew up. The old town with its pretty market place is particularly charming. In 1536 the town was destroyed by fire and many of the town dwellings subsequently erected bear visible traces of the Renaissance.

Neustadt an der Waldnaab is where lead crystal is produced in abundance. From 1562 to 1806 the town was ruled by the Bohemian princes of Lobkowitz who erected many splendid edifices here, among them the Altes Schloss and the Neues Schloss.

In Grafenwöhr the military museum not only documents the history of the army training ground founded here in 1908 but also the culture and day-to-day lives of the past residents of Upper Palatinate. The deepest hole in the ground can be marvelled at in Windischeschenbach, site of the Continental Drilling Programme between 1987 and 1995. Studies of the earth's crusts were carried out using a bore hole 9 kilometres (5 miles) deep and 70 centimetres (28 inches) wide. Tirschenreuth has a museum of fishing and in the cemetery church of St Michael a remarkable *Dance of Death* from the early 18th century painted onto the panelled ceiling.

Far up in the north of Upper Palatinate is the Stiftland, an area characterised by its multitude of baroque churches, fishing lakes and pine forest. Picturesque villages in beautiful settings are perfect places to relax and soak up the local culture, cuisine and scenery. The cultural hub of the Stiftland is Waldsassen with its Cistercian convent and baroque pilgrimage church of Kappl. The convent library with its artistic carvings draws a hundred thousand visitors a year.

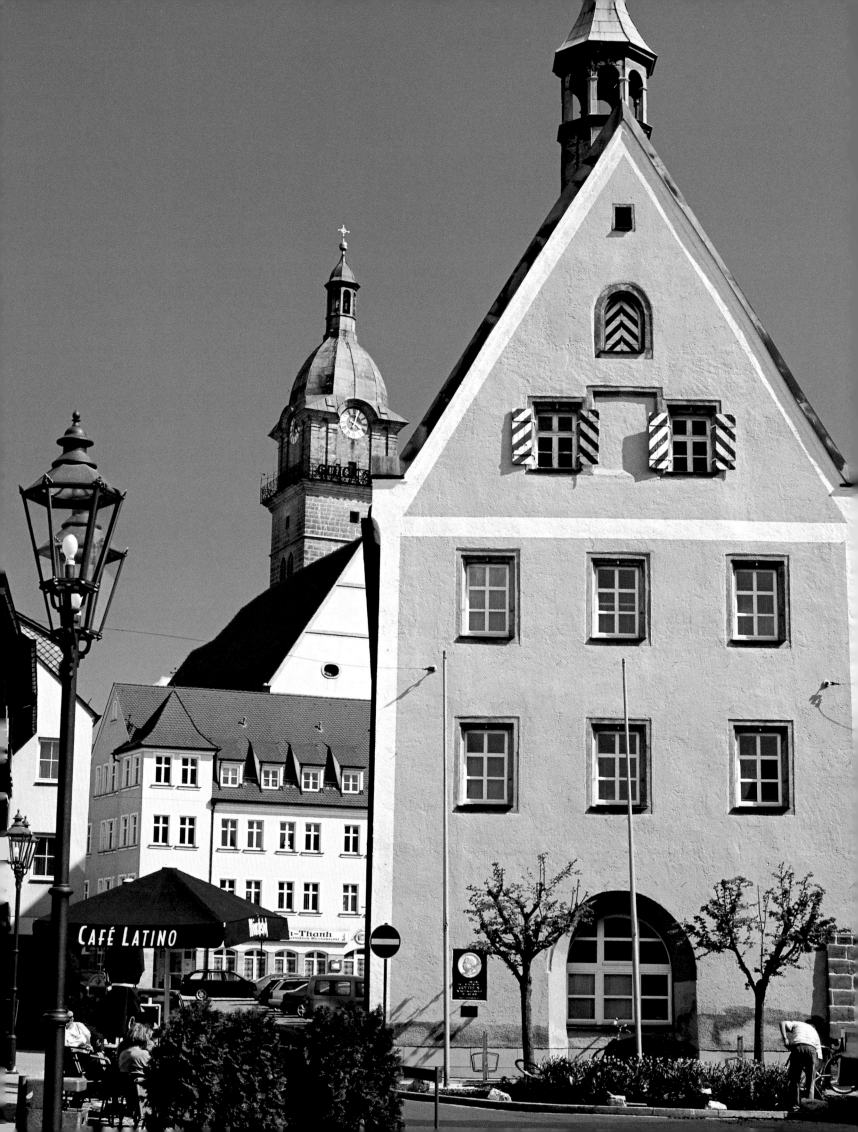

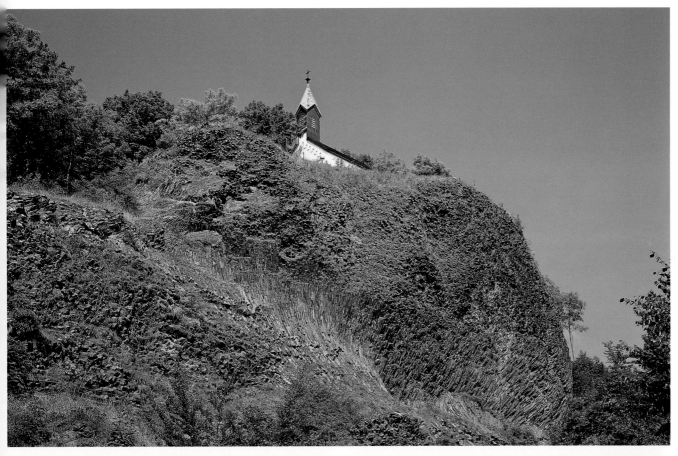

Left:
Alexander von Humboldt once said of the Parkstein near Weiden that it was "the most beautiful basalt peak in Europe". 38 metres (125 feet) high, the rock is made up of several pentagonal and hexagonal pillars up to a metre tall. The structure was formed by a flow of lava and emerged after the soft rock had been weathered away.

Left page:
The Gothic Rathaus which serves the small community of Auerbach goes back to the year 1418. Nearby are a national park, a grotto and a museum of mining.

Page 110/111:
The town of Weiden is the jewel in the Upper Palatine crown. The Oberer Markt with its charming array of gabled houses from after 1540, stretches out between the upper town gate (Oberes Tor) and the old town hall (Altes Rathaus).

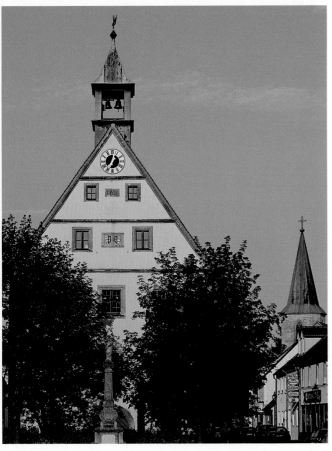

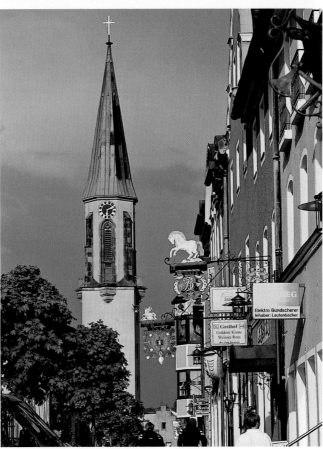

Far left:
The Rathaus in Grafenwöhr. Up until 1900 Grafenwöhr was little more than a village with just 900 inhabitants. On the founding of the firing range by the kingdom of Bavaria in 1908 the town boomed – only to be almost totally annihilated by heavy air raids in 1945. The military training ground is now used by the US Army and NATO.

Left:
The name Kemnath is derived from the old word "Kemenate" for a heated room in a medieval castle.

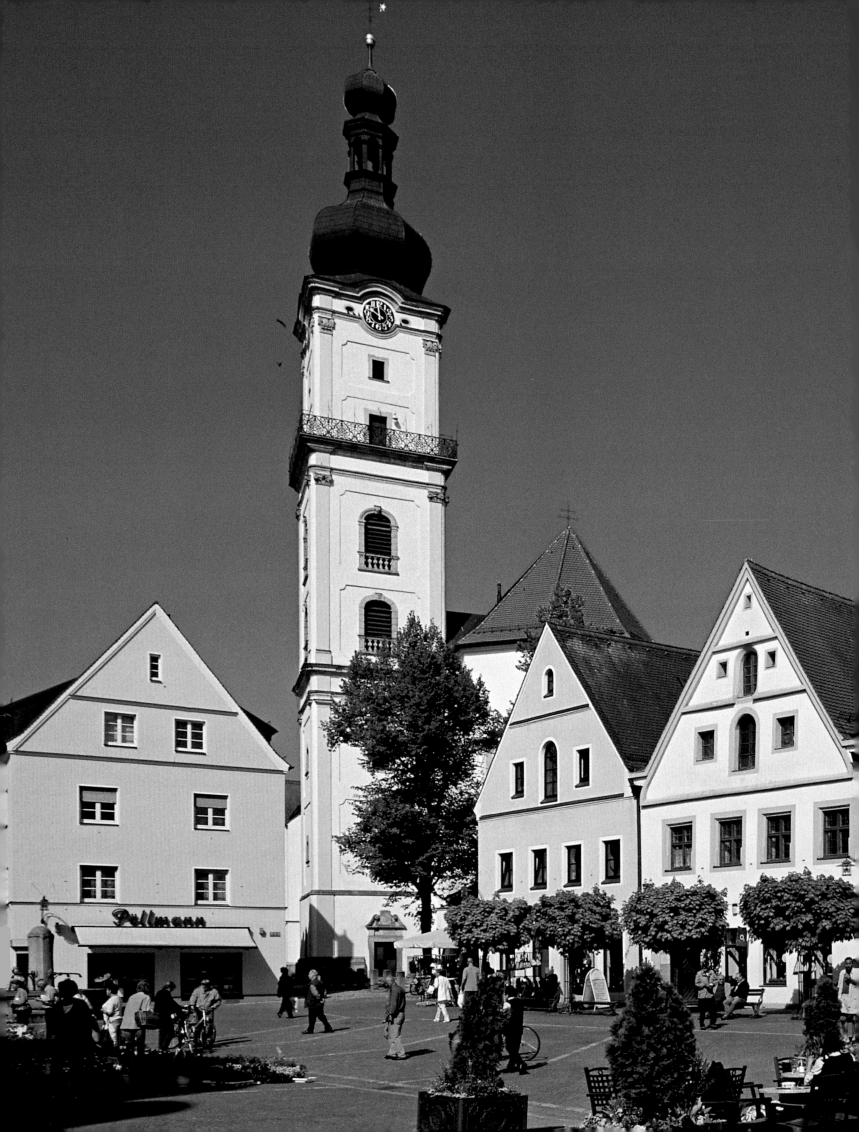

White gold – the fine art of porcelain manufacture

For many years so precious that only royal houses could afford to own it, it comes as no great surprise that porcelain, with its brilliant whiteness and shimmering transparency, was also known as "white gold". Invented in China during the 7th century, its makeup and production were a zealously guarded secret. Seven hundred years later Marco Polo was the first to import china from its country of origin to his native Italy. His discovery met with great enthusiasm. In Europe the common people ate off crude boards and bowls made of wood or clay; the wealthy dined from cups and plates of precious metal, tin or glass. By the 16th century porcelain had become a much craved commodity in trade with China.

Saxon king Augustus the Strong is alleged to have passionately professed: "The desire for porcelain is as strong as the desire for oranges." The monarch once commissioned alchemist Johann Friedrich Böttger (1682–1719) to make gold – which of course failed. Basing his experiments on the research of Ehrenfried Walther von Tschirnhaus (1651–1708), who for years had studied the composition and complicated production of fine bone china, Böttger announced that he had 'discovered' European porcelain in 1709. His method involves mixing specific proportions of kaoline (a fine, white clay), quartz and feldspar with water and soda; the paste is then left to stand for a lengthy period before being poured into moulds or shaped by hand. After the first bisque firing at temperatures of 850°C to 950°C the glaze is added. The components are sintered or glazed in the second firing at 1,300°C to 1,400°C. After Meißen (1710) the production of porcelain was begun in Vienna, London, Paris and many other centres in Europe.

The desire for white gold soon hit Bavaria. Conditions were ideal; near Hirschau, Selb and Tirschenreuth there were plentiful natural resources of the necessary raw materials kaoline, quartz and feldspar. Manufacturers soon set up shop; by the beginning of the 19th century there were even china factories powered by steam engine, such as in Hohenberg an der Eger, for example. Industrial processes soon usurped the expensive and time-consuming production of porcelain by hand, now only suited to the pockets of real aficionados, but made the popular product more affordable to the general public. At the height of the industry ninety percent of German china was manufactured in the area between Selb, Weiden and Arzberg in Upper Palatinate.

A trade with tradition

Porcelain makers often plied their trade across three generations; qualified workers with motivation, expertise and above all experience thus became concentrated in Upper Palatinate. Cheap imports from the Far East soon brought about the collapse of the local market, however; the Bavarian china industry has been at crisis point since the 1970s. Sites of production have

Left:
Mocha cups from the 19th century, fashioned in the "white gold" of Upper Palatinate. Collectors pay a fortune for such priceless objects.

Above:
This stoneware plate from the 19th century can be admired at the Stadtmuseum in Amberg. The city museum of local

been forced to close in Tirschenreuth, Waldsassen and Mitterteich. The art of ceramic decoration is also dying out in the region. Despite all this the manufacture of porcelain is still one of the mainstays of the local economy, with items ranging from household crockery to structural ceramics, from tiles for Dutch stoves to porcelain for technical use. Products by Bauscher and Seltmann, both based in Weiden, are famous the world over. Weiden is thus also an ideal location for the Internationales Keramikmuseum or international museum of ceramics, whose collection outlines the manufacture of porcelain past and present – from China to Bavaria. The newly signposted Bayerische Porzellanstraße or Bavarian porcelain route takes visitors on a trip through Upper Franconia and Upper Palatinate, introducing them to the major sites of production along the way. China experts won't be able to hide their smiles when, settling down for lunch, they turn their plates over to discover that they're eating off fine tableware created by one of the traditional names of Bavarian porcelain manufacture.

history is famous for its substantial collection of china and pottery and a must for fans of all things porcelain.

Right above:
Together with Ehrenfried Walther von Tschirnhaus Johann Friedrich Böttger (1682–1719), a German alchemist, is heralded as the inventor of porcelain in Europe.

Small photos, right:
In 1910 Christian Wilhelm Seltmann (b. 1870), a skilled porcelain turner, founded a factory for household and luxury porcelain in Weiden. In top gastronomic establishments and hotels both in Germany and worldwide, in communal catering, hospitals and care homes Bauscher Weiden is a recognised and respected trademark.

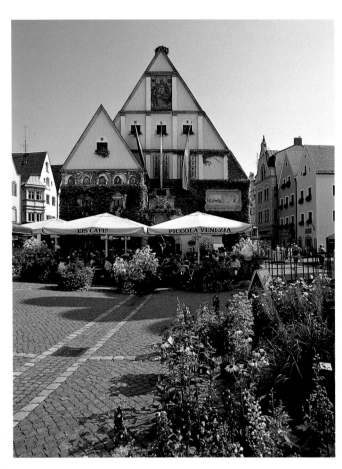

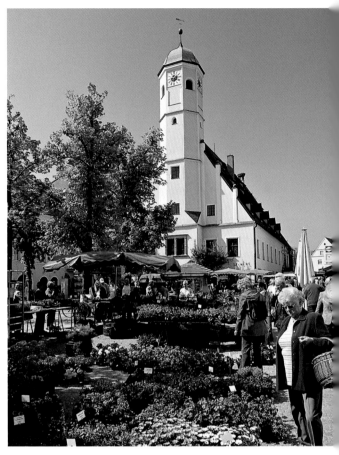

Right:

A carillon rings out every day from the Altes Rathaus in Weiden. In 1981 shops again took up residence on the ground floor of the town hall – as they had done in the Middle Ages. At that time the building was both a centre of local rule and also the focus of the town's social activities, with plays and dances often performed here.

Far right:

The market place in Weiden, benignly guarded by the Altes Rathaus, is still used for its intended purpose.

Right page:

In the space of just 18 months, in 1900/1901 the biggest church built since the Middle Ages in the diocese of Regensburg was erected in Weiden. The Catholic parish church of St Josef is totally devoted to the quirky designs of the Jugendstil period, making it one of the most beautiful sacred edifices of its time.

Right:

The Waldsassener Kasten was built between 1739 and 1742 as an administrative building and a grain store for the Cistercians of Waldsassen. In later years the local court and prison were housed within. In 1990 the building opened its doors anew as an international museum of ceramics, currently featuring china and porcelain artefacts from eight centuries and in various different techniques.

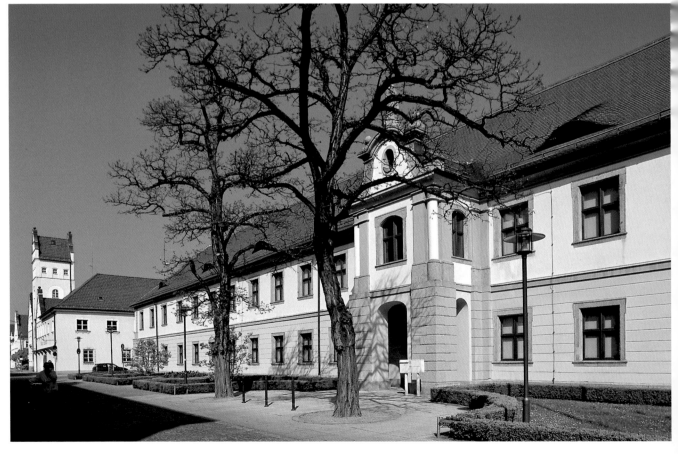

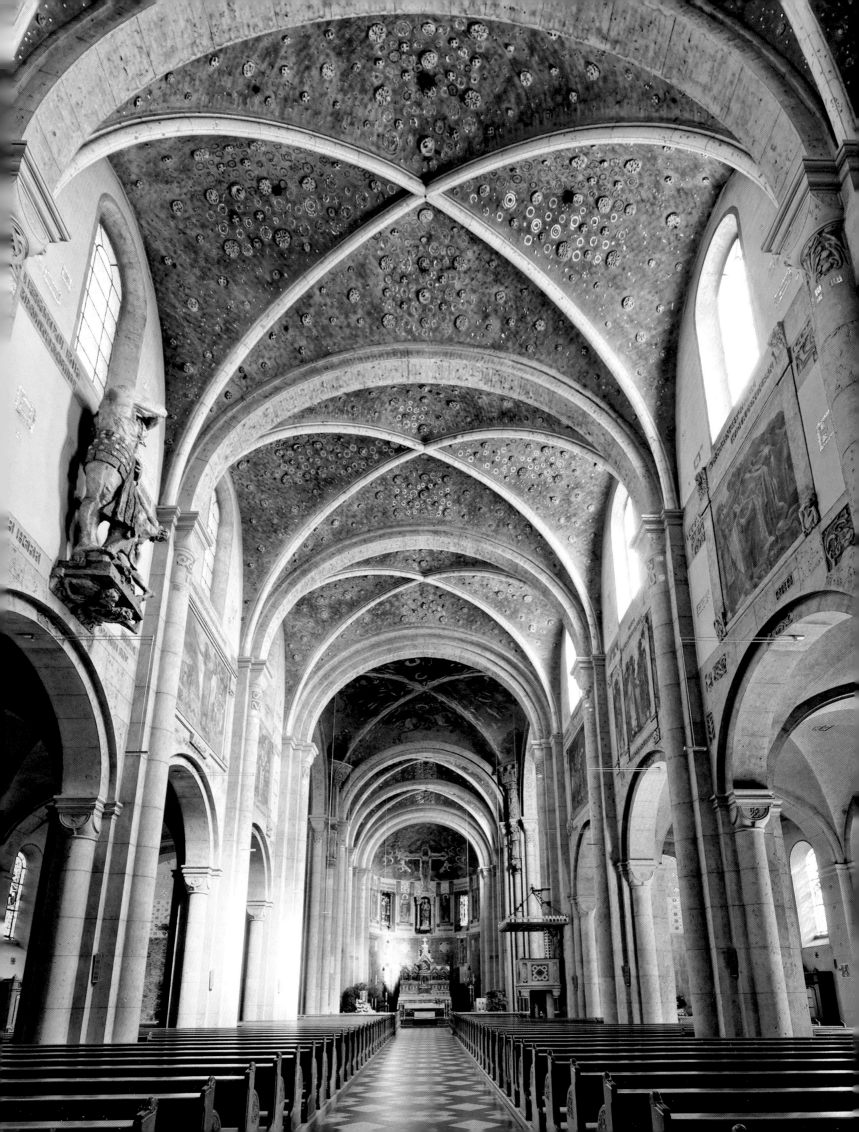

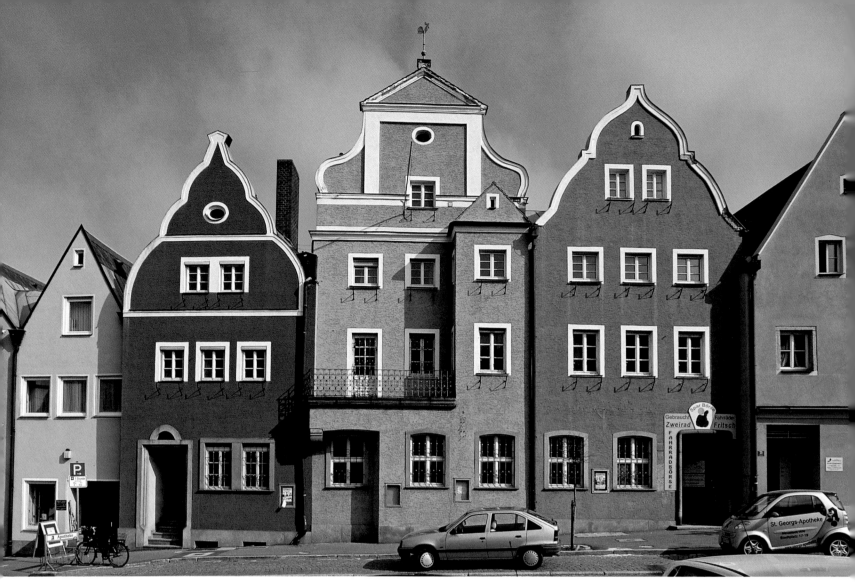

Above:
These colourful homes line Stadtplatz in the heart of Neustadt, where on May 29 2005 a world record was made; the square was the venue of the biggest first aid course in the world, in which 408 participants 'flaked out' in the blazing sun were placed in the recovery position.

Right:
With just 6,000 inhabitants it may be small, but Neustadt an der Waldnaab is nevertheless the district capital. The town hugs the fringes of the Oberpfälzer Wald National Park where the River Floß flows into the Waldnaab. The parish church of St Georg was erected between 1735 and 1737.

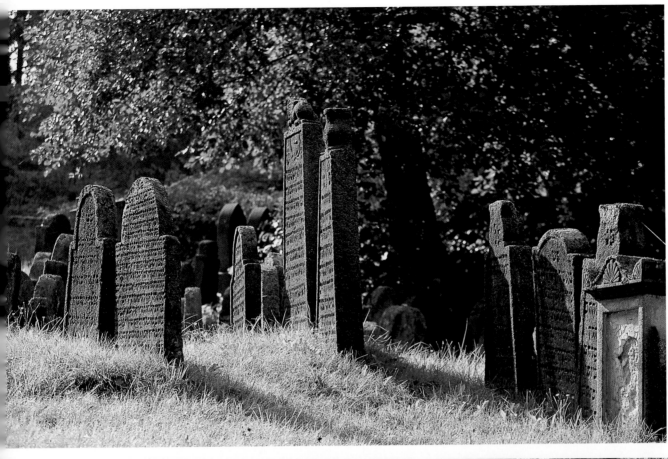

Left:
"Lined up for roll call / here they had to stand / until the posts / cast their shadows over them", wrote Harald Grill of the Jewish cemetery in Floß. The oldest legible headstone is inscribed with the year 1692. The cemetery has been preserved to this very day and commemorates not only the naturally deceased but also the victims of the Flossenbürg concentration camp.

Below:
The Doost area in the district of Neustadt was made a nature reserve in 1937, distinguished by its accumulation of round blocks of granite along the banks of the Girnitz measuring 50 cm (20 inches) to 5 metres (16 feet) in diameter.

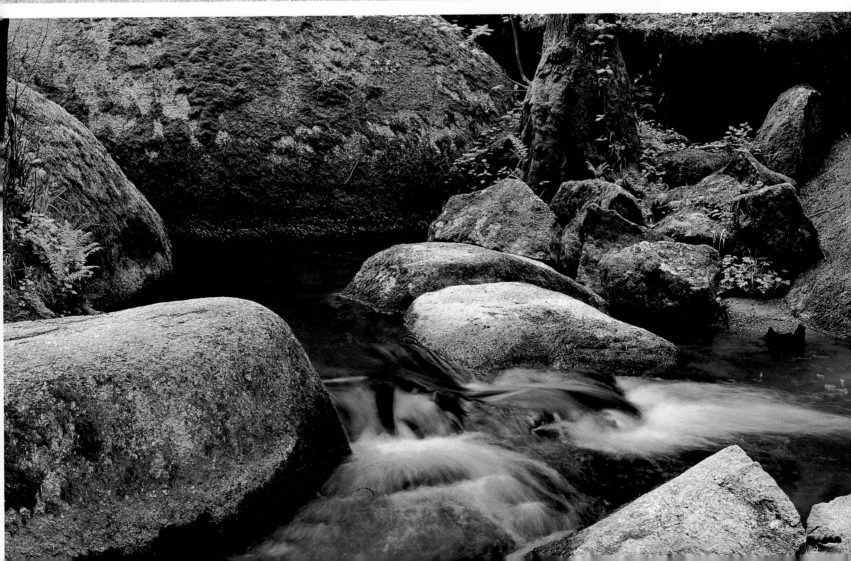

Right:
The shaft house of the Continental Drilling Programme in Windisch-eschenbach rises a giddy 83 metres (272 feet) high up into the air. Via bore holes over 9,000 metres (29,500 feet) deep the contact zone of two Continental plates was investigated here between 1987 and 1995. The earth's crust here is the most strongly structured in the whole of Europe and in an area of high geological interest.

Far right:
A memorial pays sober homage to the victims of the Nazi concentration camp at Flossenbürg. Evangelical theologian Dietrich Bonhoeffer was killed here just 14 days before the liberation.

Right:
Burg Flossenbürg straddles this bizarrely formed granite rock. It was founded in c. 1100 by the Hohenstaufen and originally consisted of just a tower. The keep was added in the 13th century and the gates in the 1500s.

Right page:
Burg Flossenbürg is now a ruin. During the 1980s work was begun to preserve the few remains. The ruins are a popular place for day trips, particularly as there are great views from the top of the keep.

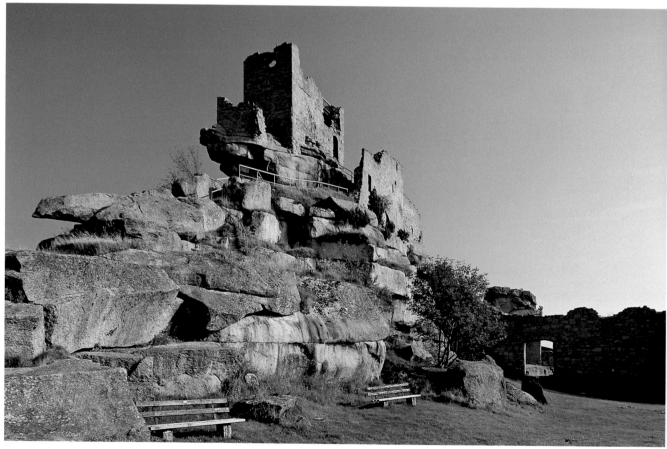

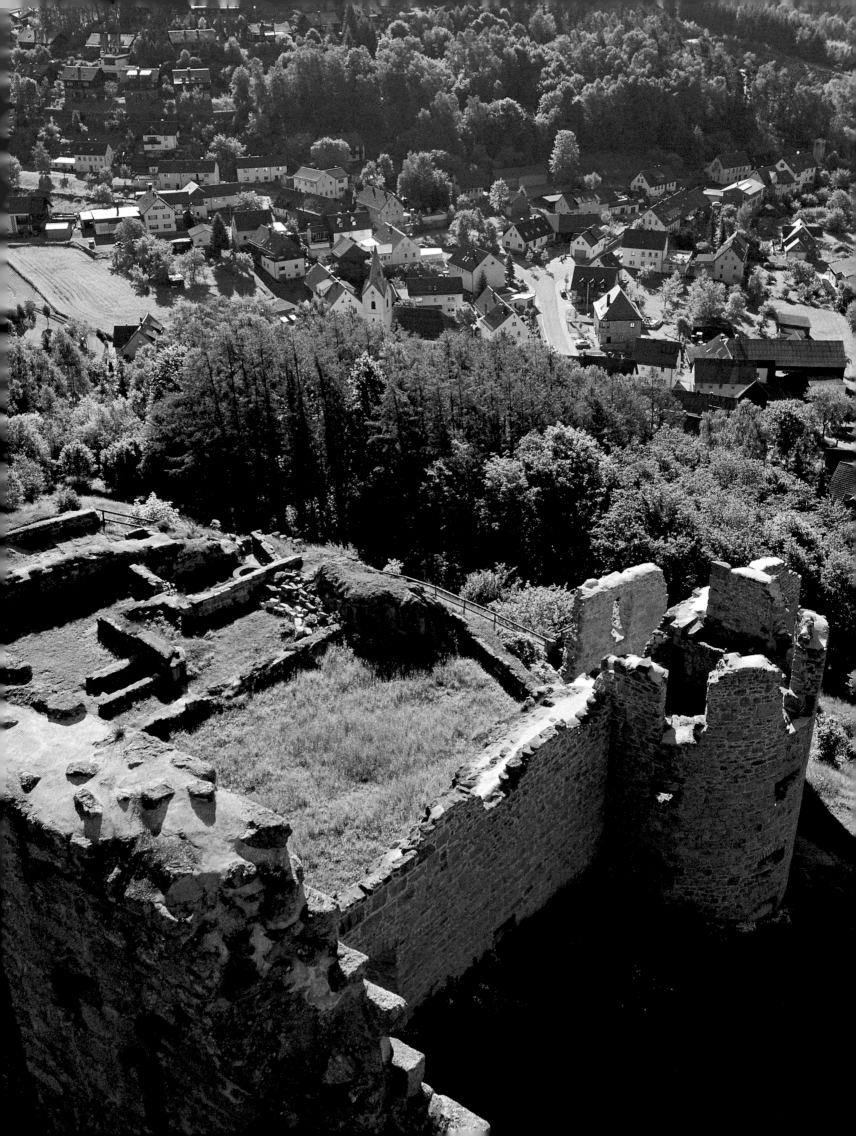

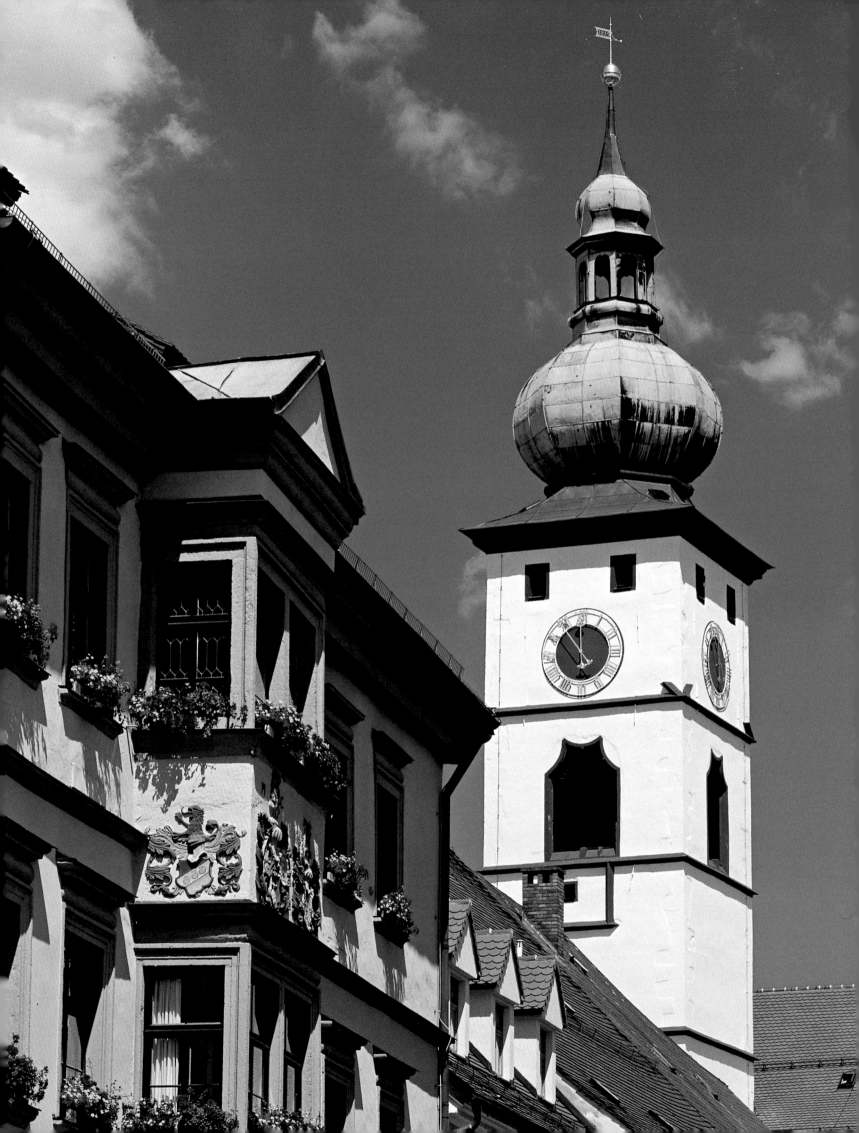

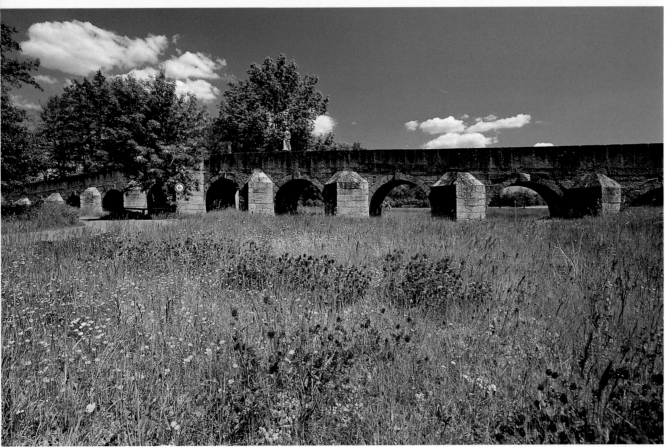

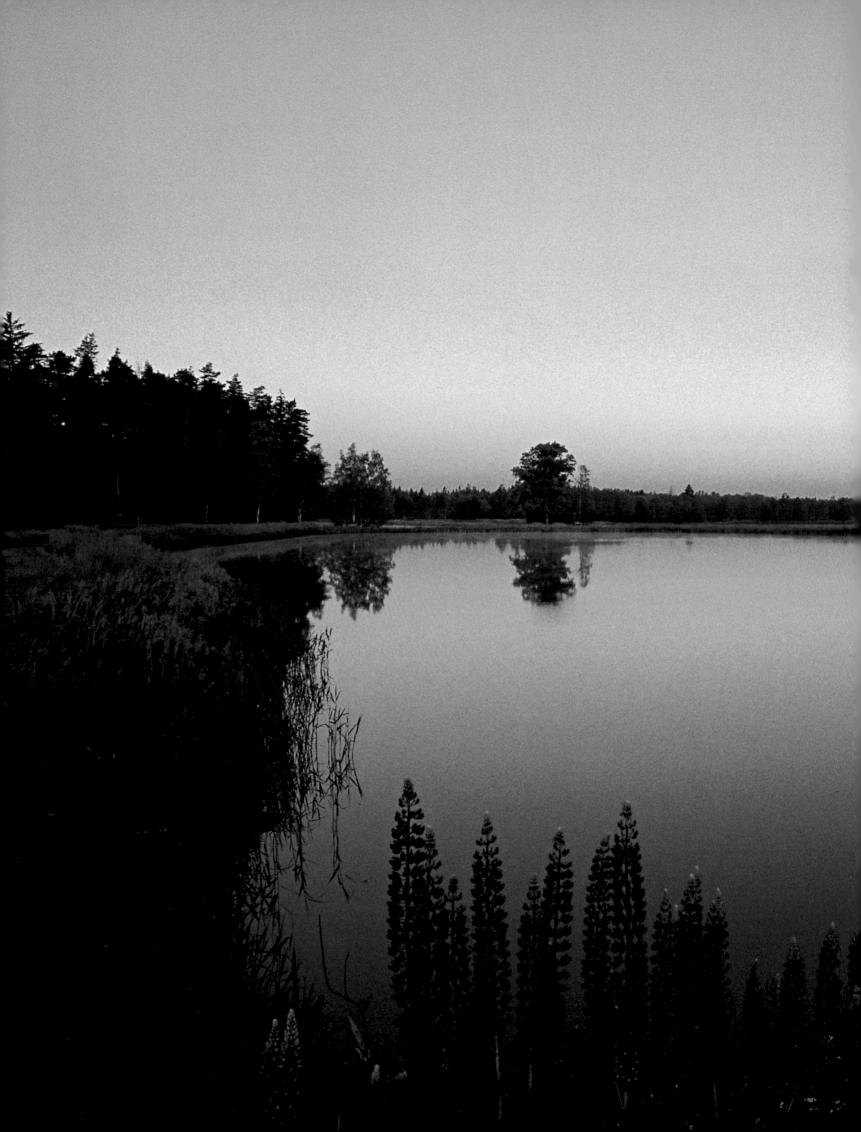

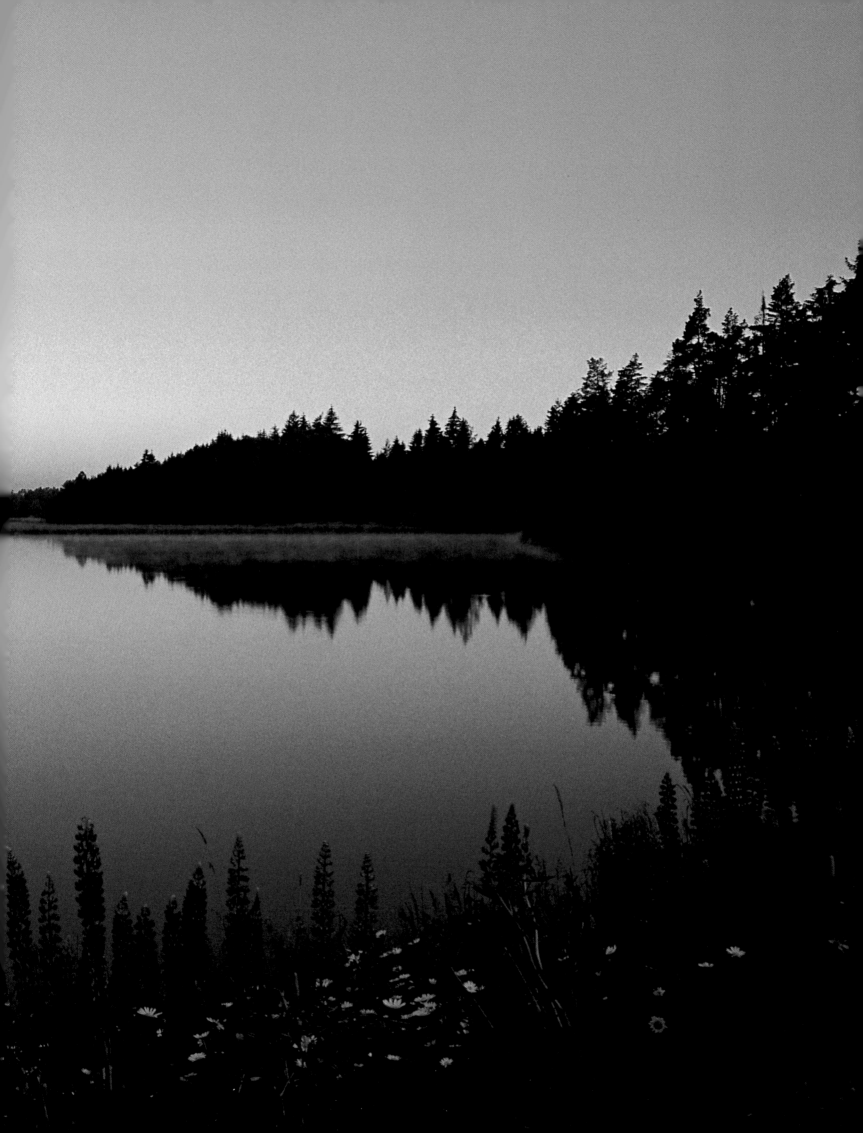

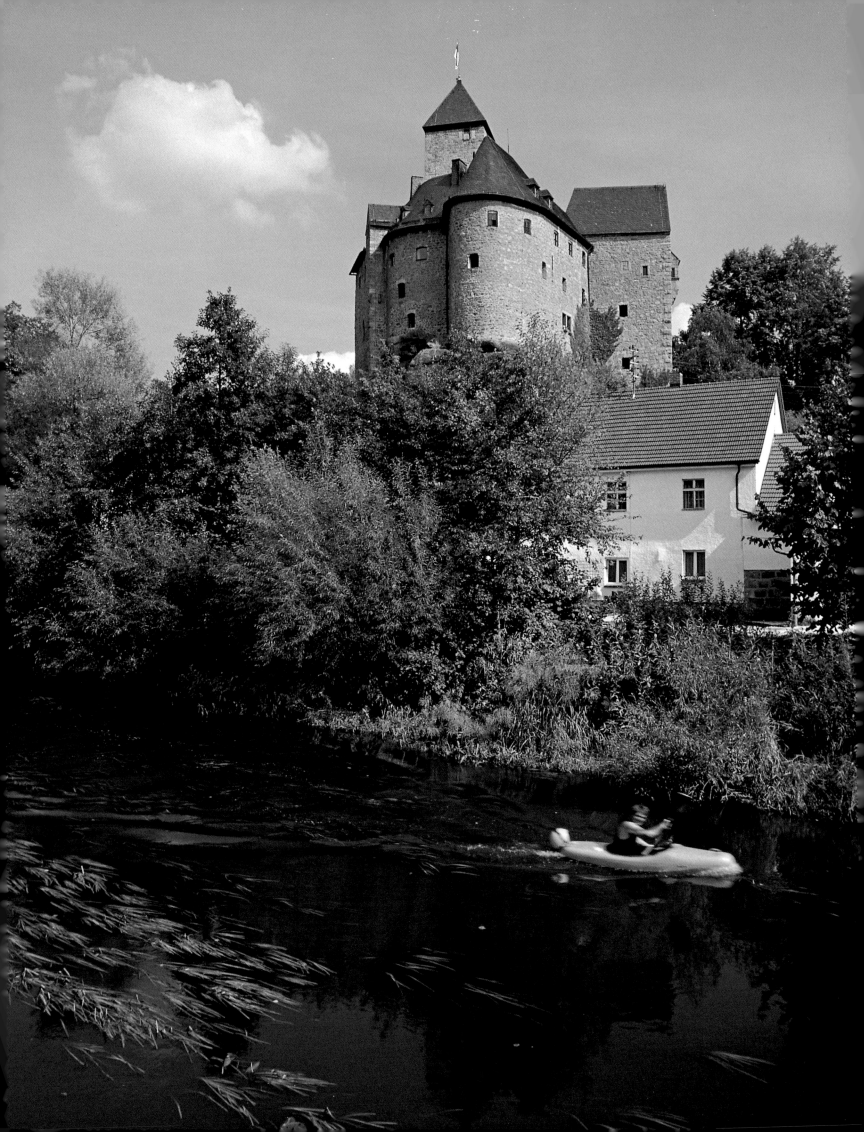

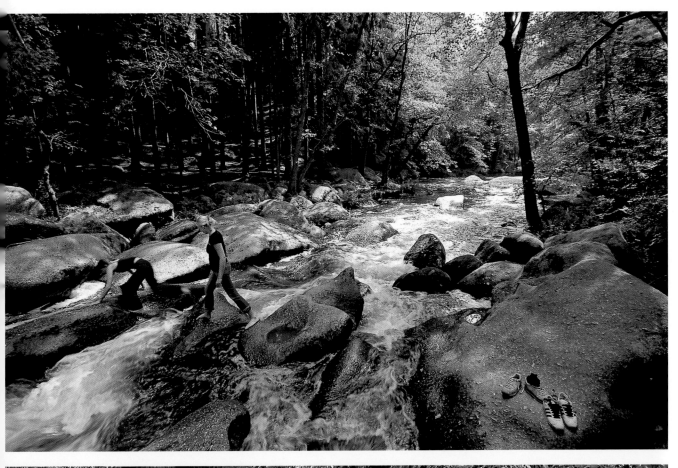

The Waldnaabtal with its many astounding rock formations is a beautiful conservation area serviced by a network of good hiking trails. During the Middle Ages the castles of Altneuhaus, Herrenstein and Schwarzenschwal watched over the valley from their elevated positions high up on the rocks. Today little remains of these once mighty fortresses.

Left page:
The oldest parts of Burg Falkenberg in the Tirschenreuth area are said to date back to the 11th century. The castle was rebuilt between 1936 and 1939 and has been lived in since its completion. It now houses an exhibition devoted to antique weaponry and the Persian and Russian artworks collected by resistance fighter Count Friedrich-Werner von der Schulenburg (1875–1944).

On foot through the Waldnaabtal the Blockhütte beer garden near Falkenberg is a good place to take a rest. Surrounded by hilly forest you can sit outside in the fresh air and watch the kids playing happily in the meadow, far away from the roar of city traffic – with good food and friendly service to boot.

Right:
Country idyll at a pond near Wiesau in the Stiftland. The name "Stiftland", still in use, goes back to the days when the monastery of Waldsassen ruled the land. Situated on the Czech border, the region is perfect for relaxing hiking and cycling holidays.

Right page:
One of Germany's more idiosyncratic sacred buildings is surely the Kappl Dreifaltigkeitskirche on Glasberg near Waldsassen. Its dedication to the Holy Trinity has been taken quite literally, with all sections of the structure dominated by the figure three, manifested in the exterior by three steeples and three turrets with three onion domes.

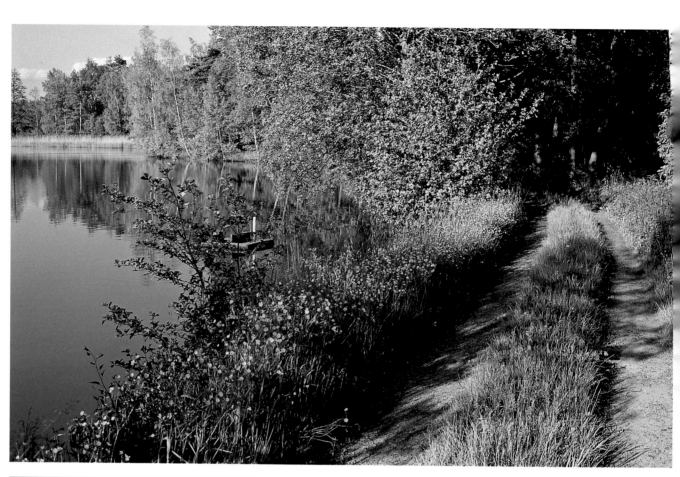

Right:
Mitterteich is the glass and porcelain capital of the Upper Palatine Stiftland, also known as the "gateway to Bohemia". The first porcelain factory here was opened in 1886. Thanks to the rich deposits of kaoline found near Selb Upper Palatine porcelain became a mainstay of local industry. Since the 1970s the manufacturing business has found itself in crisis, however, with thousands of jobs having been lost.

Page 128/129:
Waldsassen's undisputed landmark is its baroque basilica, erected in its present form between 1682 and 1704, during which artists of renown from all over Europe contributed to its makeup. From here it's just a few kilometres to the Czech border.

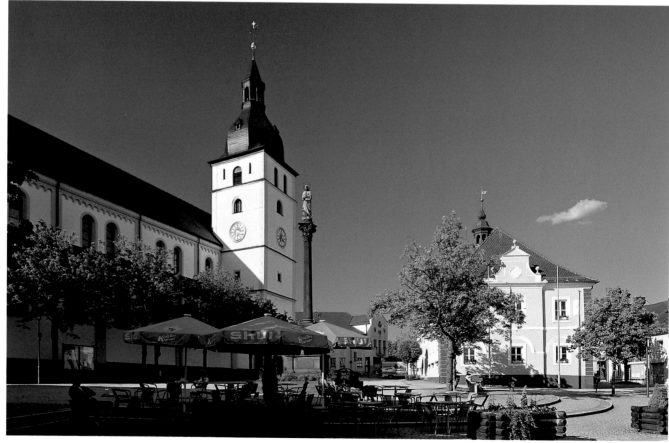

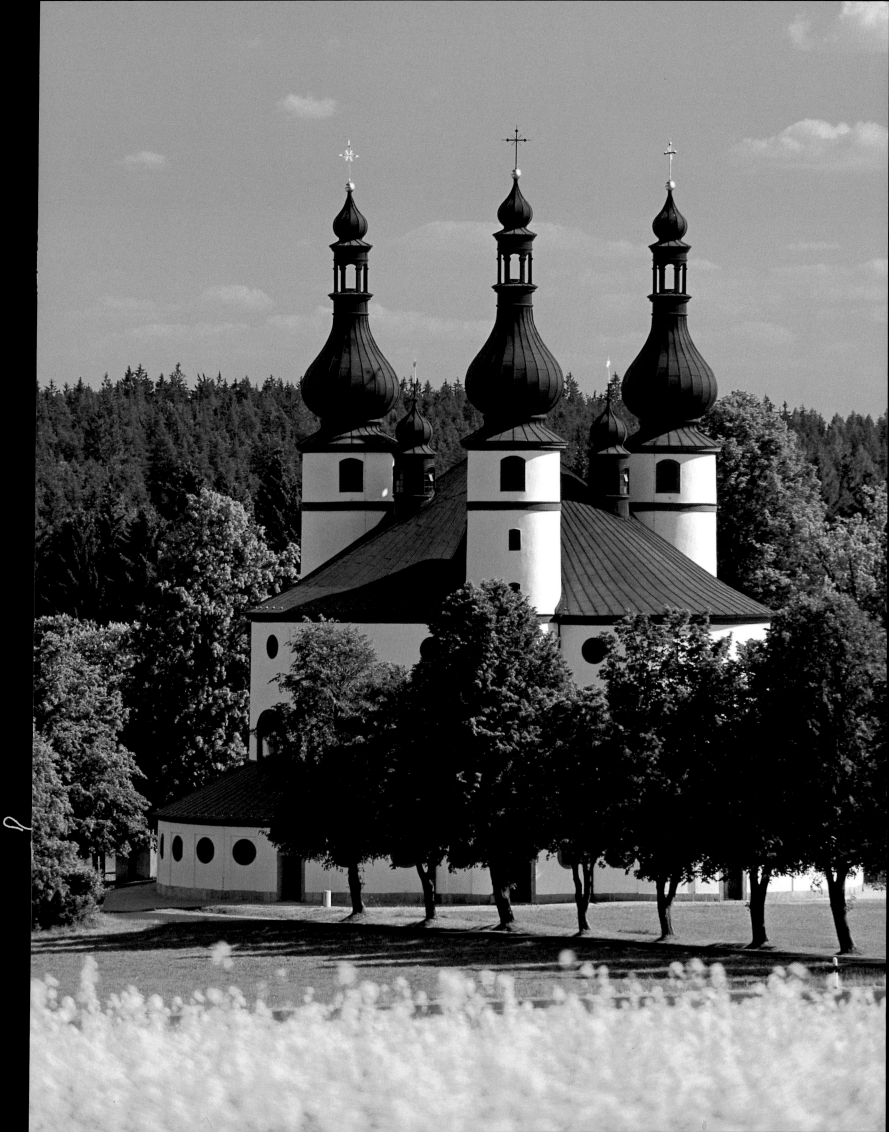

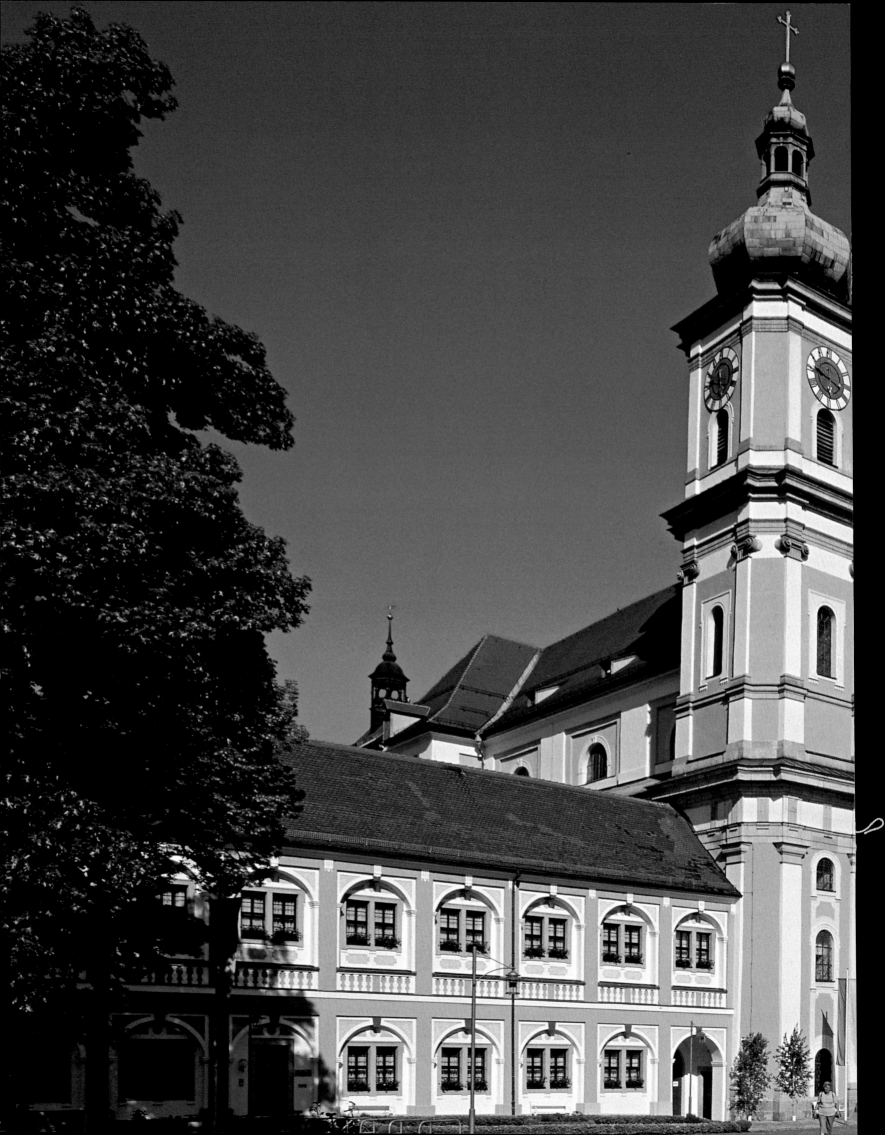

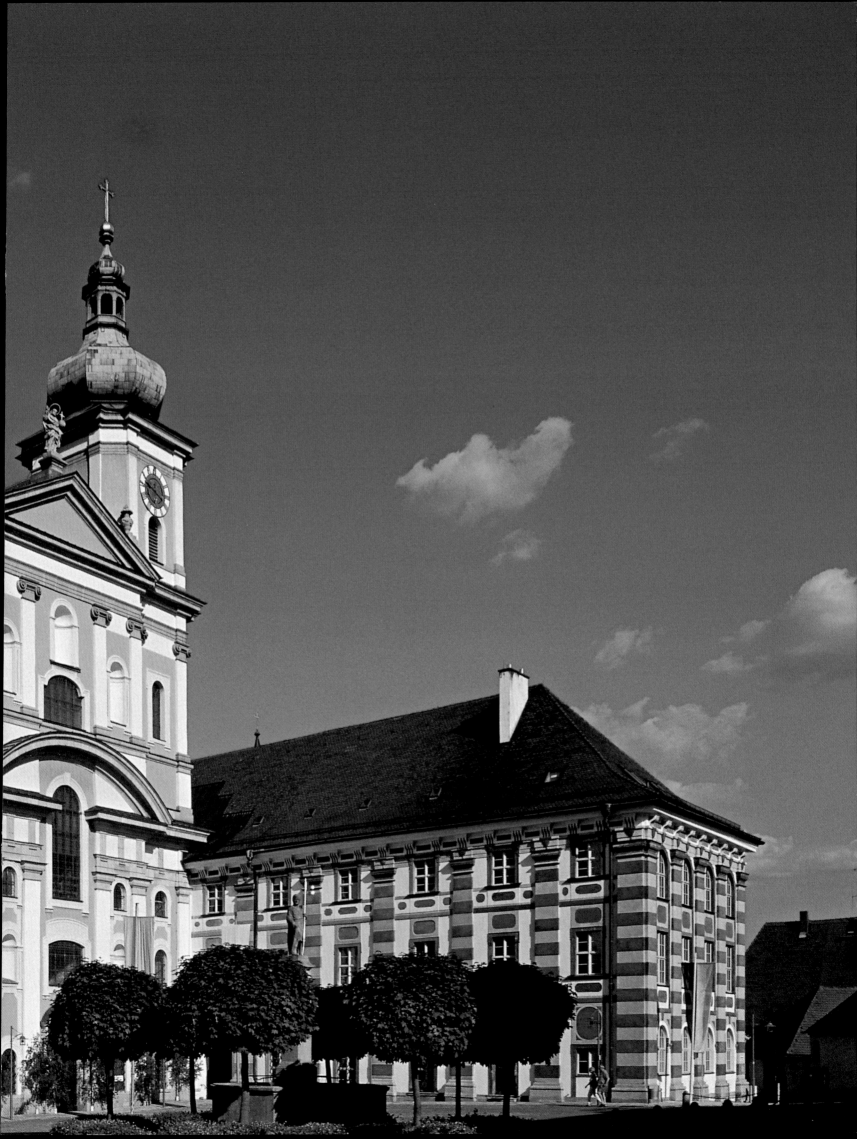

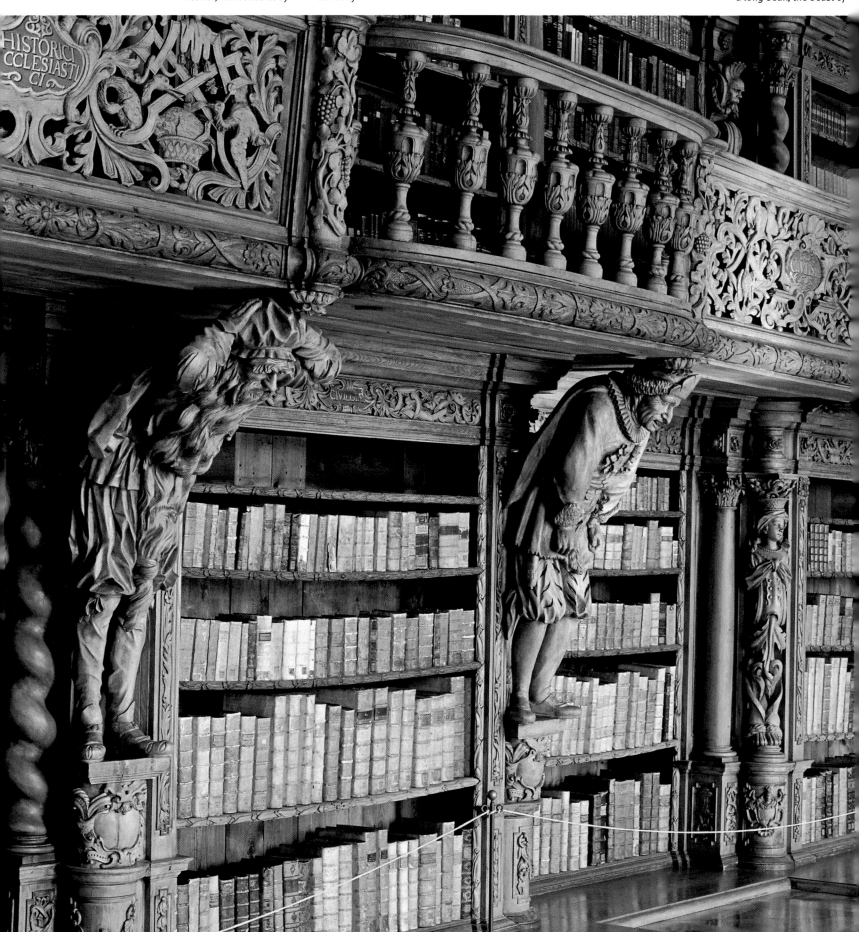

Below:
The internationally famous monastic library at Waldsassen is one of the most important libraries for art historians in southern Germany. The interior, marvelled at by 100,000 visitors a year, was created between 1724 and 1726. The ten wooden life-size figures supporting the gallery represent various vices, such as stupidity, vanity and curiosity.

Small photos, right:
The last of the ten statues embodies the vice of hypocrisy. A man dressed as a cleric is having his nose pulled by a bird with a long beak, the beast of

self-recognition. Other sculptural highlights include busts of famous personalities from Antiquity, among them Sophocles, Plato and Caesar. The library ceiling is adorned with splendid stucco. The ceiling frescos depict scenes from the life of Cistercian St Bernhard of Clairvaux and likenesses of the great Greek and Latin Doctors of the Church. Many of the books in the library disappeared in the wake of the dissolution of the monasteries.

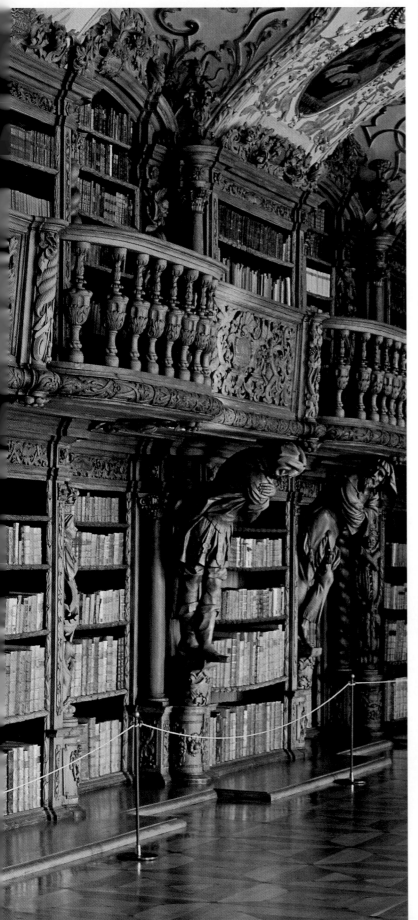

At the ruined castle of Weißenstein. During the 19th century it was 'discovered' by tourists from far and wide and by the Romantic artists of the age. Restored in the 1990s, it still attracts visitors wanting to (briefly) transport themselves back to the days of knightly chivalry.

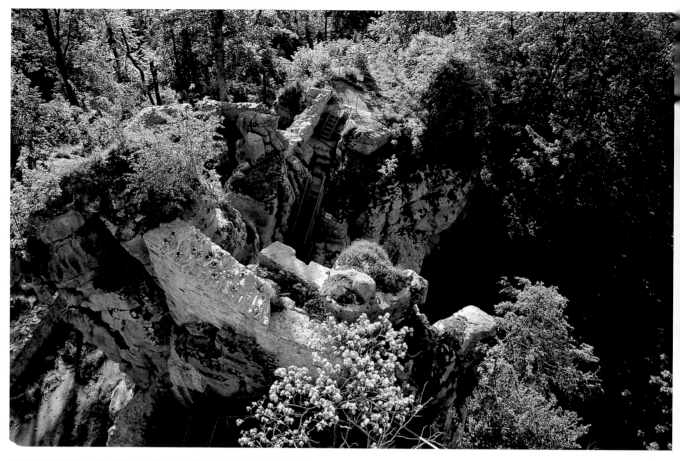

Right page:
Castrum Weizzenstain: the ruins of Weißenstein in their exposed position atop one of the highest elevations in the area (758 m/2,487 ft) is one of the best castles in the Bayerischer Wald. It was put up during the second half of the 12th century to monitor the goings-on on the main trade route between the Danube and Bohemia.

The Steinwald southeast of the Fichtelgebirge is a national park. This "stone forest" undoubtedly gets its name from the many blocks of granite and bastions of rock which are haphazardly scattered across this bizarre terrain. Many have strange names, as befits their shape, and some are popular with climbers, such as the Räuberfelsen or Robber's Rock.

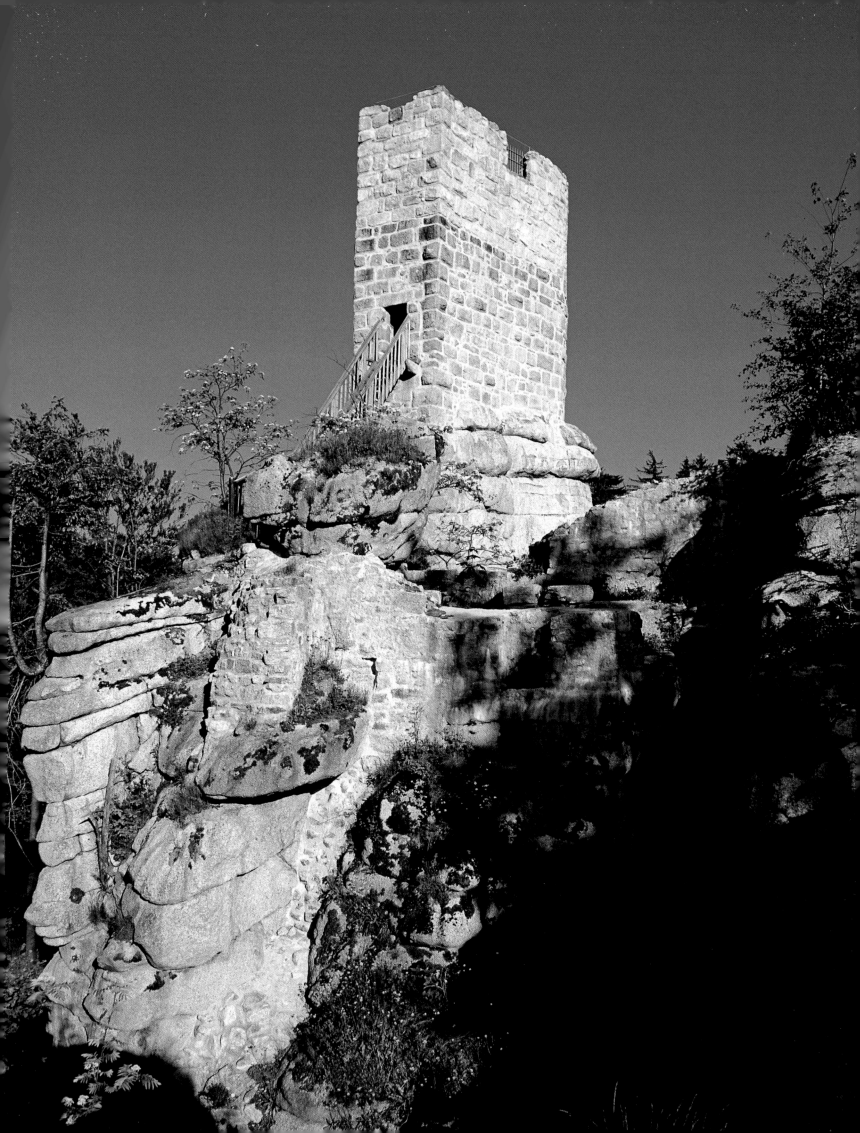

INDEX

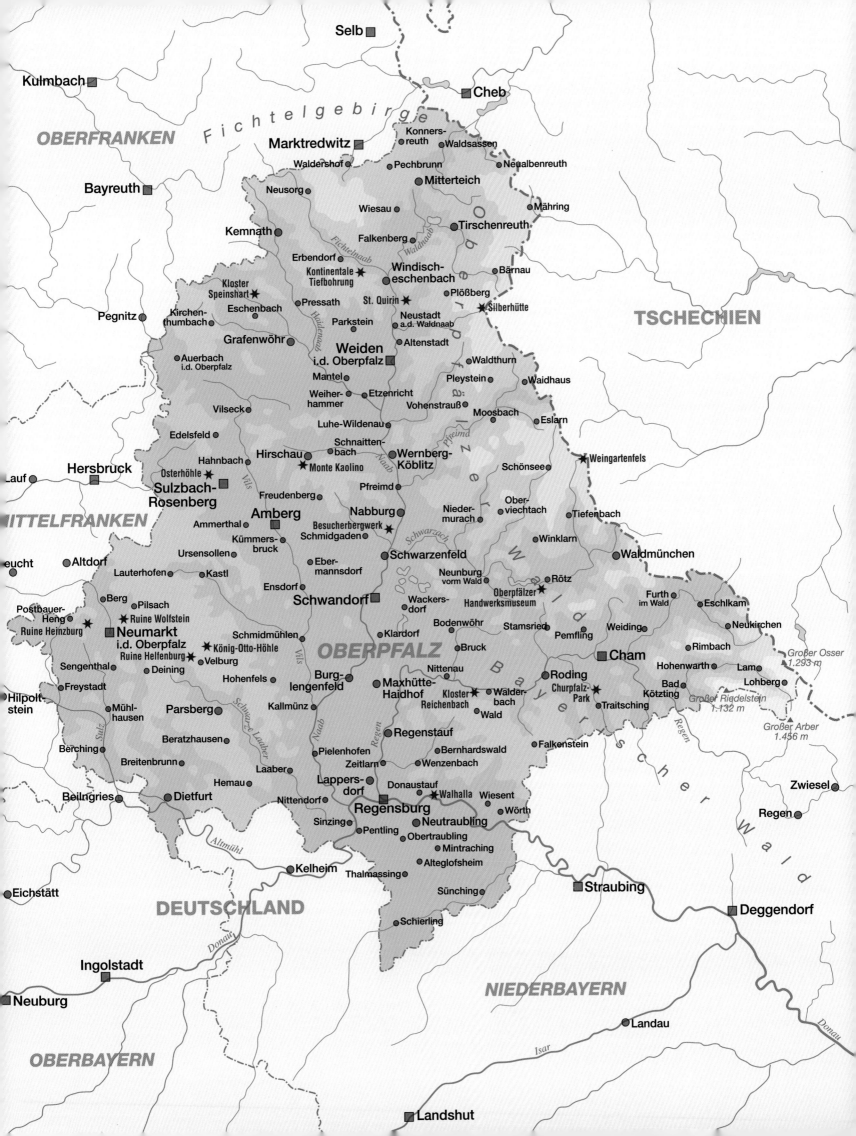

Since the beginning of the 20th century the inhabitants of Dietfurt on the River Altmühl have duly celebrated a 'Chinese' carnival once a year. The event dates back to an old story which tells of a journeyman who once came to Dietfurt, wanting to settle here, but was turned away. When the man complained, the local judge asked him if he knew who had built the biggest wall in the world. "The Chinese", answered the craftsman correctly. The judge replied: "And why? To keep out strangers". The journeyman angrily packed his bags and stalked off, telling everyone that he'd been refused entrance to Dietfurt because he wasn't Chinese ...

Credits

Design
www.hoyerdesign.de

Map
Fischer Kartografie, Aichach

Translation
Ruth Chitty, Schweppenhausen

Printed in Germany
Repro by Artilitho, Lavis-Trento, Italy – www.artilitho.com
Printed/Bound by Offizin Andersen Nexö, Leipzig
© 2010 Verlagshaus Würzburg GmbH & Co. KG
© Photos: Martin Siepmann
© Text: Georg Schwikart

ISBN 978-3-8003-4060-6

Photographer
Martin Siepmann is a freelance photographer and writer. He has had his work published in numerous books on regional and international travel and also in magazine reports and calendars.
www.martin-siepmann.de.

Author
Georg Schwikart lives in Sankt Augustin near Bonn where he works as a freelance author and publicist. He has had numerous books and contributions to anthologies, newspapers and magazines published and also works for radio and television. Verlagshaus Würzburg has produced many books on various travel destinations by Schwikart.
www.schwikart.de

Details of our programme can be found at
www.verlagshaus.com